The Bishop's Palace at Salisbury

A concise history of the former palace of the bishops of Salisbury

Peter L Smith

Many new photographs by Roy Bexon

Spire Books Ltd

PO Box 2336, Reading RG4 5WJ
in association with
The Cathedral School, Salisbury
www.spirebooks.com

For Joyce

Spire Books Ltd
PO Box 2336, Reading RG4 5WJ
www.spirebooks.com

Copyright © 2013 Spire Books Ltd, Peter L Smith and Roy Bexon

CIP data: a catalogue record for this book is available from the
British Library
Designed by John Elliott
Printed by Berforts Information Press Ltd.
ISBN 978-1-904965-41-1

Contents

Foreword

Salisbury enjoys many historic and beautiful buildings but one of the least well-known is probably the Bishop's Palace which sits adjacent to the Cathedral. For many centuries it was the private residence of the bishops of Salisbury. In recent times this landmark has become the incomparable location for the Cathedral School. Access for the wider public has therefore always been limited. In years to come the Cathedral hopes that it might be able to give much greater availability to this southern landscape of the Close including the view of the Bishop's Palace to those who might seek to enjoy its rich history and enduring beauty.

Peter Smith has been a valued member of the Cathedral School community for over thirty years and so there is nobody better to introduce us to the ancestry and idiosyncrasies of this extraordinary building and to some of the personalities who shaped its existence. Through his scholarship and painstaking research we gain a sense of the many generations who have inhabited this residence, the mark they left upon it, and their legacy which is ours to enjoy. Some of the names will be familiar but hidden away in Peter's text are stories of some less well-known bishops who nevertheless made religion in our land a more attractive, intelligent and trustworthy enterprise.

I am enormously grateful to Peter for telling the story of this immensely important building and, through it, reminding us of the debt we owe to some of our Salisbury ancestors who were full of character and full of faith.

The Very Revd June Osborne
Dean of Salisbury

THE FORMER PALACE OF THE BISHOPS OF SALISBURY

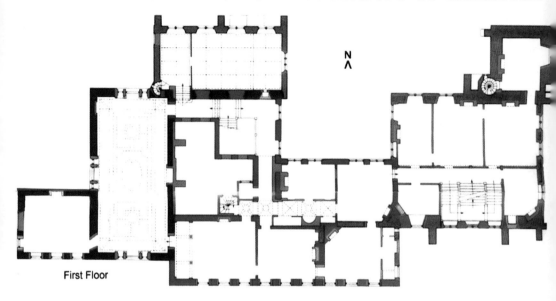

First Floor

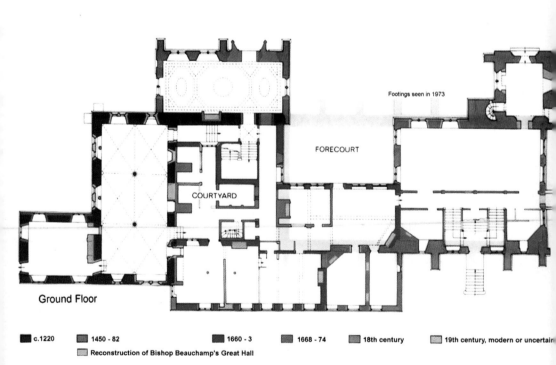

Ground Floor

■ c.1220 ■ 1450 - 82 ■ 1660 - 3 ■ 1668 - 74 18th century 19th century, modern or uncertain

Reconstruction of Bishop Beauchamp's Great Hall

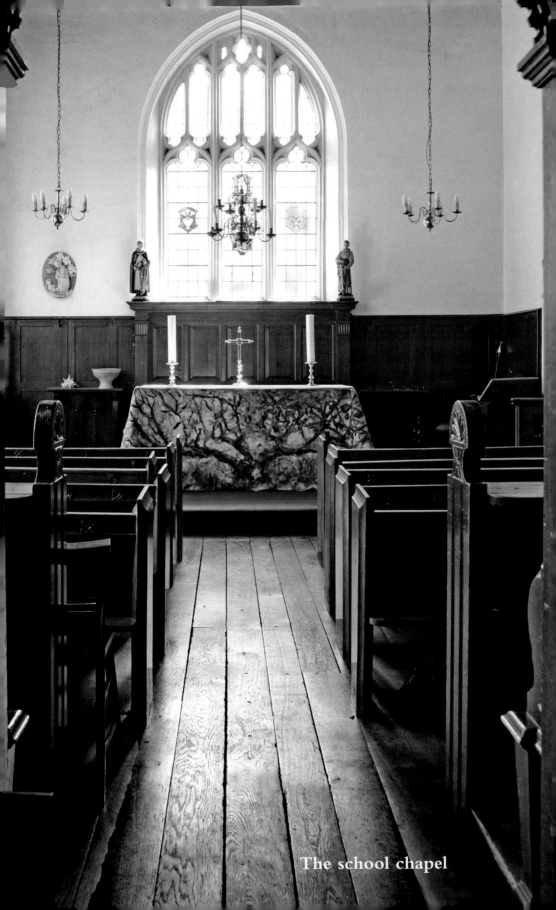

The school chapel

Salisbury Cathedral Close

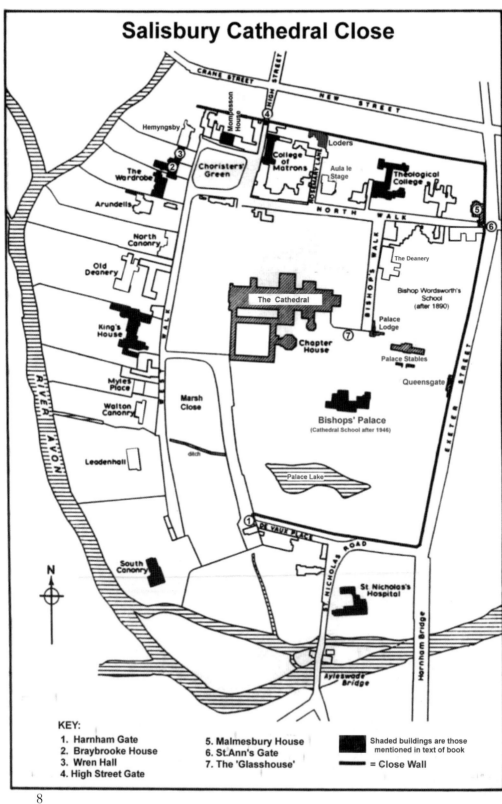

KEY:
1. Harnham Gate
2. Braybrooke House
3. Wren Hall
4. High Street Gate
5. Malmesbury House
6. St.Ann's Gate
7. The 'Glasshouse'

Shaded buildings are those mentioned in text of book

= Close Wall

Preface

The former Bishop's Palace in Salisbury is one of the greatest and most interesting secrets of this ancient cathedral city. Not easily seen, it stands to the south-east of the Cathedral and can be glimpsed through the door at the south end of the cloisters. This view reveals the west end of a building which dates back almost 800 years to the early thirteenth century when it was built on the orders of Bishop Richard Poore. Visitors can also discover the Palace by walking around the east end of the Cathedral. It stands beyond an ornate gateway, at the end of The Close road known as 'Bishop's Walk'.

Such is the sequestered nature of the Palace that many people who have lived in Salisbury all their lives are unaware of it and, regrettably, many writers on the city give it little mention. The present book aims to remedy this situation. Originally my intention was to deal simply with the history of the building and the many complex changes during its eight centuries of its existence. However, it soon became clear that some of the more notable

The Bishop's Palace from the south-east cloister door.

bishops and their families deserved a place in this narrative. As the book developed, this aspect grew in importance and it is through the lives of the people who used the building over the ages that I hope that it will come alive.

A major change occurred in 1947 when the Palace became the home of Salisbury Cathedral School and this transformed the way the building and its grounds were used. The School has added its own buildings and radically altered the internal spaces to make a thoroughly modern educational centre. The grounds today are mostly playing fields which had once been the gardens and meadows for the private pleasure of the bishops and their families.

It has always been a problem for the occupants of the Palace to remain peaceful, quiet and separate, especially in modern times when, in summer months, tourists and school parties take over the Cathedral and its surrounding green spaces. Nonetheless, it is possible to visit the Palace during vacation times on application to the Head Master (Salisbury Cathedral School, 1 The Close, Salisbury, SP1.2EQ). Visitors who wish to view the grounds are always welcome (out of term-time) and should check in with the friendly and helpful staff at the School's reception foyer.

Peter L. Smith
September 2012

Acknowledgements

I am hugely grateful to all those who have helped in the production of this book. In particular, I would like to mention:

Simon Maybee, See House Team (Church of England Church Commissioners), who has given so much of his time to help with the history of the portraits of the Bishops of Salisbury on show in the Palace.

Rosemary Barnes, Margaret Lovett, Julia Mettyear, Cynthia Munro, Ninian Stewart and Jane Ellis-Shön (Salisbury & South Wilts Museum) whose help and advice has been so much appreciated.

A close friend (who wishes to remain anonymous) who has prepared and drawn the various plans of the Palace. I am very grateful for the time that he has given freely, and for the care and attention to detail shown.

Roy Bexon who was responsible for many of the new photographs in this book.

Geoff Brandwood and John Elliott, who have worked so hard to edit and publish this book. Their patience with the vagaries of the author deserves much praise. I have hugely appreciated their immediate acceptance for its publication and their realisation of its historical potential.

Linda Hone for all of her effort and enthusiasm in the marketing and promotion of this book.

It has taken over 30 years to research and to discover the various elements that have culminated in the publication of this book. I would like to record

here my thanks for all of the help and support given by so many people over these years to develop and to expand the resources of the Cathedral School Archive. From this base the present book has at last become a reality.

Photographic acknowledgements

The Warden and Fellows of Merton College, Oxford, for their permission to use the portrait of Bishop Edward Denison and in particular, the help of Dr Julia Walworth, Fellow Librarian, for her help with this (7.6).

The Victoria & Albert Museum and The Fitzwilliam Museum, Cambridge: pictures by John Constable (3.13), (3.14) & (3.15).

The National Portrait Gallery: portraits of Francis Price (1.9) and of Bishop John Jewel (2.9).

The Higgins Art Gallery & Museum, Bedford: picture by J.M.W. Turner (3.16).

English Heritage: picture by Alan Sorrell of Old Sarum Bishops' Palaces (A.1.8).

The Bishop of Portsmouth for his permission to use the portrait of Bishop Neville Lovett and, in particular, Neil Pugmire, Diocesan Communications Adviser, for his help with this (5.4).

Many of the illustrations in this book come from the Cathedral School archives, the Palace portrait collection (see list in Appendix 3), or from the private collection of the author. Many of the new photographs were taken by Roy Bexon. The captions to the illustrations show the sources of any pictures that do not derive from the above collections.

Introduction

When the momentous decision was made in 1218 to move from the hilltop at Old Sarum, and to create a new cathedral, the Bishop of Salisbury immediately set to work to build his 'new place' in the open fields of Old Salisbury (the name given to the ancient manor of Milford). When the foundation stones for the new cathedral were being laid in 1220, the bishop's palace was actually nearing completion. It was placed to the south-east of the Cathedral, next to it but not over-shadowed by it. From here, the bishop had an extensive view of the open fields all around and the prospect of the wide world beyond. It is very likely that, with a new cathedral close and a whole city to plan, he must have considered the placement of his new house to be very symbolic. In many ways, its position was to reflect the role played by the bishop in the Cathedral Close: it would be part of The Close, but not obviously so. The other Close residences would be within the domain of the dean and the canons who were responsible for the Cathedral. The position of their grand houses, surrounding the new cathedral, would make it all too obvious that these would be the homes of those actively involved in its administration. Eventually, the Bishop's Palace would be walled off from The Close – even today, it cannot even be seen from The Close walks. This acts as a reminder that, whilst the Cathedral is the seat of the bishop's authority, it is not under his direct rule. The Palace is the only residence that has direct access not only to The Close itself, but also to the outside world. Its entrance to the Cathedral is via a 'back door', not through one of the grand entrances on the west and north sides. The bishop, whilst concerned with the life of the Cathedral, is even more responsible for the diocese beyond his gates.

The real fascination of the Palace lies in the way it reveals the diverse social changes across its eight centuries of existence. To meet the needs of the passing generations of bishops, and its latest occupant, the Cathedral School, the Palace has undergone extensive alterations. Some have added extra buildings, others have removed parts, and some have simply adapted

areas for changing purposes. In the north front, one can appreciate the building styles spanning the entire history of the building. At the extreme west end is the original thirteenth-century Palace of Bishop Richard Poore. This is a very simple building – similar to other large stone-built manor houses of the time. However, it has lost its original lancet windows and in their place are large Venetian-style eighteenth-century windows. To the east, the next block of buildings juts out beyond the rest of the Palace. This is the first part of the huge fifteenth-century extension built by Bishop Richard Beauchamp in the Perpendicular style. However, cut into its front is a late eighteenth-century 'Gothick' Revival porch. At the back of this block is the only Victorian detail – the little tower that houses the Chapel bell. The central area of the Palace is totally seventeenth-century, with three walls of knapped flints in a chequer pattern. To the east of this front is the Beauchamp Tower, marking the end of the fifteenth-century extension. The twentieth century is represented by the Head Master's house at the extreme east end.

When the Palace was first constructed, it just had a large hall and very limited living quarters. It would have been used principally for the accommodation of the bishop and his staff when attending the Cathedral. Surprisingly these visits were very infrequent. The bishop rarely stayed at the Palace, so much of his time being occupied by lengthy circuits of his diocese (see Appendix 1). Additionally, bishops were powerful figures in the King's government and frequently needed to attend the monarch's councils. From the thirteenth century onwards, the administration of the State was increasingly centred in London and it became necessary for the bishop to have a house there so that he could attend parliament and do business in the capital. If the bishop was in Salisbury so infrequently, then the Palace must have been simply an administrative centre. A trustworthy deputy (usually the Archdeacon) would deal with minor infringements against Church law in the regular bishop's court. He would also be responsible for sorting out problems concerning ecclesiastical law – often these were framed as appeals (e.g. an appeal to annul a marriage). For us, living at a time when the Church has no power and little influence, it is almost impossible to realise what the authority of the medieval Church actually meant. Today, a man's duty to the secular power is inevitable and obligatory, while his duty to the Church is purely optional, a matter for his own conscience or his own taste. In the Middle Ages, the allegiance demanded by the Church was just as great and just as indisputable as that required by the State. Every man was subject to the secular power, which had certain rights over his property and his labour. However, he was equally in the power of the Church, which not only

deprived him of a considerable proportion of his living, but also claimed to control his life and to give him his final passport either to unending joy or to unspeakable and eternal torment.

A bishop's palace had the two-fold purpose of housing the bishop and his servants and accommodating his guests on a lavish scale. The palace at a cathedral was the seat of the bishop's authority but, in addition, most bishops had a house on each of their chief manors, and there are remains of these in various parts of the country. A bishop's house of the Middle Ages would have been much the same as that of other lords. It consisted of a great hall with pantry, buttery and kitchen, a great chamber for the use of guests, a private set of chambers for the bishop and his household with a chapel, all surrounded by a high curtain wall, defended, where space allowed, by a ditch, and entered by a strong gatehouse. Here the bishop could emphasise his authority and status by displaying his wealth in elaborate architecture and a lavish interior.

The nearest equivalent today to the medieval bishop might be that of a senior administrative civil servant. The bishop would have been a respected figure, though often not a popular one. The wealth, power and responsibility of his office required a staff of 50 to over 100 people. The bishop's main expenditure lay in the maintenance of his household. There were, first in importance, the legal officers, each with his clerk or secretary. Then there were the ecclesiastical attendants, the chaplains and clerks of the chapel. Finally, there were the members of the household – the squires, valets, servants and pages. Some bishops also had a personal bodyguard of soldiers. Many of the bishop's officials were about their master's business in various parts of the diocese or in London, but the majority of them formed the bishop's '*familia*' or household and followed him in his seemingly endless journeys from manor to manor.

Originally the Palace was chiefly an administrative centre, but by the end of the Middle Ages it had become much more of a residence. In the late fifteenth-century, Bishop Beauchamp's extensive additions to the Palace reflected a desire for more comfortable lodgings. He was also concerned to accommodate large numbers of important visitors, at times even the king and his entire court. However, he still had to be absent from his Salisbury base for long periods. It is worth noting that Bishop Beauchamp was also responsible for the huge rebuilding of the palace at Sonning on a scale similar to his work at Salisbury (see Appendix 1).

After the Reformation, the clergy could marry and have families. In addition, bishops now no longer needed to spend so much of their lives on endless journeys around their dioceses and they wanted to have a

> The Episcopal residence of Salisbury, standing where a bishop's home ought always to stand, in the city from which he takes his title and under the walls of his own cathedral, has, according to mediæval usage, a just claim to the title of 'palace'...
>
> The Palace, as it is one of the most beautifully situated, so is it one of the most picturesque of the Episcopal residences in England. Immensely long, entirely without plan, its spacious apartments succeeding one another like so many pieces in the game of dominoes, added on just when and where they were wanted without any thought of symmetry, broken with countless projections and gables, it exhibits the enviable picturesqueness of a house that has grown and has been growing through more than six centuries. Among its noble trees, with its broad sweeps of brilliantly green turf and the trim flower garden, which brightens its long southern front, with the grey walls of the most graceful of English cathedrals towering above, and its unrivalled spire shooting its tall shaft into the sky; the irregular mass of the palace ... arrests the attention more forcibly and lives in the memory more vividly than many a better designed and more architecturally perfect building.
>
> Edmund Venables, *Episcopal Palaces of England*, 1895

central base to enjoy a settled family life. Accordingly, in Salisbury, the Palace became the bishop's home, hence a need for greater comfort and more rooms as private apartments for the bishop and his family. When a bishop remained unmarried, he would gather a group of young men at the Palace to be trained for the priesthood. A good example is that of Bishop John Jewel, who formed a training centre for promising students prior to them commencing their university studies. By the end of the seventeenth century, two of the bishops had repaired the damage caused during the Commonwealth period and created a more 'modern' style of palace. Gone was the need for a sumptuous great hall – now the desire was for smaller apartments for bedrooms or living rooms.

On entering The Close today, the impression is one of eighteenth century opulence. At that time, it became the fashionable address for Salisbury's upper classes, and their building activities eclipsed the architecture of the Palace. It remains visually, an essentially medieval building. Some eighteenth century bishops were much involved with the conversion of the Palace into a lavish neo-classical mansion. Yet, despite the great expenditure this entailed, many of the bishops of this century did not remain in office long enough to enjoy the luxury thus provided (see Chapter 3). As there was a rapid turnover of bishops throughout the century, it could help to explain why none of them attempted to cloak the medieval front with a classical

façade (as happened elsewhere in The Close). It is also noticeable that many of the bishops resided in London during the parliamentary 'season' and then moved to Salisbury for the rest of the year. This was the same as the style of life led by many of the aristocracy, who returned to their country seats when there was no fashionable reason to be in London. It follows that the bishops, when arriving here from London, could look forward to living in rooms of enlightened splendour. The exterior aspect could take second place in their attention as they were here for only a relatively short time each year.

During the nineteenth century, the bishops were wealthy enough to maintain the Palace as their grandiose Salisbury home. Two of them had large families to house and the Palace increasingly became a beloved place of domestic bliss. The gardens received much attention, becoming less formal, while the huge kitchen gardens helped feed the large numbers of occupants. All this involved a large staff of servants and gardeners. Yet these Victorian bishops did little to alter the Palace buildings, which show how the eighteenth century had provided more than satisfactory accommodation for the next generations to enjoy. Bishop Denison added buildings to enhance the grounds and accommodate the staff employed outside the main building. Bishop Wordsworth restored the Undercroft and the Gatehouse to make them look more medieval in appearance.

All of this grandeur more or less disappeared in the twentieth century when the bishops no longer had the means to maintain such a huge building. Following the First World War, they actively sought ways to move to more modest and affordable accommodation. Of the three bishops between 1911 and 1946, one was a bachelor and the other two of an age when they had no family to house at the Palace. During the Second World War, there was a need to house large numbers of people, but the general situation in the twentieth century was one of a huge building with insufficient people to occupy it fully. Added to this was the strain caused by the gradual fall in bishops' incomes. The former sources of income, such as church tithes or rents paid for church lands, were diverted elsewhere in the Church and bishops were, for the first time, expected to live on a fixed income. The result was almost inevitable – the need to find a smaller and more manageable residence. This trend was not unique to Salisbury, but the Palace here was among the first to be given over to a very different use.

The Palace is now the home of Salisbury Cathedral School. Where once bishops resided in splendour, now the cathedral choristers and their fellow pupils learn, sing and play. This change came at just the right moment for the Cathedral School, then faced with possible closure. What was looked on in 1946 as the most opportune and exciting development for the School,

has caused a great many unforeseen problems. In the modern era, it is no longer easy to make any changes to ancient buildings and in order to meet the needs of modern education; the School has had to add more buildings in the grounds of the Palace. Inside the Palace itself, the School has found it difficult to adapt rooms that are either too large or too small. Fortunately, since 2001 the school has been able to house its boarders elsewhere in The Close and this has considerably eased the problems of planning the School's usage of the Palace.

The study of history has recently been described as the study of 'change through time'. The history of the Bishop's Palace at Salisbury perfectly demonstrates this. What was described in 1218 in Bishop Richard Poore's charter as his 'new place' has gone through a complex series of alterations. This book will try, not only to outline these changes, but also to show why they were so necessary. Much more may yet be discovered about the history of this building and it is to be hoped that this first study of the Palace will act, not only as a guide, but also as a basis for future research.

1

The first Palace

Just over two miles north of Salisbury stands the ancient hill fort of Old Sarum. There, after the Norman Conquest, the Bishops of Salisbury established not only a great cathedral, but also a castle keep and a fortress-like palace. Then, after 1140, a new palace was built. Little remains of it – just part of one wall of the northern domestic wing (see Appendix 1). If weather conditions were as unpleasant as described in complaints by the clergy, then the palace must have been in the coldest, most windswept position on the north-west side of the hilltop. Uncomfortable as this may have been, the decision to set up a new city in the flat lands below had much more to do with trade and a ready supply of water than escaping chilly living conditions. Nonetheless, it is interesting to note that, when the new palace was built, the bishop had the good sense to choose a site on the warmer, southern side of the new cathedral.

The move from Old Sarum

William de Waud (Dean of Salisbury 1220–37?) describes how the decision to move from Old Sarum was taken by Bishop Herbert Poore, at the suggestion of the Cathedral canons. They made their choices for a site for the Cathedral and the canons' houses before 1200 but planning was delayed, probably caused by problems of raising the huge sums of money required and by the Bishop's death in 1217. Fortunately, Richard Poore (Herbert's brother) revived the project soon after his appointment as the new bishop. He obtained papal blessing to remove the Cathedral and organised the canons to raise the necessary money (1.1).

The Papal Bull of Pope Honorius III, dating from 1218, gave Richard Poore papal authority to, 'transfer the church to another, more suitable, place.' It begins by listing the various perils of living at Old Sarum:

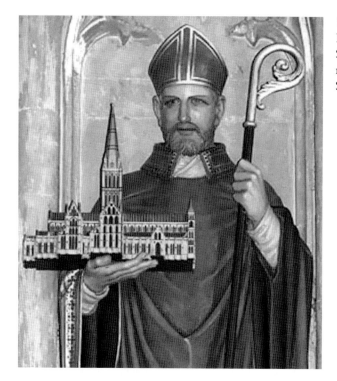

1.1: Bishop Richard Poore, Bishop of Salisbury 1217-28: modern statue in Salisbury Cathedral.

continual battering by winds so severe that divine service is inaudible and buildings were constantly in need of repair;

water so scarce that it had to be bought for an extortionate price;

restrictions imposed by the castellan on churchgoers during church festivals;

inadequate housing resulting in the canons' absence from the church because they had to seek lodgings elsewhere.

The papal legate investigated these complaints and found them to be genuine, and so the Pope sanctioned the move.

A charter, signed by the Bishop, records the Chapter's decisions following the Papal Bull. It too is dated 1218 so the decision to move, unanimously agreed, was taken immediately word came from Rome of the Pope's assent. This was followed by a seven-year covenant, made by the whole Chapter, to make regular quarterly contributions to the expense of building the Cathedral. A similar undertaking was made binding on those canons who were absent at the time the decision was made. No sums of money were stated nor is the location of the new site mentioned in either the Papal Bull or the Bishop's charter.

The location actually chosen for the new Cathedral Close was next to the confluence of the Rivers Avon, Nadder and Wylye. This was a large, level area of marsh and water meadow called 'Myrifield' (i.e. 'Mary's field'). It seems to have been one of the common fields of the Bishop's manor of Milford. Low-lying and easily waterlogged, it was not ideal agricultural land, and the loss of rents and dues from the farmers who cultivated it would have been less than from some other potential sites. It is easy to understand how attractive their new site must have seemed to the emigrating priests – low, level, warm, and close to the River Avon's banks. The men who built and planted here were weary of quarrelsome winds and voices. They wanted space, sun, stillness, comfort, rest and beauty, and the quiet ownership of their own. However, the peace and quiet here, such a marked contrast to their old position at Old Sarum, brought them new a new set of discomforts.

Bishop Richard Poore (d. 1237)

Richard Poore was probably the son of Richard of Ilchester, Bishop of Winchester. He was also the brother of Herbert Poore (Bishop of Salisbury 1194-1217). Richard Poore was appointed as Dean of Salisbury in 1197. During the Interdict in England in King John's reign, Richard returned to Paris to teach until it was lifted. It was probably during these years before he held an episcopal office that he completed Bishop Osmund's *Institutio*, which detailed the duties of the Cathedral clergy at Salisbury, along with their rights. He also wrote the *Ordinale* (on the liturgy, and specifying how the various specialised services interacted with the basic divine service) and the *Consuetudinarium*, which defined the customs of Salisbury itself. Both the *Consuetudinarium* and the *Ordinale* were guides to the 'Sarum Rite', the usual form of liturgy in thirteenth-century England.

On the death of his brother in 1217, Richard Poore was appointed Bishop of Salisbury. His most important work was the removal of the cathedral from Old Sarum to Salisbury and the building of the magnificent Early English cathedral there. He also obtained a charter from King Henry III in 1220 for the establishment of the city of Salisbury. Richard Poore petitioned Pope Gregory IX to have Osmund (the second bishop of Salisbury) canonised, but was unsuccessful (eventually Osmund was declared a saint in 1457).

In 1220, he ordered his clergy to instruct a few children so that they might in turn teach the others in basic Church doctrine and prayers. He promoted the education of boys by endowing some schoolmasters with benefices, provided they did not charge for instruction. 'Poore House' at Bishop Wordsworth's School in Salisbury honours his legacy to Salisbury schools. Bishop Poore was translated to the see of Durham in 1228. He died on 15 April 1237 at the manor of Tarrant Keyneston in Dorset. Durham and Salisbury both wanted to house his tomb, but it is likely that he was buried in the church at Tarrant Keyneston, which was what he had wished.

The land lay so low as to be almost a swamp, and the river ran so close that in times of flood it would run into the Cathedral. The resulting floods could stop services for several days.

The new Salisbury Cathedral began as a wooden chapel, started on the Monday after Easter 1219, and here on Trinity Sunday, Bishop Poore celebrated divine service for the first time and consecrated a graveyard. The canons promised to 'assist in the building of the new fabric according to their prebendal estates, continually for seven years'. On the Feast of St. Vitalis, 28 April 1220, the first five foundation stones of the new building were laid by the Bishop (for the Pope), Archbishop Stephen Langton, Earl William and the Countess Ela of Salisbury. Construction went steadily forward until completion 38 years later. Following the laying of the foundation stones, Bishop Poore 'prepared a solemn entertainment, at a great expense, for all who should appear'. Consequently, more than twenty years after its first planning, and a little over two years after it was approved, the new Salisbury was born.

By August 1219, the canons were considering when they should move to their new houses. It was decreed 'that the translation from the old place to that of the new fabric should be made on the Feast of All Saints [1 November] next following, by those who were willing and able', or in other words had adequate houses ready for occupation. It seems that some were hesitant, possibly on grounds of expense. By 1222, the need for the canons to build was becoming pressing, and on 15 August the Chapter decreed that 'everyone who has a site must begin to build to some purpose by Whitsuntide next ensuing, or failing this, the bishop shall dispose of his site'.

Building the new Palace

The Bishop's Palace was the first recorded building on the site of the new Cathedral Close. On 28 June 1218 Richard Poore issued a charter 'ad Novum Locum apud Veteres Sarisbirias' ('from his new place at Old Salisbury', i.e. Milford). Evidence for the building work at the Palace comes from two useful documents. In the Close Rolls of the 5th and 6th years of Henry III, there are two grants by the King in 1221. These are concerned with grants of timber from the royal forests to Bishop Poore for this building at Salisbury.

Therefore, as these large timbers would have been used for the roof of the Palace, the building must have been nearing completion. It was finished in time for the festivities of September 1225, when the first altars of the new Cathedral were consecrated in the presence of the Archbishop of Canterbury (Stephen Langton) and 36 of the canons, including the Master Builder of the Cathedral, Elias de Dereham. Writing in 1814 in his *The*

Grant of Building Materials: The King to Peter de Malo-Lecu health. Know that we have given to our venerable father Richard Bishop of Salisbury twenty couples [of beams] in our park of Gillingham [Dorset] to make his hall at New Sarum. And therefore we order you to let him have those twenty couples whenever he can most conveniently have them.

Westminster, 9 May 1221

Grant of ten couples [of beams]: The King to John of Monmouth health. We order you to let the venerable father Richard Bp. of Salisbury have ten couples of oak in our wood of Milcet, [Melchet, near Whiteparish, south of Salisbury] which we have given him to make his chamber at Sarum.

30 December 1221

Cathedral Church of Salisbury, William Dodsworth noted: 'After some hours spent in prayer in the new church, they went down, with many nobles, to the house of the bishop, who generously entertained the numerous company during the whole week'

King Henry III and the Justiciar, Hubert de Burgh, visited Salisbury in October and again in December 1225. As the King was just thirteen at this time, he was able to see the beginning of the Cathedral and then, in 1258, to attend the consecration of the completed building. It must have been a rare experience in the Middle Ages to witness the whole span of the building of a cathedral as building work on such a huge scale was usually spread across several generations. The royal party, if they did not stay at the nearby royal palace at Clarendon, would probably have stayed in the new Bishop's Palace. By the time of Bishop Poore's translation to Durham in 1228 the Palace must have been completed and in regular use.

This Palace, as it would have looked on its completion, would have been set in a large area of meadows. On the south side was a wide green bounded by an irregular, water-filled wide ditch. The wide green is still there – having changed from a hay meadow to the playing fields of the Cathedral School. The ditch would eventually evolve into the lake we see today. The boundary walls, with a gate to Exeter Street, would not appear for at least a century. Without these, the Palace would have been open on all sides to the outside world. Exeter Street would have been nothing more than a well-worn track for travellers heading toward the ford across the River Avon at Ægel's Ford (later to be spanned by Ayleswade Bridge). For a long time the Palace would have been very close to the huge building site from which was emerging the awesome new cathedral. Admittedly, the first building would only have

23

taken 38 years to complete; but this would then have been followed by a further 50 years to construct the tower and spire. Once the irritations caused by the noise of the cathedral builders had ended, the Palace must have been a place of earthly peace in its rustic setting, a peace only disturbed by the regular meetings of the Bishop's Court or the bustle of the clerks dealing with the administration of the diocese.

The use of the Salisbury Palace in the Middle Ages

Standing on the north side of the current building, we can view this first Palace at the right-hand end of the building. It is a long stone structure, rather like a medieval barn, with a small wing at its far end. It comes as quite a surprise to realise that this comparatively small building served the needs of such an important bishop and his staff as it is not much larger than many large manor houses of the time. However, it comes as an even greater surprise to realise that the bishop very seldom used this palace. As Appendix 1 shows, the bishop had a number of alternative residences spaced out across his diocese. Most of the life of a bishop was spent making journeys across his diocese, using these residences as places to stay *en route*.

A bishop in the Middle Ages would have had a sumptuous life style – but the price he paid for it was a heavy one, for he had no permanent home, no place where he could collect his treasures or enjoy his library. Life was very full, as he had to combine his pastoral duties with the responsibilities of a landowner and feudal lord, judge and magistrate, King's Counsellor and Member of Parliament. He was never free from work or the routine of administration, besides 'the care of all the churches' that weighed heavily upon those who took their work seriously. It is no wonder that there was little time left for scholarly activities, nor was the interminable procession from manor to manor conducive to quiet study. Medieval bishops, like other great landowners of those times, lived as nomads and may often have meditated upon the text: 'For here have we no continuing city, but we seek one to come' (*Hebrews*, 13 v. 14), as they trundled from one manor to another preceded by the luggage wagons and surrounded by their squires, valets and pages. No manor could have supported the episcopal household for more than a few weeks, at the end of which it was necessary to pack up and move on to another of the many manors where a store of food and fuel would be waiting. In addition, a bishop would sometimes travel to London at the command of the King or the Archbishop, sometimes to Rome, sometimes to some other part of the continent 'on His Majesty's service'.

The bishop's inspection of various parts of his diocese, known as the 'visitation', was not possible from one central place. The vigilance required,

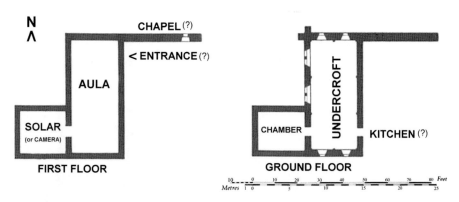

1.2: Plan of Bishop Poore's Palace, 1225.

to check fraud or falsification of accounts, had to be on site. What is surprising on looking at the registers is how infrequently the bishop signed documents at the central 'Cathedral Palace': some bishops seemed hardly ever to go there. Once a bishop entered the Cathedral Close, he was in the domain of the Dean and Chapter and there was bound to be hostility and suspicion or tension at the best of times. The Dean and Chapter were so sensitive of their rights and privileges that bishops usually found it advisable to stay away from their cathedral cities as much as possible. The accounts of the Communar (the senior lay administrator on the Cathedral staff) in the fourteenth and fifteenth centuries show that the bishop never spent more than a few days in any quarter of the year at his Salisbury Palace, even for the ceremonies and feasts in which they had the right and duty to take the leading part. Simon of Ghent, the Bishop from 1297 to 1315, is only known to have been in Salisbury for one Christmas and five Easters during the eighteen-year episcopate.

The infrequency of bishops' appearances in their cathedral city is very relevant to the study of the Palace at Salisbury. Once built in the thirteenth century, it then probably remained largely unaltered for over 200 years. The Palace was required as a courtroom, for special feasts and so on. If the bishop had to use this Palace, he did so for as short a period as possible. Often one or two important manor houses became the usual base for his duties in connection with patronage, confirmation, ordination and so on. Normally, therefore, one or two of his manors situated not too far from his cathedral (in particular that at Woodford) became his main residences and the nearest thing to home that he had.

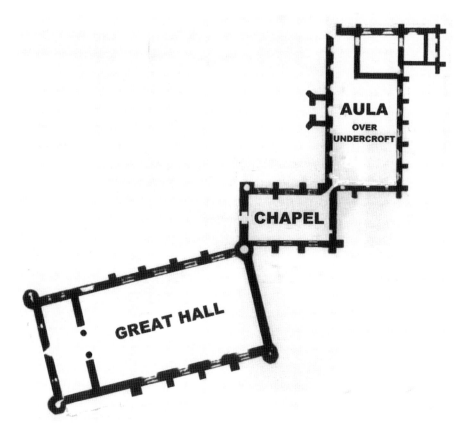

1.3: Wells Palace plan showing the twelfth- and thirteenth-century buildings.

Bishop Richard Poore's Palace

The Close Rolls suggest that we possess nearly all of Bishop Poore's work. There is a hall ('Aula') and a chamber, often referred to as the 'Solar' or the 'Camera', with the hall placed immediately over a vaulted Undercroft. The Aula was the chief building, and would have been completed first. The Chamber had a steeply pointed roof, which is set at the side of the south-west part of the Aula, forming a building in the shape of a Greek capital gamma (Γ). The Palace would have been comparable with many of the larger houses of the time. Royal palaces and manor houses of the twelfth and thirteenth centuries generally comprised a hall with one or two adjacent chambers. The hall was generally situated on the ground floor, but sometimes over a lower storey, which was half-subterranean: it was the only large apartment in the whole building and accommodated the owner and his numerous followers and servants. Most of the bishop's household staff not only took

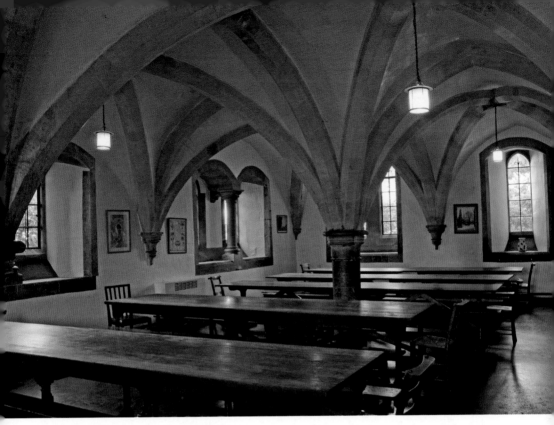

1.4: The Undercroft, looking north.

their meals in the hall, but also slept in it on its floor. The private Chamber would be situated on the first floor and this room was used, not only as a bedroom by the bishop, but also as a reception room **(1.2)**.

The kitchen was probably situated in more or less the same area as the present Cathedral School kitchen, parallel to the chapel wing, thus making with the hall three sides of a court or quadrangle, a very common arrangement. Access to the hall must have been via a staircase. It could well be that there was both an outer stone staircase from what is the court and a turret staircase at the head or southern end of the hall. One old plan of the Palace shows a projecting semi-circular building of the right size, but only on the ground floor, or perhaps in the corner where it adjoins the solar. In the Middle Ages, domestic kitchens were of various shapes and forms. The kitchen was often a separate, sometimes a detached building, set apart from the Aula to avoid the danger of fires – a real danger from the large fires needed in such medieval kitchens. In the thirteenth century, the pantry, buttery and sewery (a room for storing linen and table furniture) were usually appended to the entrance end of the hall. On an old plan of the Palace, there is a pantry on the south side of the Undercroft.

The plan of Bishop Poore's Palace shows an extra section of wall jutting out to the east of the Undercroft and the Aula. The lower part of this wall

cannot now be seen, being covered by later additions made under Bishop Beauchamp in the fifteenth century. However, the south face of this can be seen high above the kitchen courtyard. This wall has caused a great deal of controversy. One view is that this was the base and south wall of the first Chapel. There would have been a Chapel in the Palace from the start, but no evidence of it has been found. There were windows in this wall at first-floor level, which were later filled in during the seventeenth century. The lower part of one of these windows is now a tiny door next to the altar of the Chapel. This allows access to the roof over the staircase. If the chapel was here, then it would have been exactly in the same place as the present one.

Another theory is that there was a Great Hall running eastwards from the Poore buildings. One writer even suggests that this could have been an aisled hall that may have been destroyed by fire; later to be replaced in the fifteenth century by Bishop Beauchamp's Great Hall. There is an intriguing piece of evidence that might support this theory. When the floor of the east tower of the Palace was being resurfaced in the 1990s, a well was discovered just inside the door. This would have been a very peculiar place to have a well serving Beauchamp's Great Hall since, on entering, any visitor would have been in danger of coming to a watery end! However, if there had been a Great Hall in the thirteenth century, it would have been smaller than the later one and would probably have had a kitchen at its eastern end. This well would then have been in the ideal place to supply the kitchen. Regrettably, the floor was resurfaced so quickly that no proper recording took place. The problem remains that any buildings that may have been in this area have long since disappeared under the later extensions. If there was a large hall here, then it would have made the accommodation of Richard II's Parliament here in 1384 very straightforward – with the Lords in the Great Hall and the Commons in the Aula. It would also have made the Palace more like the plan of other bishops' palaces of this period, in particular Bishop Jocelyn's at Wells (**1.3**). The Palace at Wells was built at almost exactly the same time as the Salisbury Palace. Like Salisbury, it had an Aula over an Undercroft and a Chamber. At Wells, though, the Chapel has remained intact and stands where we would expect the one at Salisbury to have been – to the south-east of the Aula. Bishop Burnell rebuilt the Chapel at Wells at the end of the thirteenth century and then added a magnificent Great Hall to the end corner of the Chapel. It is, therefore, possible that the Salisbury Palace might well have had a Great Hall at this early period too.

The Undercroft

This room is mostly in its original state (**1.4**). It has a vault with massive

stone roof ribs springing from a row of low sturdy pillars and carries the whole weight of the Aula above. It is 54 feet long and 24 feet wide, being divided into bays, three in its length and two in its width. Originally, the Undercroft was probably used for storage. Whatever use it was put to in the past, it must have been an awkward and uncomfortable room for any purpose because of frequent flooding. There is a saying attributed to Bishop Burgess (Bishop 1825-37): 'Salisbury is the sink of the Plain; Salisbury Close is the sink of Salisbury, and the Bishop's Palace is the sink of The Close.' Nowadays the Undercroft is kept free of water by electric pumps.

By the end of the nineteenth century, the Undercroft was much neglected. Canon Venables noted in 1895 that, before the renovations by Bishop John Wordsworth, 'This noble apartment, [was] degraded and defaced and cut into domestic offices'. Despite the problems of damp in this room, it was used as the main servants' hall of the Palace. Bishop Wordsworth's restoration was carried out under the architect Arthur Reeve. Once his renovations were complete, it was with some pride that it was opened for visitors at the first Cathedral Commemoration of Benefactors in 1889. 'It is very moving to have the honour of taking up Bishop Poore's work,' Wordsworth wrote, 'if it be his, as we suppose.' He had many ideas for the usefulness of this vaulted chamber for diocesan events. Unfortunately, it was soon realised why Bishop Poore had raised his Palace on such a substructure. As so often happens with this room in a period of extended heavy rain, the Undercroft was flooded and the new floor burst up, the wooden blocks of the pavement bobbing about in the stagnant water like a sad little fleet! The blocks were soon more firmly fixed, but once more later broke up with yet another flood.

The embrasure at the south end of the eastern aisle, now occupied by a two-light window, was formerly a doorway, which possibly gave access to the larder. Above this, on the level of the Aula, would have been the sewery. This was a sensible arrangement, for by this means the pantry or the buttery would have been placed on the level of the kitchen and at no great distance from it, while the sewery would have been within easy access of the Aula through a small doorway that may well have been placed in the south wall. The side windows of the Undercroft were altered under Bishop Wordsworth. Detached columns supporting the inner arches in the centre were inserted to give a greater sense of lightness. Previously, each light of the western windows stood in a separate embrasure, the outer splays of the inner openings having been returned towards each other in the centre, thus forming a solid block of masonry between the two lights. After the renovation, it was believed by Arthur Reeve that the size and form of the lights resembled those in Bishop Poore's original design, and that enough of

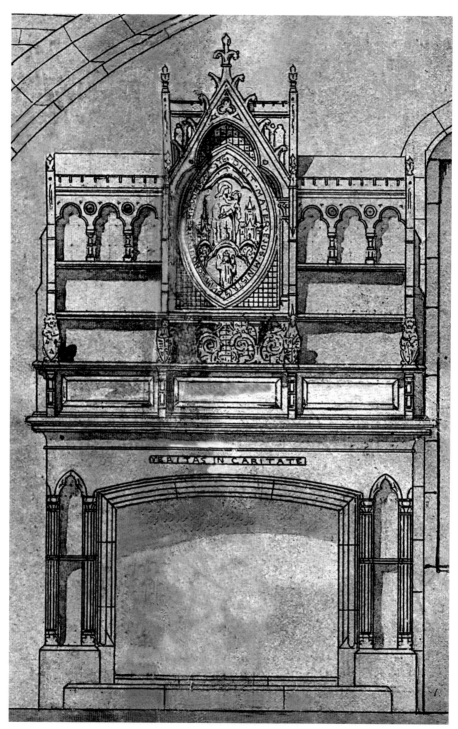

1.5: Bishop Wordsworth's fireplace: drawing by architect Arthur Reeve, May 1889.

1.6: New door in the partition wall: drawing by Arthur Reeve, May 1889.

the inner arches remained to reproduce them exactly. Probably the single-light window in the south wall was a nineteenth-century addition. An embrasure occurred here, but it bore no signs of ancient work, and if a small building formerly projected from the north wall containing the larder on the ground floor and the sewery above, it is unlikely that there would have been a window at the south end of the eastern aisle of the Undercroft.

After these alterations, the Undercroft was very much as it looks today, with two exceptions. First, a thin partition wall was left across the southern end that cut off the south bay. This partition wall (removed in 1946) was probably part of the original plan of the Undercroft. During Bishop Wordsworth's renovation, a new door was inserted into this partition wall (1.6). While this work was proceeding, a thirteenth-century doorway was found embedded in the wall. Partition walls were often built across

medieval vaulted apartments in this way. Secondly, an ornate Victorian fireplace (recently removed) was put into the north-west wall. If there was a fireplace in the Undercroft it must have been where the Victorian version was, but this portion of the wall has been so much cut about by various alterations that no traces of any ancient fireplace can be found **(1.5)**. Today the Undercroft is the Cathedral School's dining room.

The south-west chamber (the 'Blee Room')

Leading off from the Undercroft by a set of wooden steps is a large room to the south-west. This would probably have been a store-room in the early days of the Palace. It has been extensively altered so that it is impossible to visualise it as an ancient room internally. One interesting feature of this room is the eighteenth-century, Adam-style fireplace. This used to be in the Dining Room of the west wing until its demolition in 1931. This room is known today as the 'Blee Room' in memory of Michael Blee, Head Master of the Cathedral School from 1974 to 1991. His portrait (by Alison Campbell-Jensen) hangs above the fireplace.

The Aula

The immediate impression of this magnificent room is of a grand eighteenth-century drawing room. However, it always comes as a surprise to visitors when it is realised that the beauty of this room is literally 'skin deep'

1.7: The Aula in the thirteenth century: artist's impression, adapted from an illustration by Marjorie Quennell (A History of Everyday Things in England, *vol. 2, Batsford, 1918*).

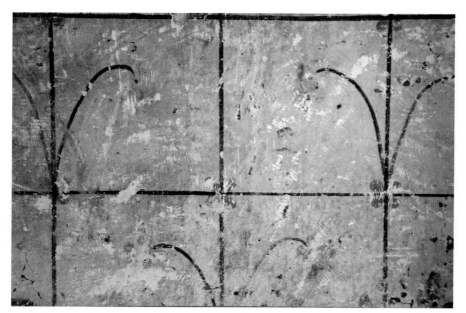

1.8: Original wall of the Aula, showing thirteenth-century decoration.

since the visible walling consists of just thin cladding attached to battens. Underneath this eighteenth-century splendour is the original medieval stone-walled Aula built by Bishop Richard Poore. (To avoid confusion with the later Beauchamp Great Hall, this room will be referred to as the 'Aula'). In the thirteenth century, it would have been open to the rafters, with a dais at one end and large tables along the sides. There would possibly have been either a central fire on a large stone base, or a large fireplace in the west wall. The overall effect would have been very much the same as that of the great hall of any manor or castle of the period – large, stark, and cold in winter **(1.7)**. From a description by the architect Francis Price, here before the extensive rebuilding of this room during the eighteenth century, we know that the Aula had 'high level windows and three arches on one side'. The outline of these could still be visible under the present thin wall surface.

During renovation in 1965-6, holes were cut through the thin eighteenth-century cladding on the west side. These revealed that the original stone walls were decorated in the thirteenth century with rectangular panels lined with red to imitate stone jointing and small red flowers with four petals on curved stems. This form of decoration has been found elsewhere in The Close at Salisbury: in the Old Deanery, the North Canonry and the Leadenhall. The cut-outs in the walling also revealed the jamb of a fifteenth-century fireplace **(1.8)**.

The Aula as the Bishops' Drawing Room

Bishop Thomas Sherlock (Bishop 1734-48) carried out an extensive refurbishment of the Palace as well as initiating a programme of important repairs in the Cathedral. He employed Francis Price in both enterprises **(1.9)**. Price, a carpenter by origin, had risen to become a general builder and surveyor. He had a precocious understanding of medieval buildings and produced a detailed survey of the Cathedral fabric in 1753, the first such account to be published in England. By 1736, Price had designed the new roof for the Aula. He consulted John James, who was then completing Nicholas Hawksmoor's new west front at Westminster Abbey. The roof was executed almost exactly as planned and still survives. It forms an interesting comparison with the contemporary high roofs that Price was framing in the Cathedral.

On Sherlock's orders, the whole of the original Aula was transformed, the principal idea being that the room should be converted into a grand drawing room. Price provided the design for the new, elaborate plaster ceiling and further designs for the ceiling of the former dining room beneath the Chapel. The room was altered by covering the old grey stone walls with false walls and inserting a new ceiling. The latter, with its impressive eagle centrepiece, is much higher than the original base of the roof and necessitated raising the gable ends and side walls. To support the extra weight, huge brick buttresses were added to the east wall **(1.10)**.

In 1998, English Heritage carried out extensive renovations to the roofs of the west range of the Palace. Four months after the work began on the roof of the Aula, the site foreman unearthed two men's leather shoes hidden in rubble in the roof. These date from around 1540, a period when when shoes had no heels. Although one is left and one right, they are not a pair. These shoes (now in the Salisbury and South Wilts. Museum) could have been put there to ward off evil spirits and there seems to have been a tradition of placing shoes in the roof of buildings that had undergone alterations. Other items found in the west range roof space included a medieval ridge tile. There were also some freshwater oyster shells, probably left behind by Francis Price's workmen from their eighteenth-century packed lunches!

Dendrochronological research was carried out for English Heritage during this renovation. During the reconstruction of the Aula in 1736, Francis Price used some second-hand timbers in the roof. It was assumed that much of the timbering in the roof of the Aula would be of thirteenth-century origin; but, surprisingly, most of the timbers were found to date from 1521. The earliest timbers are those re-used as rafters. Four other groups of re-used timbers have been identified in the roof. Whilst no documents

suggest the origin of the fourteenth-century timbers or the 1521 scissor-braced roof, they are more informative for the others. Two moulded wall-plates, one dating to 1432-64 from the west wing roof and the other dating from 1460-92 may be part of the new building work carried out by Bishop Richard Beauchamp who built the Great Hall sometime between 1457 and 1466. Jointed roof timbers dating to 1570 re-used as rafters and purlins in the Drawing Room roof may relate to work by Bishop Jewel (*c.*1568). Following the damage caused during the aftermath of the Civil War, Bishop Humphrey Henchman (1660-3) carried out repairs to the Chapel area of the Palace. Purlins dating to 1662, re-used as purlins in the Price roof of 1736, must have originated from Henchman's repairs. The best-documented work is the re-roofing of the Aula by Francis Price. It is interesting to note that although this roof was still in the proposal stage in November 1736, timbers had already been felled in the winter of 1735-6 and the spring of 1736.

The most striking aspect of the work carried out for Bishop Sherlock at the Palace is the stucco decoration, both in the new drawing room and in the refurbished fifteenth-century parlour. Drawings survive of the proposals made in 1739 for the redecoration of the parlour and Bishop Ward's dining room by the Blandford Forum architect, Francis Cartwright. Comparisons of style between the plasterwork at the Palace and that in contemporary Close houses indicate that much of it must have been executed by a team working under his guidance. Most of their commissions appear to have been for ceilings, but Cartwright's drawings show walls articulated by stucco decoration, with a broad frieze of Vitruvian scroll dividing the lower storey from an upper, which was arranged as a regular series of tall panels. Closely similar is the scheme chosen for the staircase at Mompesson House, which has a frieze of Vitruvian scroll, and for Malmesbury House (both open to the public). On the ceilings, the plasterwork is designed around raised panels. These are commonly arranged in series, with larger square or rectangular panels enlivened by dished corners and other shapes. Among the principal decorative motifs are full-face portrait heads and scallops, both on cartouches and mouldings. A boldly modelled eagle with open wings forms the centrepiece of the ceiling in the Palace Aula. Here, the new ceiling was provided with a cornice modelled with egg-and-dart decoration. The stucco decoration is generally accompanied by richly detailed joinery, to be found, for example, in the chimneypieces and doors with their architraves at the Palace. Cartwright may have supplied these, as several parallels can be made with similar joinery in houses at Blandford Forum, erected after the disastrous fire there in 1731. There are 32 portrait heads around the frieze.

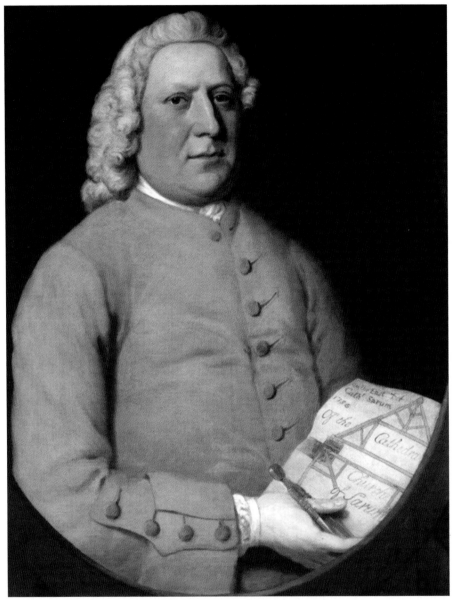

1.9: Francis Price, by George Beare, 1747 (*National Portrait Gallery*).

Each is of a different character and it has been suggested that these may have been modelled on actual people connected with the Palace. If so, then we may well have a unique portrait gallery of the Bishop's staff of servants or gardeners. Many of the heads are of boys, some wearing a 'jockey'-type cap. It is just possible that these could have been portraits of some of the choristers of the time **(1.11)**.

1.10: Brick buttress on the east side of the Aula.

The alterations made by Bishop Sherlock were not the end of the Aula's transformation. From 1783, on the instructions of Bishop Shute Barrington, the changes made by Bishop Sherlock were then themselves altered. The present elegant Venetian-style windows were inserted. He also had the massive marble fireplace put into the east wall, replacing a smaller one

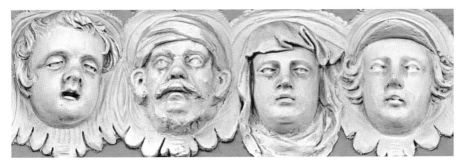

1.11: Portrait heads from the frieze of the Aula.

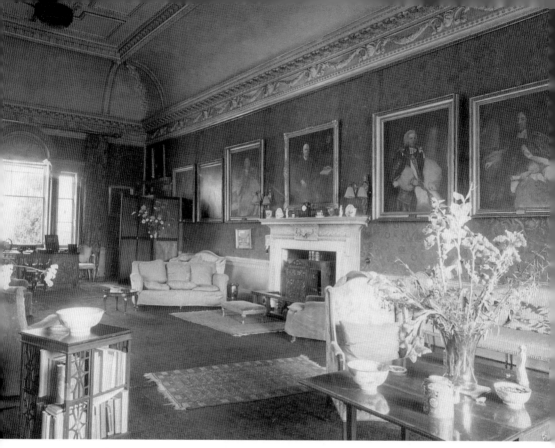

1.12: The Bishop's drawing room (the Aula), c. 1939.

inserted under Bishop Sherlock. Alterations were made to the doorways of the room, three of them leading to other areas of the Palace: the fourth, at the north-west corner is a 'dummy' which leads nowhere and there simply to balance the other three.

Today the Aula is known as the 'Big School Room' (or 'B.S.R.' for short). The Cathedral School moved into the Palace in 1946 from its previous residence in Wren Hall. The original schoolroom in Wren Hall was known as the 'Big School Room' and this name was then transferred to the Aula. It was carefully renovated in 1966, so revealing the room in its true eighteenth-century splendour. It has often been the glorious backdrop for concerts and many formal functions. One occasion of note was the visit by Prince Charles and Princess Diana who hosted a reception at the Palace in 1991 as part of the spectacular Spire Appeal Concert – 'The Symphony for the Spire' (**1.12**).

The portrait collection

The Aula is also the centre of the extensive collection of portraits of former Bishops of Salisbury, which was started by Bishop John Douglas

(Bishop 1791-1807) (for more details on this collection, see Appendix 3)..
In addition to the rows of bishops is an imposing portrait over the fireplace
of King George III **(1.13)** who, in the last decade of the eighteenth century,
discovered the benefit of the salubrious air of Weymouth. Salisbury proved a
convenient halting place for the King and Queen and their family. The royal
party would be given refreshment at the Palace, and often a visit was paid
to the Cathedral. It was on one of these occasions that the King, hearing
that a new organ was needed, asked to be allowed to provide one, as a gift
'from a gentleman of Berkshire' (then within the diocese). This was the
instrument that was later transferred to Sarum St Thomas's Church in 1876,

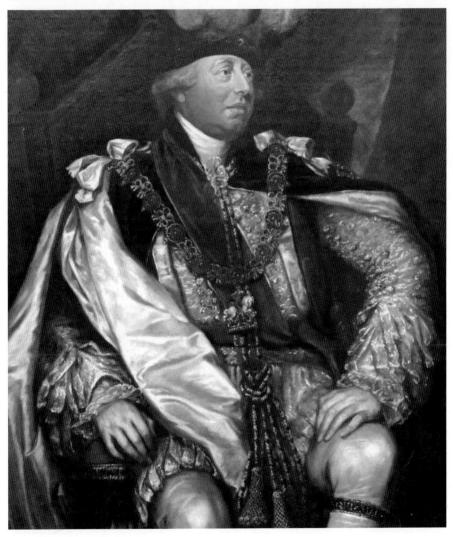

1.13: King George III: artist unknown.

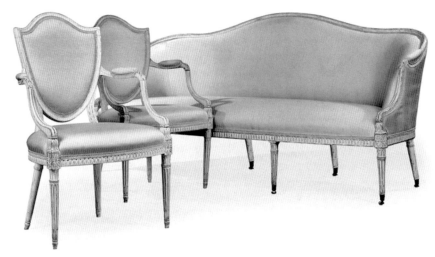

1.14: Sofa and two chairs from the Bishop's drawing room, now in U.S.A. They have brass labels worded: 'Heirloom, Bishop's Palace, Salisbury. M.A.F.W – OCT. 1911' (i.e. Margaret Wordsworth's initials with the date of the death of her husband, Bishop John Wordsworth) (*Christie's, New York, sale catalogue, November 2010*).

to make way for the present 'Father' Willis organ. On 20 August 1792 the King visited the Cathedral to view the recent alterations, with the architect, James Wyatt, in attendance.

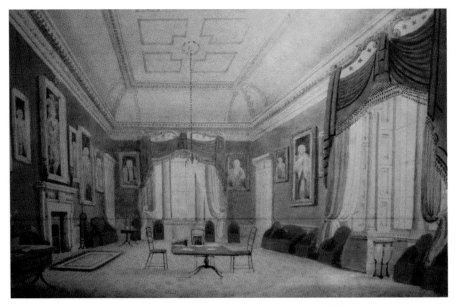

1.15: The Bishop's drawing room, 1817: watercolour by S.J. Buckler.

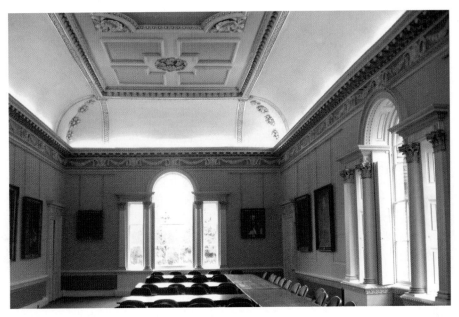

1.16: The Aula ('Big School Room'), looking south

Furniture in the Bishop's Drawing Room:

In the photograph of the Aula (*c.*1939), a line of huge settees can be seen along the walls **(1.14)**. These were made for Gillows, the noted eighteenth-century furniture retailers. When the Palace was passed on to the Cathedral School, instead of selling this suite, it was distributed among Bishop Wordsworth's family – three sons and a daughter each took away two chairs and a settee (some large five- or six- seaters or two- or three- seaters). It would seem very likely that Bishop Barrington purchased this furniture for the Palace. The graceful neo-classical settees and chairs derived from the designs of James Wyatt, the most fashionable architect of the last two decades of the eighteenth century. Wyatt was actually employed by Barrington in the extensive renovation of the Cathedral. This suite would have perfectly complemented the new design of the Great Drawing Room by Barrington's architect, Sir Robert Taylor **(1.15, 1.16)**

The Bishop's Private Chamber ('Solar' or 'Camera')

This first-floor room was originally the private bedroom of the Bishop **(1.17)** and was probably the only room in the original Palace where the Bishop could have some solitude. Here he could conduct private conversations away from the mêlée of the Aula. Private rooms like this were a luxury that very few could afford. However, it has been as extensively

41

altered as the Aula and is now unrecognisable as an ancient room. The only clue to its antiquity is the flintwork in the exterior west wall and the two thin windows that were placed where lancet windows would originally have been in the gable above. In the nineteenth-century, this south-west chamber was only a passage to a large west wing added by Bishop Burnet (Bishop 1689–1715). The window at first-floor level used to be a door and the outline of the arch can still be seen around the window. The stone square shape in this wall was once a fireplace in the west wing.

Today this room is a classroom. The huge mahogany bookcase on its east wall is only a section of the original, which used to stand against the north wall of the anteroom to the south-east of the Aula, and was possibly part of the nineteenth-century Palace library. The pair of tall windows at the top of the wall only serves to light the roof space over the upper room. The first-floor window replaced a door and the window on the ground floor was inserted, following the removal of the west wing in 1931. The roof area

1.17: West wall of Bishop Poore's solar.

1.18: Thirteenth-century wall painting on walls above the solar. It is only visible in roof area above the ceiling.

over this room is of great interest (but only visible by an athletic explorer of the interior of the present roof). It has thirteenth-century trussed rafters. At the gable end, on the jambs of the windows, is a pattern of painted ashlar decoration in red with small flowers, as in the Aula **(1.18)**. Following the slope of the rafters is a running scroll pattern, in red, of leaves and trefoils. This leads to the conclusion that the original room would have been open to the rafters.

There is no trace or record of any further fourteenth-century alterations to the Palace, except for general licences to crenellate issued to the bishops in 1337 and 1377.

2

Bishop Beauchamp's Palace

In the aftermath of Jack Cade's Revolt in 1450, rebels from Salisbury dragged Bishop William Ayscough from the church at Edington and beheaded him. The assassins justified themselves with the claim that he was one 'who had always lived with the King, and never kept hospitality in his own diocese'. This seems a strange excuse for the crime since, as we have seen, bishops rarely appeared in their see palace. It seems more likely that the rebels, who supported the Yorkist cause, objected to the Bishop's close association with the Lancastrian King Henry VI. Ayscough was a secretary and confessor to the King. We do not know why he was at Edington. The friars of Edington Priory petitioned two years later that they had 'sustained intolerable damages through the sons of perdition who dragged William, late Bishop of Salisbury, from the monastery and slew him, and breaking down the houses and buildings of the monastery, took, and carried away their goods and jewels'.

Bishop Richard Beauchamp (died 1481, Bishop 1450-81)

Bishop Beauchamp was a member of the great family, the younger son of Sir

A number of outbreaks of violence in the southern counties accompanied Cade's rebellion in 1450. It was at Edington Priory that: 'William Ascoghe, bishop of Salisbury was slayn of his owen parisshens and peple … aftir that he hadde saide Masse, and was draw from the auter and lad up to an hill there beside, his awbe and his stole aboute his necke; and their they slew him horribly, thair fader and thair bisshoppe, and spoillid him unto the naked skyn, and rente his blody shirt in to pecis.

J.S Davis (ed.), *English Chronicle*, Camden Society, 1855

2.1: Bishop Richard Beauchamp and King Edward IV: ceiling boss in St George's Chapel, Windsor.

Walter Beauchamp of Powyck who was Speaker of the House of Commons in 1416. He studied at Oxford University and was appointed Archdeacon of Suffolk and then Bishop of Hereford (1449–50). He was appointed Master and Surveyor of the King's Works at Windsor Castle and supervised the first

2.2: Great hall screen: adapted from an illustration by Valerie Bell (Picture Reference Book of the Middle Ages, *Brockhampton Press, 1967*).

stage of rebuilding St George's Chapel. He became Dean of Windsor in 1477 **(2.1)**, although from as early as 1452, he had acted as chaplain to the Order of the Garter and in 1475 he was appointed their Chancellor. This honour was held by succeeding bishops of Salisbury until 1830 (with one long interval from the reign of Edward VI to Charles II when laymen held the post). Many of the portraits of the bishops in the Palace have the Garter Badge displayed on their robes.

Perhaps warned by the awful fate of his predecessor, Bishop Beauchamp was not only a resident bishop but also an active one. He was also a building bishop. Whilst Bishop Poore's Palace occupies only a relatively small proportion of the total area of the present-day buildings, the rest of the older buildings of the complex are largely the result of the work of Beauchamp. The scale and grandeur of the surviving porch tower and the two-storey north range are characteristic of this energetic man.

The Great Hall

From the entrance hall on the ground floor of the East Tower (in the fifteenth century), there would have been a wide passage beyond. This was at the east end of the Great Hall and behind a large wooden screen **(2.2)**. This screens passage would have passed right through the building: the former south door is now blocked off, but the line of it can still be seen on the south wall of the building between the easterly buttresses. The service rooms leading to the Great Hall were to the east of the screens passage. These were the kitchen, pantry, and buttery – all contained within a separate service wing. There are no remains today of these rooms because this wing was removed during the seventeenth century. A new wing, housing a kitchen to serve Bishop Seth Ward's dining hall, then covered the site. The whole of this eastern building was demolished in the late eighteenth century. The present Head Master's house (built in 1958) now stands where this wing would have been. Remains of one of the edges of a door leading to the fifteenth-century service rooms still exists. This is in the east wall of the School locker room, next to the door to the Head Master's House.

Beyond the huge dividing wooden screen, was the Great Hall itself, on which the whole palace was centred. Bishop Beauchamp seems to have mostly disregarded Bishop Poore's Aula, which had little part in his overall plan. The walls of the new Great Hall were supported by tall buttresses, of which one remains on the north side and three on the south. The whole hall was finished off with a crenellated parapet. This was an enormous and grand room (90ft x 36ft) with large Perpendicular-style windows along both sides. These would have been similar in character to the existing window in the

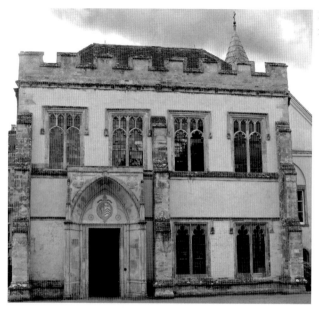

2.3: Beauchamp Building, north-west block.

east wall of the chapel, but of much greater size and divided horizontally by transoms. Beauchamp's hall was very similar in scale to King Henry VIII's Great Hall at Hampton Court (108ft x 40ft). The area once covered by the Great Hall has undergone such extensive alterations that it is now extremely difficult to decide what its original appearance may have been. The whole area of the hall, including the screens passage would have been under one roof. If, as seems likely, the present walls are of about the original height, it can be seen what an extremely fine apartment this room must have been. It could be that there was a projecting bay window at the western end of the north wall, beside the high table, such as fifteenth-century architects frequently deployed for such halls. The roof of the hall and the embattled parapets of the side walls would no doubt have been carried up to the east wall of the area in the centre of the Palace in an unbroken line.

This would have been the reception room used by King Edward IV and his wife Queen Elizabeth Woodville on their visit to the Palace in 1466 as guests of Bishop Beauchamp. The Queen was so impressed that, after Beauchamp's death, she supported the appointment of her brother, Lionel Woodville (Dean of Exeter) as the next Bishop of Salisbury. Almost the whole of the Great Hall was reduced to a ruin during the Commonwealth period following the Civil War, although parts of the outer walls have escaped destruction. This extensive demolition is the reason why it is difficult to work out what were the exact limits of the Great Hall as it was originally designed. After the Civil War, part of the shell of the building was preserved.

However, the extensive alterations that followed add to the difficulties of understanding the full details of the building.

The Bishop's private apartments

To meet the growing desire for domestic comfort, Beauchamp had an extra building constructed jutting out beyond the west end of the Great Hall and facing north **(2.3)**. This was to house his private apartments. The lower room had large arched windows along its whole length and an extra one on its east side. This was used then as a 'parlour' for entertaining smaller numbers of guests than in the Great Hall. The upper room is simply described as 'a chamber'. This grand room, with its high roof and large glass-filled windows, could have been a grand stateroom. It is more likely that this would have been the chapel. The outer walls of this building have some interesting carved stone details. On the north and west walls, each of the windows has a pair of small portrait heads of kings and bishops attached to the lower ends of the dripstones. At the east end, the dripstone has a carved figure of a ram.

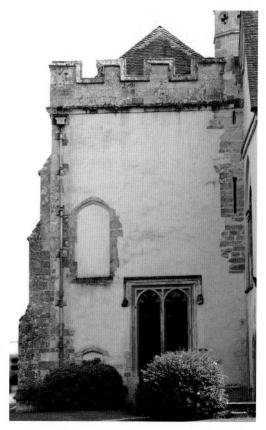

2.4: Exterior wall of west end of the Beauchamp Building, showing the outlines of two blocked-up doors that used to connect with the old fore-building.

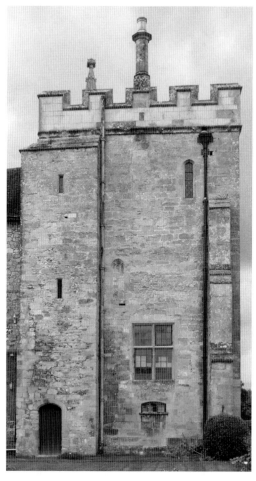

2.5: East tower, east wall. At the left is the original garderobe shaft, lit by two slit windows. Waste outlet below the tower: the new door was inserted by Bishop Barrington's restorers. Note the blocked window caused by the insertion of the new floor in the eighteenth century.

To connect these two rooms and to give access to the Aula, an extra building was required. This was the forebuilding and would have been a stone-built extension that covered the bottom half of the Aula and the west side of the private apartments block. This forebuilding provided a link between the Beauchamp building and the Aula. Nothing remains today of the forebuilding, except the outline of the two doors that led to it in the outer west wall of what is today the Music Room and the Chapel. The upper door would have given access, through the forebuilding into the Aula. Until the eighteenth-century, this was probably the only way to enter the Chapel. The lower door would have led to a staircase to allow access to both the Aula and the Chapel. However, as no trace of a door has been found on the north wall of the Undercroft, the forebuilding would not have had a direct entry to this room. The whole of the forebuilding was removed in the alterations made by Bishop Sherlock in the eighteenth century (2.4).

The East Tower

The main entrance to the new Great Hall would have been through the East Tower. This is a very imposing building, being four storeys high, crenellated and with a pinnacled spirelet rising some twenty feet above it. The first-floor room of the tower is now used as the School's staff room. The spiral staircase within the spirelet reaches the upper two chambers. The topmost room is shown in a plan of the nineteenth century as a rather remote eyrie for the bishop's chaplain. Running down the east side of the tower is an original shaft that would have served the medieval garderobes on the upper floors. Beyond the outer arched doorway is a small entrance hall. Originally, the entrance hall of the tower would have been a high chamber, lit by a small window at what is now first-floor level (the window, now blocked in, can be clearly seen on the outer east wall). This leads to an inner door, which is also arched. This was clumsily cut off at the top by the insertion of a new floor by Bishop Barrington's restorers in the eighteenth century (**2.5-2.7**).

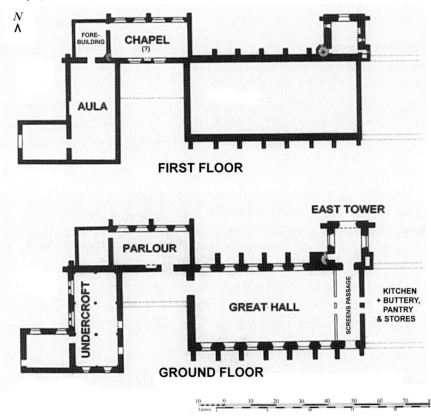

2.6: Plan of Bishop Beauchamp's Palace (1470).

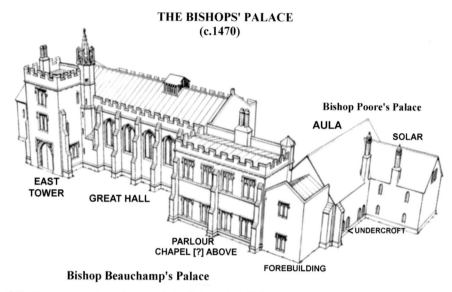

THE BISHOPS' PALACE
(c.1470)

Bishop Poore's Palace

AULA

SOLAR

EAST
TOWER GREAT HALL

UNDERCROFT

PARLOUR
CHAPEL [?] ABOVE

FOREBUILDING

Bishop Beauchamp's Palace

2.7: Reconstruction picture of the Palace (c. 1470).

Bishop Beauchamp succeeded in reasserting episcopal authority in Salisbury after Bishop Ayscough's murder. In 1457, after a sustained effort by the Dean and Chapter of Salisbury Cathedral for over sixty years, well supported in its latter stages by the Bishop, the canonisation of St.Osmund was finally granted and a new shrine erected in the Cathedral. In the Bishop's will he made provision for a chantry in the Cathedral. Chantry chapels built for the Beauchamp family in the fifteenth century were amongst the most expensive and elaborate of the period. Bishop Beauchamp's chantry chapel at Salisbury was equally lavish. It was built during his lifetime, in the late 1470s, on the south side of the Cathedral Trinity Chapel. The chantry was demolished during James Wyatt's restoration of the Cathedral in about 1790 and Beauchamp's tomb cover was removed to the nave. Today, the main memorial to Bishop Beauchamp in the Cathedral is the lierne vault over the main crossing (1479-80) which bears his arms. He also ordered the construction of the two strainer arches in the Cathedral. These were erected to prevent any further sagging of the huge pillars that carry the weight of the tower and spire.

Bishop John Capon (alias Salcot) (died 1557, Bishop 1539-57) and the Salisbury Martyrs

Bishop John Capon was Bishop during the Reformation. The alternative form of his name probably comes from Salcott, near Colchester, where he

was born He graduated from Cambridge in 1488 and became a Benedictine monk and later Abbot of St Benet's Hulme, in Norfolk. Capon was a strenuous and ostentatious supporter of King Henry VIII's divorce from Katharine of Aragon. In 1530, he was elected as Abbot of Hyde Abbey (Winchester) and three years later was appointed Bishop of Bangor. He took up this appointment despite his original protest that he had no knowledge of the Welsh language. He continued as Abbot of Hyde, holding the bishopric *in commendam*, until 1539. In the 1530s, Thomas Cromwell organised the dissolution of the monasteries in England and Wales. Abbot Capon decided that he would do well for himself if he were to surrender Hyde Abbey to Cromwell before his commissioners inspected the Abbey. The surrender was signed in 1538, and Capon was rewarded by the King with the bishopric of Salisbury **(2.8)**.

Following his support of Protestantism in the reign of King Edward VI, Bishop Capon reverted to the Roman Catholic faith on the accession of Queen Mary. Three noted Protestants, John Maundrel, William Coberley and John Spicer were arrested for causing disruption during Roman Catholic church services in Wiltshire. At the Palace the Bishop interrogated them secretly. They were offered the chance to recant and so receive a pardon. However, the three men firmly declared their Protestant beliefs and they were burned at Salisbury on 24 March 1556. There is a large plaque commemorating the three martyrs on the wall of Malmesbury House in the Cathedral Close (plainly visible just a few paces beyond St Ann's Gate).

Bishop Capon died in 1557. He was buried in Salisbury Cathedral on the south side of the Quire. Protestant writers have criticised Capon as a time-server and a papist – 'a false dissembling bishop,' as he is called by

2.8: Arms of King Henry VIII. Placed here by Bishop Capon to demonstrate gratitude for his appointment as Bishop of Salisbury.

John Foxe, who frequently names him as a persecutor of martyrs under Henry VIII and Mary. There is no doubt that he despoiled the properties of the Diocese of Salisbury simply to enrich himself. Bishop John Jewel, who succeeded Capon, said of him, 'A capon hath devoured all' by way of criticising his predecessor's pilfering of Cathedral property while in office. After the turmoil of the Reformation, there was a period of calm under the rule of Bishop Jewel. One of the great names in English Church history, he was a key figure in defining the identity of the Church of England and its differences from the Church of Rome. He was no building bishop, being a man of simple tastes.

Bishop John Jewel (1522-71, Bishop 1560-71)

John Jewel was born in Devon in 1522 and he gained his degree at Corpus Christi College, Oxford in 1540 **(2.9)**. After 1547, he became one of the chief disciples of Peter Martyr, an Italian theologian who was converted to the reforming ideas of the Protestants. On gaining his B.D. in 1552, Jewel was appointed Vicar of Sunningwell (near Abingdon, Berkshire), and Public Orator of the University, in which capacity he had to compose a congratulatory epistle to Queen Mary on her accession. He was, nevertheless, suspected of having Protestant beliefs and fled to Frankfurt in 1555 and soon joined Peter Martyr at Strasbourg. In 1555, on the appointment of Peter Martyr as Professor of Hebrew at Zürich, Jewel accompanied him as his assistant. He remained there for two years but, following the accession of Queen Elizabeth I, he returned to England, and made earnest efforts to secure what would now be called a 'low-church' settlement of religion. He was strongly committed to the Elizabethan reforms of the Church in England. He was consecrated Bishop of Salisbury on 21 January 1560 and then took on the rôle of literary apologist of the Elizabethan Settlement. In his *Apologia Ecclesiæ Anglicanæ*, published in 1562, he laid down the first methodical statement of the position of the Church of England against the Church of Rome, and it forms the groundwork of all subsequent controversy.

One of Jewel's first tasks after his arrival in Salisbury was a review of the properties of the diocese. He found that everything was in wretched condition, his houses 'decayed and lands all leased out.' He attributed the state of affairs to the rapacity of his predecessor, Bishop Capon. The Diocese suffered its greatest impoverishment during Capon's period of office under the Protestant King Edward VI, rather than during his later career under the Roman Catholic Queen Mary Tudor. The decay of physical properties and the milking of the Diocese by both the Marian and Elizabethan governments distressed Jewel. However, this was more probably the result of

the long vacancy of three years between the death of Bishop Capon and the appointment of Bishop Jewel.

The Bishop's Palace was then a magnificent building, with Bishop Beauchamp's enormous Great Hall still standing as the central building of the whole complex. In 1563 Jewel's young friend, Herman Folkerzheimer, whom he had met in Zürich, stayed with him for some while at the Palace. Folkerzheimer wrote that the Palace was:

> so spacious and magnificent that even sovereigns may, and are wont to be suitably entertained there, whenever they come into these parts. Next, there is a most extensive garden, kept up with especial care, so that in the levelling, laying out, and variety, nothing seems to have been overlooked. A most limpid stream runs through the midst of it, which, though agreeable in itself, is rendered much more pleasant and delightful by the swans swimming upon it; and the abundance of fish, which [the bishop] is now causing to be enclosed by a latticework.

Jewel's household was large. In addition to the many servants necessary to the maintenance of the Palace and its grounds, his 'family' included a staff of clerics who assisted him in his diocesan and scholarly work and several young gentlemen evidently attached to the household in the manner of squires, as was customary in the great houses of the day. Together the young men explored Salisbury and the surrounding countryside. On one occasion, the Bishop himself took part in a lengthy outing to Old Sarum and Stonehenge. Folkerzheimer was no less impressed than the modern tourist by the strange monuments on Salisbury plain, and the Bishop, like a modern guide, indulged in some interesting conjectures concerning the stones. He thought that they were probably the work of the Romans who had built them symbolically in the form of yokes.

According to Folkerzheimer, Jewel set a very good table and an impressive one. He particularly noted the abundance and magnificence of the silver plate. The young Frieslander, in fact, seems to have been torn between a desire to report the great good fortune of his erstwhile fellow exile and the fear lest he portray Jewel's new life at Salisbury in such glowing terms that his Swiss friends would feel Jewel had betrayed his reformist principles. Folkerzheimer explained most carefully that luxury seemed to afford no great pleasure to the Bishop, who regarded it all rather as a means to provide for the pleasure of others. His richest possession was his library, a form of riches to which the Zürichers would certainly not take exception. Jewel's library was in fact Folkerzheimer's main reason for the extension of his stay in Salisbury, since it was especially rich in the field of his immediate interest – history.

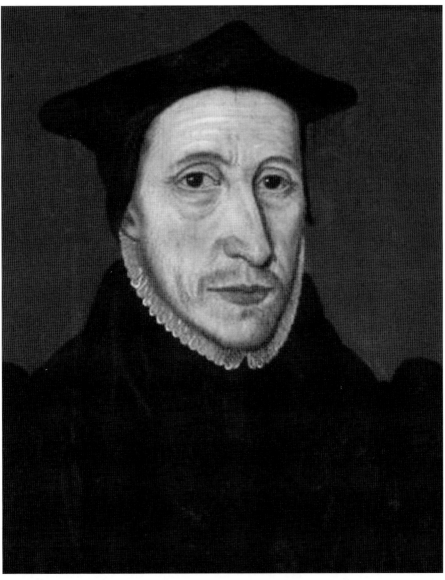

2.9: Bishop John Jewel: artist unknown, 1560s (*National Portrait Gallery*).

It was through Bishop Jewel's generosity that any young man who showed intellectual promise was certain of a university education, even if his means were small. He always had about six young men in the Palace in training for the universities. Richard Hooker was the most notable of these students. As Hooker's family were very poor, the Bishop became his patron for he was a boy who showed considerable intellectual promise. In 1567, the bishop sent Richard (then aged 14) to Oxford University, and consigned him to

Richard Hooker (1554–1600)

He was born in the village of Heavitree, near Exeter. With Bishop Jewel's help, he continued his education at Corpus Christi College, Oxford. He gained his M.A. in 1577, and became a Fellow of the college in the same year. He became assistant Professor of Hebrew at the University, and took holy orders in 1581. Hooker later served as Sub-Dean of Salisbury Cathedral. His book *Of the Laws of Ecclesiastical Polity* (1593) is primarily a treatise on Church/State relations. In 1595, Hooker became Rector of Bishopsbourne and Barham in Kent. He died on 2 November 1600 at his Rectory at Bishopsbourne and was buried in the chancel of Bishopsbourne Church.

the care of the President of Corpus Christi College. There is a story told by Isaak Walton of a visit to the Palace by Richard Hooker, who was on his way from Oxford to see his mother at Exeter. With a travelling companion, he stopped off at the Palace to see Jewel. They dined together that evening. On leaving the next morning the Bishop gave Hooker an abundance of good advice and his blessing, but through a lapse of memory, forgot to give Hooker any means for the continuance of his journey. The moment the Bishop remembered, he sent a servant to overtake Richard and to bring him back with all possible speed. On his return Jewel said to him, 'Richard, I sent for you back to lend you a horse which has carried me many a mile and, I thank God, with much ease'. Here he put into Richard's hands a walking staff with which he said he had travelled through many parts of Germany. 'And Richard', continued the Bishop, 'I do not give, but lend you my horse. Be sure you be honest and bring him back to me on your return this way.' With these words, he put money into Richard's hands for the journey, and more for his mother, promising him a further supply on the restoration of this 'horse'. Hooker never ceased to be grateful to the memory of his first patron.

Bishop Jewel collapsed after a sermon at Lacock, Wiltshire. He was taken to the manor house of Monkton Farleigh where he died on 23 September 1571. He was buried in Salisbury Cathedral. Richard Hooker, spoke of Jewel as the 'worthiest divine that Christendom hath bred for some hundreds of year'.

King James I

King James I was a frequent visitor to Salisbury. He enjoyed debate and discussion about theology and he would have found contact with the

learned members of the Cathedral staff much to his taste. He would also have greatly enjoyed the pleasures of the chase at Clarendon and at Wilton. His first visit to Salisbury was on 26 August 1603 when, for three days, he was the guest of Bishop Henry Cotton who, like the King, had been one of Queen Elizabeth's godsons. The King was frequently a guest at the Bishop's Palace; but he must have felt that he ought not to impose on the Bishop's hospitality too frequently, so sought other quarters for some of his many visits. The 'King's House' in The Close takes its name from having been the residence of the King on some of these occasions. The mansion had recently been restored and considerably enlarged by Mr Thomas Sadler. The cathedral choir was considered not to be large enough to cope with the demands of a cathedral service for royalty. The Chapter account books show that, in 1611, the choir had to be augmented by boys 'fetched from Windsor', by professional singers, and by 'the King's musicians with Whynd Instruments'; whilst in 1613 money was paid for 'Flowers and for Perfumes for the King and Queen in the Choir'.

On 2 August 1618, on one of the occasions when the King was resident at Mr Sadler's, the Great Hall at the Palace was fitted up as a stateroom. Here Viscount Lisle was created Earl of Leicester, and Lord Compton, Earl of Northampton. The ceremony was elaborate, the hall being hung with an arras and a 'cloth of estate' set up. After the ceremonies were over supper was served in 'the Great Chamber', the peers wearing their robes and coronets. Four days later, Robert, third Earl Rich, was here created Earl of Warwick, and, on the following day, William, Lord Cavendish, Earl of Devonshire. At various times a number of knights were dubbed here, amongst whom were Sir Giles Estcourt of Salisbury in 1611, and Sir Thomas Sadler on 8 August 1623. James came again and again, until his visits became a burden both to the city and to the Bishop. They were not sorry when these costly visits came to an end.

King Charles I

In 1625 Charles I visited Salisbury. He was returning from Plymouth where he had inspected the fleet that was about to set sail against Spain on the disastrous expedition to Cadiz. Charles was so short of money that he borrowed £1,000 from the City Council. When Charles demanded that the Palace should be used as a base for the new French Ambassador, Bishop Davenant met the demands of the King with a respectful but firm refusal. At a Royal Council held at the Palace, the Duke of Buckingham demanded that the King remove Bishop John Williams of Lincoln from his post as Lord Chancellor. Williams was accused of having a too liberal an attitude

towards the Puritans. Charles went along with Buckingham's demand: it was a poor decision, one of many steps that created the discontent with the rule of the King. In addition, that year, warrants were issued directing the lord lieutenants of counties to search the homes of leading Roman Catholics. The Bishop had authority to receive and store any weapons received resulting from these searches. Weapons belonging to Lord Arundell of Wardour and Lord Castlehaven were seized and stored for safekeeping at the Palace.

The Commonwealth period

After the Civil War, Parliament dismantled the Church of England and the bishops were deprived of their livings. The Parliamentary Trustees sold the Palace at Salisbury to William and Joseph Barter for £880.2s. From that time, the Palace passed through various hands with each new owner damaging and mutilating the buildings by turns. Most of Beauchamp's Great Hall was demolished because it was made of 'good saleable ashlar'. At one time, it was the property of one Van Ling, a Dutch tailor. By then the Great Hall had almost completely disappeared and the rest of the fabric had suffered considerably. Van Ling converted what was left into an inn for traders in Salisbury Market. He also opened up a gap in the south wall of The Close to act as a more convenient entrance into the Palace grounds for traders coming across Harnham Bridge to reach Salisbury Market. It seems likely that Van Ling must have used the west end of the Palace as living quarters. The destruction of the Great Hall would have made the east end almost uninhabitable. He divided one portion of the building into tenements for those making an overnight stay at the Palace. This was presumably in the former parlour and chamber. This would leave the Aula as a centre for Van Ling's inn where, it could be supposed, there was suitably sober Puritan entertainment laid on for visitors.

Bishop Humphrey Henchman (1592–1675, Bishop 1660-3)

Humphrey Henchman was appointed Precentor of Salisbury Cathedral in 1622 (2.10). He married the niece of John Davenant, Bishop of Salisbury and was appointed Rector of Westbury and of the Isle of Portland. As a Canon Residentiary of Salisbury, he was distinguished for his hospitality, for the regularity of his attendance at the Cathedral services and for the care he took to secure reverence in the church and more dignified ceremonial at the altar. He took part in the ordination of George Herbert and 'within less than three years lent his shoulder to carry his dear friend to the grave'.

The Civil War was a disaster for Henchman. He was a staunch Royalist and, for his support of the king, he lost all of his preferments. His rectory

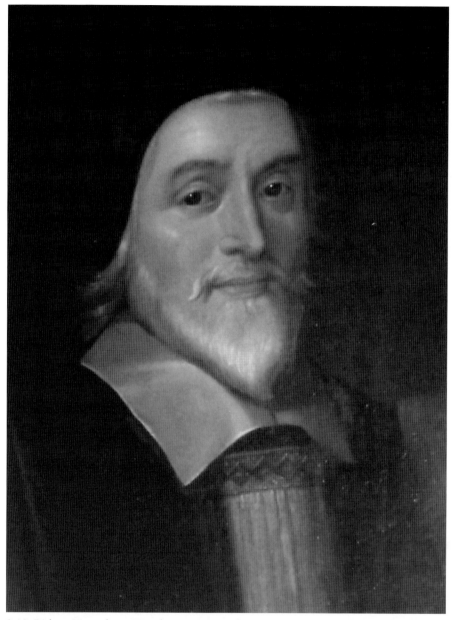

2.10: Bishop Humphrey Henchman: artist unknown.

house and library at Portland was destroyed. During the war, he resided in a private capacity in The Close at Salisbury. Here he kept up a secret correspondence with the Royalist leaders and he was instrumental in arranging the escape of King Charles II from England after the Battle of

Worcester in 1651. On 13 October, very early in the morning, he conducted the King from Heale House, near Salisbury to Clarendon Park. The King then continued to Brighton and crossed safely to France.

At the Restoration of King Charles II in 1660, Henchman was appointed Bishop of Salisbury. The Bishop arrived at Salisbury to find his Palace in a dreadful state of repair. The damage during the Commonwealth must have turned at least half of the Palace into an uninhabitable ruin and Henchman organised extensive repairs. He concentrated on the west end of the Beauchamp building where Van Ling's partitions would have been removed. The shape of the building as we see it today was the result of Henchman's remodelling of the remains of the Great Hall. The Hall's west end now became a thinner wall. This was ornamented with a chequer pattern of

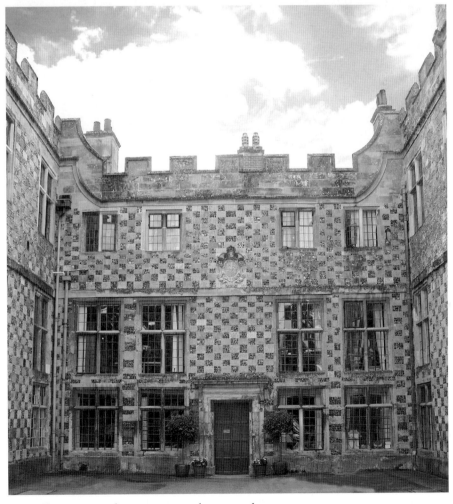

2.11: The seventeenth century central courtyard.

2.12: The Chapel staircase, built by Bishop Henchman. Access to the Chapel was from his new dining room: some of the woodwork matches the chapel screen.

stones and flints. This building line was continued around a new courtyard – the centre becoming a new front entrance **(2.11)**. This is how this area looks today, the entrance door being the principal entrance to the School's reception area. A new block of rooms was planned on the south side of the Palace, well beyond the former building line of the Great Hall and the Aula. These were to be taken up to three floors. On the ground floor would have been the kitchen with its service rooms; the second floor three private rooms for the Bishop and his family; the top floor would have been suitable for housing the Palace servants.

As Henchman wanted to consecrate the upper chamber as the Bishop's Chapel, he needed to give it a suitably imposing staircase. His grand oak staircase became the new way to reach, not only the new south side rooms, but also the Chapel and the Aula. A new door was inserted into the north-east side of the Aula. It would seem likely that there was a new door created into the new Chapel, but no evidence exists of this. Without this door, people wishing to enter the Chapel would have had to reach it via the Aula and then through the forebuilding. We do know that Henchman had the

large windows on the south side of the Chapel blocked in so that a new roof could be constructed to cover the new staircase and its long landing (**2.12**).

Almost all of Henchman's renovations exist today – giving the overall shape of the central zone with the new rooms on the south and west of this. As he was Bishop of Salisbury for only three years, it is remarkable how much he achieved. Bishop Seth Ward continued his work later. Unfortunately, owing to Bishop Ward's claim that no work had been done to repair the Palace before his time, he gave future generations the idea that only he had done all of the work to reshape the Palace. It must be admitted that Henchman had done nothing to tackle the worst ruined area on the east side of the Palace; but this was probably because of the limited time that he was here.

The Palace Chapel

Bishop Henchman altered Beauchamp's upper chamber to be a chapel (dedicated 1662) and then used the parlour below as a dining room. The problem remains that, if there was a chapel in the Palace before Bishop Henchman's time, then we know little about it or where it was situated. As the bishops' manor houses contained chapels in which ordinations were frequently held, mainly at Ramsbury and Sonning, it is likely that their principal house did so too. It is curious that there is no mention of ordinations in this house in the registers until the time of Bishop John Jewel who often held small ordinations '*in Palatio Episcopali Sarum*'. On one occasion he ordained six deacons and seven priests at Salisbury (27 March 1568), but usually his larger ordinations were in the Cathedral or at Westbury Church. It follows that '*in Palatio*' means 'in the Palace Chapel'. However, the first specific mention of it is in the register of his successor, Bishop Edmund Gheast (1571–6), who held an ordination in September 1588 '*in Capella sive Oratorio infra palatium Episcopale Sarum*' ('in the Chapel also known as the Oratory within the Palace of the Bishops of Salisbury'). It follows that, when Bishop Humphrey Henchman 'restored and perfected' the upper chamber 'under which lies immediately our refectory in the said Palace of Sarum' after the Restoration, and consecrated it to sacred uses on 28 August 1662, he only revived a practice that had been in force for some time before the Civil War.

The Chapel, with the Ante-Chapel, is about 40ft long and 18ft wide. It is in the upper part of Bishop Beauchamp's range of buildings west of the Great Hall. The Chapel originally had a lead roof carried on wooden boards (known as 'sarking boards'). The rafters would have been open to view and were originally painted with yellow ochre. Some traces of this paint have

2.13: Green man, ceiling boss: east end of Chapel.

been found on the sides of the rafters. The ribs of the panelled roof have been presumed to date from the same period as the walls. However, recent investigations have been carried out using dendrochronology. The results of this study have shown a very interesting, if very confusing, conclusion. The ribs are now known to date from 1541. Therefore, it follows that this ceiling must have been reconstructed, probably during the time of Bishop Jewel. Panels were also inserted between the ribs, which are made of Baltic oak. However, these panels date from 1407-23 so these must have been reused either from this room or from elsewhere in the Palace or another building in The Close. The ribs are decorated with gilded fifteenth-century bosses – one of which (over the east window) is a representation of the head of a Green Man, traditionally ornamented with leaves **(2.13).**

In the eighteenth century, Bishop Sherlock's architect, Francis Price, raised the ceiling of the dining room below the Chapel. This was done to insert the beautiful and restrained plaster ceiling of the dining room. The result of this was that the height of the Chapel was reduced. Up to this time a door in the north-west corner of the Ante-Chapel entered the Chapel from what was the forebuilding of Bishop Poore's Hall. On the removal of the forebuilding, a new large arched entrance was cut through the south wall of the Ante-Chapel, approached by seven steep wooden steps. This remains the entrance to the Chapel today.

Another result was that the sill of the east window had to be raised. The

2.14: The Hungerford Chantry (*R. Gough*, Sepulchral Monuments in Great Britain, *1796*).

whole window appears to have been taken out and raised by approximately two feet – the point of the arch externally now cuts up into the stringcourse below the parapet. Whether the tracery of the window is original is doubtful, but it is certainly not a good specimen of fifteenth-century work. It looks more like a bad copy made by men who had lost the feeling of the old style of architecture. It is distinctly less good than the side windows of the Chapel, which appear to be wholly original. There is an alternative theory concerning this east window. While Bishop Barrington's restoration of the Palace was proceeding under Sir Robert Taylor, James Wyatt was restoring

2.15: Carved head of an angel on the Chapel screen.

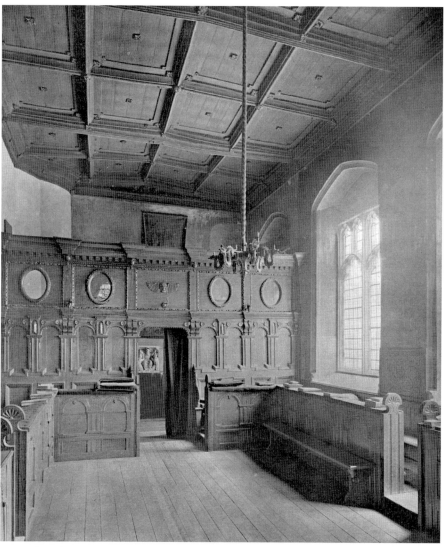

2.16: The Chapel, 1905.

the Cathedral. Part of Wyatt's work was the destruction of the two chantry chapels at the east end of the Cathedral – the Beauchamp Chantry and the Hungerford Chantry. One theory runs that the east end window of the Beauchamp Chantry was moved and placed into the east wall of the Palace Chapel. On examining an old print of the Beauchamp Chantry, it is immediately apparent that the two windows, whilst similar, do not match. There may be a case for the north windows of the Hungerford Chantry. While these are not quite high enough, the design is remarkably similar **(2.14)**.

To divide off the west end of the chapel Bishop Henchman added the screen made with pine and later painted to resemble oak graining; the lower part of the screen is decorated with arcades. This forms a small area behind the screen known as the Ante-Chapel. Originally, when Henchman had this screen set up, it only extended to the lip just above the blind arcades carved into it. The upper part of the screen has been attributed to Sir Christopher Wren (a friend of Bishop Ward). Regrettably there is no evidence to support this attribution. It has been suggested that the carved head of an angel in the centre of the screen could be a depiction of Bishop Ward, complete with seventeenth-century wig **(2.15)**!

As can be seen from the photograph of the Chapel taken in 1905, this upper screen had glazed oval holes set into it. Now that the School has a gallery built on to the Ante-Chapel side of the screen, these holes are now filled in with wooden panels. Henchman would have put in the pews that form a half-square around the screen end of the Chapel at the same time as the screen, so matching it in wood colour (grained oak). Originally, as in the 1905 photograph, the pews extended to the altar rail step. These have been removed to accommodate the more modern pews necessary to give sufficient seating for the School **(2.16)**.

The most interesting feature in the Palace will always be the chapel, which seems scarcely to have been touched since the 17th Century. The old quarto leather-bound prayer books contain prayers for our most gracious King George and Queen Charlotte. The skilful fingers of Miss Edith Moberly, the gifted daughter of the Bishop, have, however, lined the bare walls with paintings copied from early Italian masters and with tasteful embroidery. The chapel is arranged choir-wise with 'return stalls' facing the altar for the Bishop and reader. Within the altar rails [now in the Chapel of St Nicholas Hospital, Salisbury] were two plaster casts of the two sides of the Runic cross which marks the graves of Christopher and Susanna Hatley Wordsworth at Riseholme. A plain pastoral staff, with polished brass crook and oaken shaft, also belonging to his father, stood by the Bishop's stall, and there were other relics of Riseholme in the Ante-Chapel. It was in this chapel that Institutions were sometimes held and doubtless many other religious services of a public or private kind. In the ordinary household services, at Morning Prayer some admirable prayers written and selected by the Bishop for the various days of the week were used; in the evening the Prayer Book form of Evensong.

Elizabeth Wordsworth, sister of Bishop John Wordsworth, writing about 1890 and quoted by W. W. Watson in his *Life of Bishop John Wordsworth* (1915).

The Chapel has its own bell tower, inserted during the time of Bishop Hamilton (1854-69). The spiral staircase inside this tower gives access to the gallery and to the roof space over the Aula.

Edith Moberly, one of the daughters of Bishop George Moberly, was responsible for a series of frescoes painted on the south wall of the Chapel. These were in the style of Fra Angelico and represented the Annunciation, the Nativity, the Visit of the Magi, the Presentation in the Temple and the Flight into Egypt. One of these can just be seen in Alexander Ansted's illustration of the Chapel. This picture also shows frescoes depicting choirs of angels to each side of the east window. At some time since 1900, all of these frescoes were covered in thick layers of whitewash **(2.17)**.

After his extensive restoration work to the Palace, Bishop Henchman was appointed Bishop of London in 1663. He was a popular bishop, both owing to the fact that he remained in London throughout the Great Plague of 1665 and did much to help those poor citizens who were left destitute by the plague. He was actively involved in the planning of the new St.Paul's

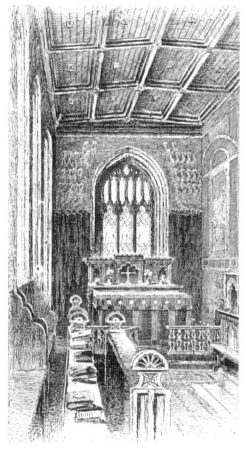

2.17: The Chapel, 1895: engraving by Alexander Ansted (*Edmund Venables, Episcopal Palaces of England, Isbister, 1895*).

There were other things which took place in the house of very great interest. Perhaps the most important, though I dare say it was thought very little of at the time, was the ordination as deacon of Joseph Butler, afterwards Bishop of Durham, in the Palace Chapel 28th October 1718. Butler was ordained quite alone, and only a few months before his ordination as a priest. We may imagine the scene in that little chapel, which has been, comparatively speaking, very slightly altered since that time, and realize the importance of the vows and resolutions then made as the young man knelt before the holy table.

Bishop John Wordsworth, 'The Bishop's Palace at Salisbury – Notes on the Architectural History of the Palace', based on a lecture given at Salisbury Museum, 27 January 1890.

Joseph Butler (1692-52) was a noted religious philosopher of the eighteenth century. He held the prebend of Yetminster Prima. After having been Bishop of Bristol and then Dean of St Paul's Cathedral, not long before his death, Butler was elevated to Durham. His writings are still a source of discussion by contemporary philosophers, especially for arguments against some major figures in the history of philosophy, such as Thomas Hobbes and John Locke.

Cathedral after the Great Fire of London in 1666. He died in the episcopal palace in Aldersgate Street in 1675 and was buried in Fulham Church. Today Bishop Henchman's portrait hangs directly opposite the entrance to the Chapel. It is a reminder of the bishop who did so much to beautify this peaceful corner of the Palace. It also allows the bishop to keep a watchful eye on those who still use the Chapel. Today this is the School Chapel and is dedicated to the founder of the School, St Osmund. It was extensively restored after the School's arrival in the Palace (1946-7: for the School Chapel, see Chapter 7).

Bishop Seth Ward (1617-89, Bishop 1667-89)

Seth Ward was a student at Sidney Sussex College, Cambridge **(2.18)**. In 1649, he became Savilian Professor of Astronomy at Oxford University, and was one of the original members of the Royal Society. In 1662 he was consecrated Bishop of Exeter, and in 1667 he was translated to the Diocese of Salisbury. His appointment had been very popular with the people of his new diocese. Huge crowds came in throngs to meet him. On his public entry into the Cathedral Close, the Head Chorister delivered a Latin speech

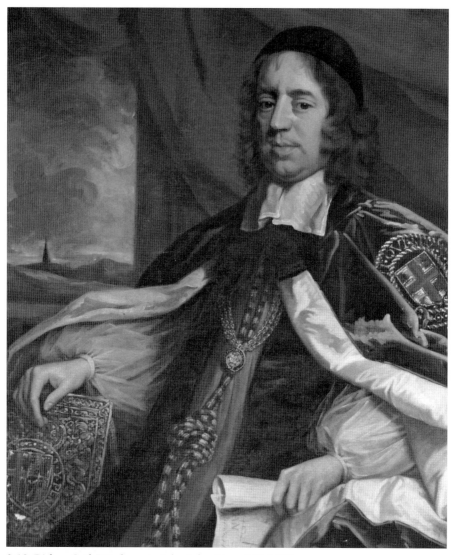

2.18: Bishop Seth Ward, portrait by John Greenhill, 1673.

of welcome, full of his praises, and declaring how happy all of them were to have such a Bishop, sent them, as it were, from Heaven.

His first care was to restore and repair the Cathedral, necessitated by the disorders of the Civil War. Much to his surprise, the Cathedral did not need very much in the way of repairs. During the Civil War and the King's exile there was no Bishop or Dean here to care for the Cathedral. Instead, several loyal gentry of the diocese employed workmen to keep the Cathedral in good repair. Bishop Ward set himself the task of supervising the decoration

of the Cathedral. The whole Quire was laid with white and black squares of marble. The stalls of the Bishop, Dean, and all the prebendaries were repainted and gilded. Bishop Ward was a friend of Sir Christopher Wren whom he employed to survey the Cathedral, principally with a view to the security of the spire. Beside other benefactions to Salisbury, he founded a hostel for widows of the clergy of the diocese, known as the Matrons' College.

His next concern was to continue the rebuilding of much of the Palace started by Bishop Henchman. The two bishops between Henchman and Ward had only been in office for short periods and, as a result, had done very little to continue the necessary repairs to the Palace. Seth Ward used James Harris (the Clerk of the Works of the Cathedral) to undertake the renovation work. Wren was also called in to advise. Harris was employed on this work in 1668 and the renovations were completed by 1674. In Bishop Ward's 'Notitiae' it appears that the cost of rebuilding the Great Hall was about £1,140, and that other repairs cost about £536 (including a sum spent on repairs to The Close wall, presumably to close up Van Ling's gap). The whole sum of £1,676 13s. 7d. was divided amongst the four bishops since the Commonwealth period in proportion to their receipts, according to the sentence of a Commission of Appeal, which gave judgement in 1674. The result was that the three preceding bishops were charged £1,375, the remainder to be covered by Seth Ward.

Having taken advice from his friend Sir Christopher Wren, Bishop Ward reconstructed the eastern half of the ruined Great Hall. In the front courtyard, Bishop Ward's new exterior work was designed to harmonise with that already existing. The construction of the new hall resulted in a three-sided court on the north, which was made more uniform by adding on the western side a false wall complete with dummy windows at second-floor level, to balance the west wall of the new hall. A central stone doorway with a cornice on scrolled brackets was inserted and a cartouche of the royal arms dated 1674 was added above. The main door here, with its nail-studded panels, was put in at this time. A colonnade was added across the front courtyard to emphasise the importance of the new central entrance. Little is known about this colonnade. It appears on the estate map of the Palace in around 1780, but there is no trace of it in the map of 1827 (see Appendix 1). The conclusion is that Bishop Barrington must have ordered its removal during his renovation of the Palace in the late eighteenth century. Barrington created a new entrance to the Palace below the Chapel, relegating the central door to be one of less importance.

In 1973, to prove the building line of the demolished Great Hall, boys of

the Cathedral School did a small archæological dig. The footings of two of the missing buttresses that supported the north side of the Great Hall were found where expected. This proved that the Great Hall did run from the East Tower to the western range of buildings. This, incidentally, disproved the view of the British Archæological Association who, when they visited the Palace in 1887, were of the opinion that the Great Hall ran from north to south (i.e. parallel to the Aula).

Bishop Ward had a large cupola added to the roof of the East Tower with a clock, turret and wind-vane **(2.19)**. This was removed in the nineteenth century and transferred to the Palace coach house. Other changes by Bishop Ward included the erection of the south range of buildings, originally planned by Bishop Henchman, from the Beauchamp wing to the east wall of the Aula. On the ground floor, there would have been a kitchen in almost exactly the same area as the School kitchen today (to the south-east of the Undercroft). There are still the remains of the huge fireplaces associated with the early kitchen design in the present-day kitchen area. Above the kitchen area are three large rooms that could have been private rooms (e.g. a library or offices) running along the south side. Next to the Aula is an anteroom with its impressive Corinthian columns leading to the Aula itself. At the other end of this room are two doors (one false). Beyond this, the other two rooms give an impression of being light, comfortable rooms that would have made a welcome domestic seclusion from the grander staterooms of the Palace.

Along the north side of this south range is a passage with a statue niche. This passage was, and still is, lit with interesting and unusual glass lantern-style skylights inserted into the ceiling. During later eighteenth-century alterations, this passage became the main east-west artery between the day and night quarters of the Palace. The passage now led to the servants' spiral stair at its west end. Off this passage is a small room that overlooks the front courtyard. At its east end, the passage leads to a room that acts as a junction between the south and the west ranges. Above these rooms today is a complex row of apartments on the second floor for visiting or temporary members of the School staff. Most, if not all of these rooms originally would have been servants' quarters.

Bishop Ward's builders constructed a compact dining hall from the remains of Beauchamp's Great Hall. This now ran from the second buttress on the north side to the rear of the old screens passage. To the south of this hall was a long wooden gallery held up by a row of wooden pillars. This was probably used for musicians hired to entertain the diners below. The dining hall was connected by a passage beneath the Gallery with Henchman's

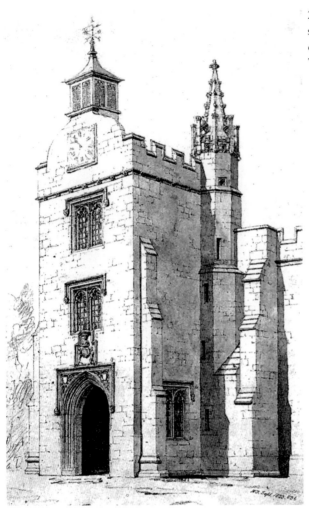

service rooms. The hall was heated from a fireplace on the north side of the room (only its chimney now remains, at roof level). At one end of this hall, Ward set up the royal arms and at the other end his own arms. It is now impossible to imagine what this hall must have been like because of the many changes made later to this part of the Palace. The interior was totally altered during the later renovations in the late eighteenth century. One important part of Bishop Ward's original design fortunately remains – the elegant oak staircase **(2.20)**. This led directly to the gallery at first-floor level. It rises in twin flights and returns as one, repeating the process to the top floor. This grand approach suggests the importance of the rooms on the top floor. Here three large bedrooms were built above the new Dining Hall. With an extra chamber within the east tower and two other smaller

2.20: Bishop Seth Ward's oak staircase.

rooms, this whole area would seem to have been the first appearance of a range of rooms designed for the Bishop and his guests to use as sleeping quarters. Around 1745, Bishop Thomas Sherlock included Bishop Ward's hall in his extensive alterations to the Palace. A sketch exists by his architect, Francis Price, of his intended improvements to this hall. Price encased the gallery pillars with wooden classical columns. These pillars, running along the corridor on the ground floor of the Palace, are all that remains today to remind us of the grandeur of Ward's dining hall **(2.21)**. On the east of Ward's hall was a large wing containing the brewhouse, larders, washhouse and a firewood store to serve the Dining Hall. This wing has completely disappeared. Today, the Head Master's House covers the site of this wing.

Bishop Ward was noted for the welcome that he gave to all his visitors. He expected any clergy, even the poorest curates, who should happen to visit Salisbury, to come to the Palace. In addition, it was quite the usual thing for any important visitors to dine with him. He never failed to treat all who came to the Palace with affability and kindness. After morning prayers, which he seldom missed, he would walk up to his chamber, and stay there until a servant brought word that dinner was ready. After dinner, he would stay with his guests, drink a cup or two of coffee or tea, while his guests, if they preferred to do so, might drink wine. When the bell tolled, he would

call for his robes and go to the Cathedral, taking all of his guests with him to the service.

He constantly helped a large number of poor folk who would assemble to meet him at the Palace gatehouse (the 'Queensgate'). When Bishop Ward heard of the problems of those in want, but who were ashamed to beg, he would send money to their houses. He also had a limited number of pensioners that he paid weekly. As one of these died another was substituted in his place. He often went out for walks in the area and during these he often gave liberally to poor people who happened to meet him. When travelling in his coach, or riding out on horseback, he often passed through

2.21: A minstrels' gallery pillar, a survival from Seth Ward's dining hall.

the village of Harnham, where all the children would stop their play and cry out, 'My Lord Bishop is coming! My Lord Bishop is coming!' Upon which, all the poorer villagers would appear at their doors, calling on God to bless his lordship, and so received alms from him. An example of Bishop Ward's popularity in Salisbury is that whenever he left to travel to London many citizens would ride with him part of the way, just to wish him a happy journey, a speedy and safe return. When he left the Cathedral Close and when he returned home, huge numbers of poor folk assembled, many kneeling with their hands raised to Heaven. They gathered just to pray for his good journey or to give thanks for his safe return.

The office of Chancellor of the Order of the Garter was conferred on Bishop Ward in 1671. He died in Knightsbridge in January 1689 after a long period of senility and was buried in Salisbury Cathedral where he is commemorated by a tablet in the south transept.

King James II's nose-bleed

In 1688, King James II lodged in the Bishop's Palace in Salisbury, which became the scene of a turning-point in British history. His Roman

2.22: Arms of King Charles II, 1674, added by Bishop Seth Ward over the central north door of the Palace.

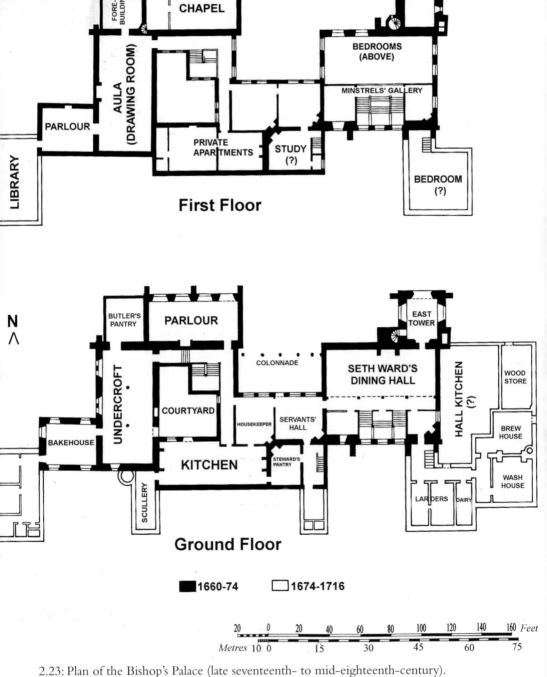

First Floor

N
∧

Ground Floor

■ 1660-74 □ 1674-1716

Feet	20	0	20	40	60	80	100	120	140	160
Metres	10	0		15		30		45	60	75

2.23: Plan of the Bishop's Palace (late seventeenth- to mid-eighteenth-century).

Catholicism put him at odds with the predominantly Protestant faith of his subjects. In 1688, the Dutch leader, Prince William of Orange was concerned that James II's beliefs were about to bring a switch in Britain's foreign policy. France, under Louis XIV, was a major threat to Holland; but an alliance between potentially Catholic Britain and Catholic France meant William

faced a threat from across the Channel too. Desperate to stave off the French, William planned an invasion of Britain to make sure England stayed on side. Events in London gave him the excuse to act. The British tolerated their King's unpopular religious preference in the belief that it would die with him but, on 10 June, a healthy boy was born to James's Queen, Mary of Modena, and was named James Francis Edward Stuart. William of Orange saw that his chance of naturally succeeding to the English throne alongside his wife (James II's daughter, Mary) had been snatched away. He activated his 'Grand Design' to invade England. His enormous invasion fleet set sail on 1 November. He put to sea with 53 warships and hundreds of transport ships carrying an army of 20,000 men, arms and equipment. The fleet made landfall at Brixham in Devon on 5 November. As there was no army or militia in the area to offer any resistance, William made steady progress through Devon.

Salisbury became the centre of extraordinary and momentous activity. As soon as James II heard that Prince William had disembarked, he assembled an army of some 35,000 troops in the area. He arrived at Salisbury on 19 November, to join his army, which far outnumbered William's forces. James's spirits must have lifted when the people of Salisbury greeted him with acclaim. The Mayor and Aldermen met their King at the gates of the city and accompanied him to the Bishop's Palace where he was to lodge. Huge cheering crowds followed the royal coach to the doors of the Palace. However, even before he reached Salisbury, the news that James had received was disheartening, and now that he was there, it became even worse. He knew that William was in control of Exeter and the West Country and suspected that some of his officers might be disloyal. All this, together with problems with his health, weighed heavily upon him. Lieutenant-General John Churchill, one of the King's most able and trusted commanders, and the Duke of Grafton, together with Colonels Kirke and Trelawney planned to desert James and join William. Kirke and Trelawney rode to Warminster where their regiments were stationed. Churchill suggested that the King, should visit these troops there, and James agreed to do so.

Very soon after the King's arrival in Salisbury, friction had developed between the clergy representing the Established Church and the retinue of Roman Catholic priests who accompanied James. The Palace Chapel had been reserved for the royal use. Dr Knightly Chetwood, the James's Protestant chaplain, arrived but when he found that the King's Roman Catholic chaplains occupied the Palace Chapel, he threatened to resign.

After some hesitation, the Catholic priests withdrew and a Church of England service was held in the Chapel before a packed congregation.

On the night of 22 November, the King was suffering great stress amid reports that the Prince of Orange was fast approaching, that London was in a state of commotion, and that disaffection was spreading throughout the North. He went to the Palace Chapel to pray but, on leaving to set out for Warminster, he suffered a serious nose-bleed. He was taken to a room for attention (it is known today as the 'King's Room' and is, by chance, the sickbay of the Cathedral School). The nose-bleed continued for three days and forced him to cancel his journey to Warminster. Had he been able to rally his troops, the inevitable battle could have changed the course of British history.

Seeing James's hesitation, Churchill fled with Grafton to join the Prince of Orange. James was informed that Kirke at Warminster had refused to obey orders from Salisbury, and it was obvious that he also was in league with William. On 24 November, on receiving the news that that Marshal Schomberg was approaching with the advanced guard of the Dutch army, James conferred with his remaining principal officers. Distrusting the mood of his forces, he ordered a general retreat. On 25 November, in rage and bitter despair, he returned to London.

On 4 December, William reached Salisbury and was greeted by the Mayor and Aldermen. The bells rang out and crowds cheered him all the way to the Bishop's Palace where he was to stay. Later that month James fled to France to live in resentful exile for the rest of his life. His daughter, Princess Mary, and her husband, William, took their places as joint monarchs.

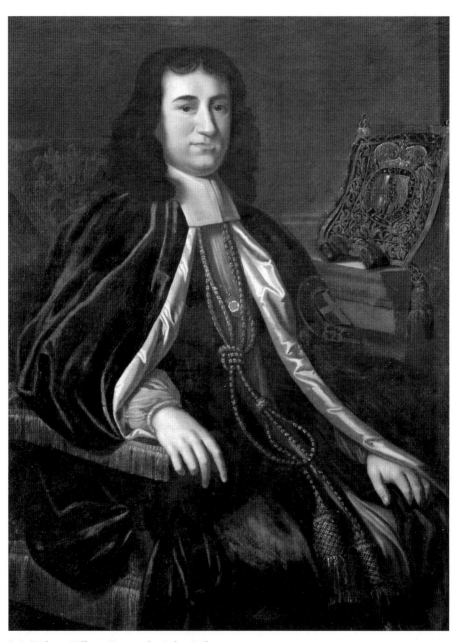

3.1: Bishop Gilbert Burnet by John Riley.

3

The Palace in the eighteenth century

Thanks to the stability following the 'Glorious Revolution', the bishops were now able to make their palace into a magnificent home, reflecting the enlightened culture of the eighteenth century

Bishop Gilbert Burnet (1643-1715, Bishop 1689-1715)

Gilbert Burnet was born at Edinburgh, the son of a judge **(3.1)**. Following his studies at the University of Aberdeen, he began his ministry in the rural church at East Saltoun in East Lothian. In 1669, he was appointed Professor of Divinity at Glasgow. During unsettled times, he moved to London where his political and religious sentiments prompted him to support the Whig Party. In 1685, he began a series of travels in Europe and was invited by William, Prince of Orange, and his wife, Princess Mary, to take up residence at The Hague. He was apparently unable to keep secrets and so was not informed of William's planned invasion of England until July 1688. However, his help was needed to translate William's 'Declaration' that was to be distributed in England after his landing. When William's fleet set sail for England in October, Burnet was appointed as his chaplain. In 1689 Burnet was consecrated Bishop of Salisbury. He had originally been a Presbyterian, and, although he had joined the Church of England early in his life, he always retained a distinctly Presbyterian outlook. He worked constantly for union between the Anglicans and the non-conformists and was a prominent supporter of reform in the Church of England. Despite his rather loose adherence to Anglican principles, and the fact that he was very intolerant of the 'high church' party, Burnet was a good, intelligent, and conscientious Bishop of Salisbury.

He was a tireless preacher, and, whenever resident in Salisbury, he gave a weekly lecture at the church of Sarum St Thomas. Every Sunday evening he lectured on the Epistles and Gospels in the Palace Chapel to crowded congregations. He made a point on Sunday mornings of preaching in 'as many churches as lay within such a distance that I could decently go to them and return on a Sunday.' On one occasion, at a time of serious flooding, his reluctance to disappoint a rural congregation nearly cost him his life. Within the first fifteen months as Bishop, he had preached and confirmed in 50 parishes. When writing his autobiography in 1710, he recorded that he had confirmed in 275 churches of his diocese, having visited the most important ones ten or twelve times. His interest in natural sciences can be seen in the magnificent funeral sermon he preached on the death of the great scientist, Robert Boyle.

Bishop Burnet was also an eminent historian. His influential book *The History of the Reformation of the Church of England* was published in three volumes between 1679 and 1714. Parliament voted thanks for Burnet after the publication of the first volume and, in 1680; Oxford University awarded him the degree of doctor of divinity. Burnet began his *History of My Own Time* in 1683, covering the period from the Civil War down to the Treaty of Utrecht of 1713. This is the best known of his histories and has the great value of being written by an eyewitness to many of the events described.

He led a routine daily life, normally starting his day no later than five o'clock during the summer and six in the winter. Private meditation took up the first two hours and the last half-hour of the day. Before breakfast, he held morning prayers for his family, which he always read himself, even though his chaplains might be present. He had his breakfast with his children. During the meal, he instructed them in religion, giving his own comment upon some portion of the Bible for an hour every morning. This over, he retired to his study, where he seldom spent less than six, often more than eight hours in a day. His last family gathering of the day was for evening prayers.

Bishop Burnet had a keen sense of humour. Every Sunday he insisted on having a huge roasted rump of beef and a massive plum pudding at dinner. Once the cook sent in a very small pudding, which Burnet felt was disrespectful to the Sabbath! On being questioned about this, the cook said that there were no plums to be had. 'Why then,' said Burnet, 'you should have made a bread pudding. For to send in such a giant-like rump and such a dwarf pudding makes a very bad balance, and I had rather my pudding had been a little worse than have so great a breach of order and symmetry.' The meals he expected to be served at the Palace were decent and plain.

3.2: South front of Palace: west wing on the left, *c.* 1900.

He kept an open table, on which there was 'plenty without luxury' and his expenditure revealed a personality that was generous but not profuse. Salisbury traditionalists did not much appreciate his architectural efforts, while his critics sarcastically observed that the kitchen specially profited from his changes! According to contemporary rumours, he was an inveterate smoker. Caricatures were circulated that represented him with a 'churchwarden' pipe stuck through the brim of his shovel hat.

There can be no doubt that Burnet's episcopate benefited his diocese. He was essentially a working bishop. Despite the size of the diocese, he always tried to give his advice and instruction to as many people as possible. Neither poor weather nor foul roads prevented him performing his engagements. The poverty of many of his clergy was a constant source of anxiety to him. Blunt in manner, and often rather tactless, underneath all his external roughness, there beat a kind and generous heart. He is remembered as an historian, theologian, preacher, a pamphleteer and active politician.

The West Wing (later known as the Sherlock Library or Banqueting Hall)

This wing was built as an extension to the bishop's private apartments, probably on the instructions of Bishop Burnet **(3.2)**. The shape of the Palace in Naish's map of 1716 clearly shows an extra block of building beyond the Aula **(3.3)**. Later in the eighteenth century, during Bishop Sherlock's alterations, it became his library, at least on its upper floor, the lower being

This wing contains the following accommodation: Ground Floor: a large and lofty kitchen, scullery, stillroom, store, butler's pantry, yard, shed, outside w.c. and staircase to the first floor. None of these rooms has been used for some time and are all derelict and dilapidated.

First floor: a large dining room 37ft. x 21ft. This is a good room but has suffered from injudicious treatment at some time in the 19th Century. The roof was originally constructed with green post trusses and probably had a plaster ceiling, In order to increase the height the tie beams have been cut, the green posts shortened and collars introduced, with a segmented panelled plaster ceiling below.

The result being that the roof had sagged, pushing out the walls and even the chimneypiece was fractured.

Extract from the report by the Royal Commission on Historic Monuments, 24 April 1931

then storerooms. During Bishop Barrington's alterations, Sherlock's library became the dining room, with a staircase to kitchens beneath, and was fitted with a magnificent chimneypiece with a pattern of classical garlands and jugs. This attractive fireplace can now be seen in the south-west chamber beyond the Undercroft (now known as the Blee Room). The wing was again enlarged in the nineteenth century to accommodate a Banqueting Hall to replace the more modest former dining room. Towards the end of his episcopate, Bishop St Clair Donaldson (Bishop 1921-36) secured the consent of the Ecclesiastical Commissioners to remove this wing and the large kitchens beneath which had ceased to have any practical use. This demolition followed a surveyor's report that showed the building was in danger of collapse, having been seriously weakened by the nineteenth-century alterations. The only trace now visible is the outline of a fireplace at first-floor level in the exterior wall on the west wall of the south-west chamber.

The Cathedral at Sarum was now entering a phase of great magnificence and worldliness. On the 29 August 1722, King George I and the Prince of Wales (later George II) paid a visit to the city. The Mayor and Corporation met them with the usual formalities, when the keys of the city with a purse of 100 guineas were presented to the King, and 50 guineas to the Prince. They stayed at the Palace, and after attending Divine Service at the Cathedral on the morning of the 30th, the King reviewed the forces that were encamped in the neighbourhood. Each night during the King's stay, the City was illuminated. He gave £250 to the poor of the City, The Close, and Fisherton, and £100 each to the Cathedral, the Matrons' College, and

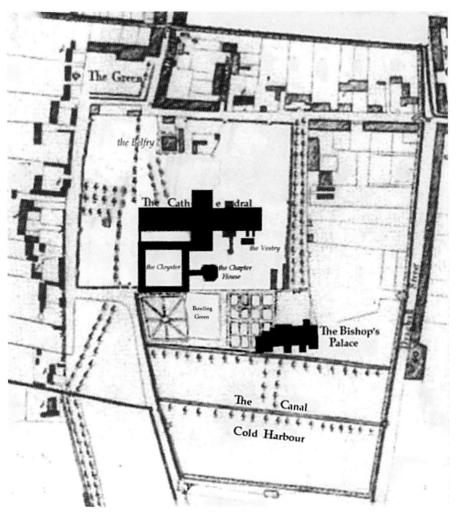

The Green

the Belfry

The Cathedral

the Vestry

the Cloyster

the Chapter House

Bowling Green

The Bishop's Palace

The Canal

Cold Harbour

3.3: Part of Salisbury Cathedral Close showing the Bishop's Palace and grounds: adaptation of part of William Naish's map of Salisbury, 1716.

the Workhouse, besides paying £1,758 11s. for the release of all the prisoners who were confined for debt.

The religious revival under Bishop Burnet ended with his death in 1715. From then until the end of the century the life of the Christian spirit burned low. The Church fell again into a slumbering state. It had emerged from the Reformation, triumphed at the Restoration, survived the Revolution, and now, securely rooted at last; it reverted to the old evils of pluralities and simony. The eighteenth century has been called the 'glacial period' of the Church. At Salisbury, in the next 80 years, there were no less than twelve

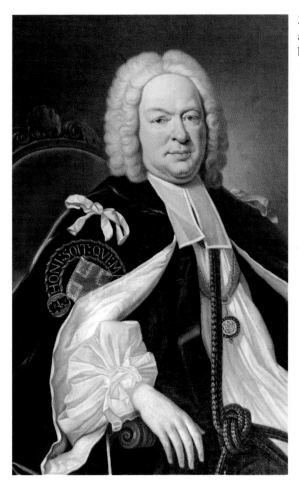

3.4: Bishop Thomas Sherlock: a copy of the original portrait by Jean-Baptiste Van Loo, *c.* 1740.

bishops, eight of whom, after but a short stay, were promoted to other sees, whilst two others did not become Bishops of Salisbury until well past the age of 70, one dying at the age of 80, and the other aged 91. Under such circumstances, progress in the life of the Church was hardly possible.

At the same time, the social arts flourished to an extraordinary degree: music, literature, the theatre, classical learning, even dancing, all found their way into the Cathedral Close. Salisbury was a wealthy city and this wealth was displayed in the architecture of the houses in The Close. Many of the medieval houses, such as the Hungerford Chantry, now acquired neo-Classical façades. The new buildings, of which Arundells and Malmesbury House are notable examples, were built in Georgian opulent simplicity. Now that the bishop was resident permanently in The Close, he needed to play an important part in its society. As described in Chapter 1, Bishop Sherlock's major alterations to the Palace (pp. 34-37) demonstrate the shift away from medieval Gothic: the walls were discreetly hidden under thin,

smooth plaster-coated false walls and topped with a tasteful stucco frieze. The medieval roof beams and rafters are now no longer to be seen – the grand, eagle-centred ceiling shutting out all sight of this ancient woodwork.

Bishop Thomas Sherlock (1678-1761, Bishop 1734-48)

Thomas Sherlock was the son of William Sherlock, Master of the Temple and Dean of St Paul's Cathedral **(3.4)**. He was educated at Eton College, where he was the contemporary of Sir Robert Walpole, Great Britain's first Prime Minister. In the course of his education, Sherlock was always at the head of his class, and he was a natural leader in sports. Aged fifteen, he went on to St Catherine's Hall, Cambridge. Here he made the acquaintance of Benjamin Hoadly, one year his senior. They did not get on well. Sherlock was one of Hoadly's leading opponents throughout the rest of their lives. Sherlock was to succeed Hoadly both as Bishop of Bangor and then of Salisbury. He was ordained in 1698 and then succeeded his father as Master of the Temple. In 1714, Sherlock was appointed Master of St Catherine's Hall and then Vice-Chancellor of Cambridge University. Through the

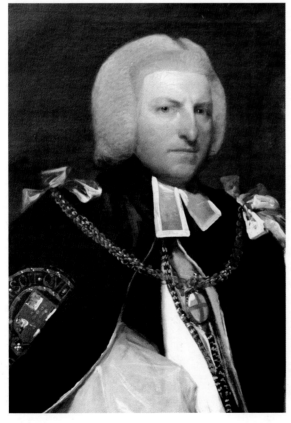

3.5: Bishop Shute Barrington: (Artist unknown) (dated 1785)

influence of Queen Caroline, he became Bishop of Bangor in 1728 and was translated to Salisbury in 1734.

Sherlock was a man who worked very hard in fits of energy, but then lapsed into what was described 'a strange lassitude'. His early and robust health began to decline not long after he became Bishop of Bangor. Gout and rheumatism, those respectable complaints of the eighteenth century, began to make inroads upon his constitution. In 1743, he had a stroke, and he was for some time confined to his bed. He recovered sufficiently to go to London as its Bishop in 1748. His acceptance of this new appointment caused some puzzlement at the time, as he has already declined offers to be appointed Archbishop of York and later Archbishop of Canterbury, both on grounds of ill health. However, in 1753 he suffered a second and more serious stroke, which more or less left him paralysed. He died in 1761. Sherlock left the vast sum of £140,000, having inherited two large fortunes from both his father and his brother. In his will, Sherlock left his library to his old college, St Catherine's Hall.

Bishop the Hon. Shute Barrington (1734-1826, Bishop 1782-91) and his restoration of the Palace

Bishop Barrington was born at Beckett Hall in Shrivenham, Berkshire, the home of his father, the 1st Viscount Barrington (**3.5**). He was educated at Eton College and Merton College, Oxford, and after holding some minor

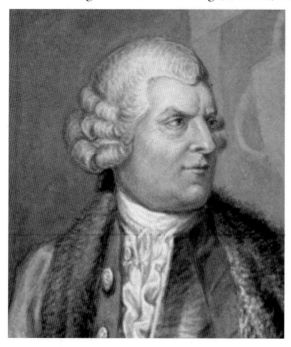

3.6: Sir Robert Taylor: watercolour after a portrait by William Miller, c. 1782.

3.7: The 'Gothick Porch', north front with the coat of arms of Bishop Barrington.

dignities was made Bishop of Llandaff in 1769. In 1782, he was translated to Salisbury and in 1791 to Durham. His rule as Bishop of Salisbury is marked by some of the most controversial changes undertaken on the architectural scene at Salisbury. He employed James Wyatt to 'restore' the Cathedral while at the Palace, he employed the architect Sir Robert Taylor to carry out extensive restorations to the buildings. Within just three years, Taylor and Barrington had managed to alter almost every part of the Palace (3.6).

Taylor's alterations to the Poore and Ward halls have been noted earlier. Bishop Seth Ward's hall and Beauchamp's tower porch were floored over at gallery level, creating six new bedrooms, with panelled joinery, coved ceiling cornices and wooden chimneypieces. These bedrooms were linked to the west part of the house by truncating the room west of Ward's stairs and cutting a doorway into the central range. The bedrooms were also given direct access to the garden by making a window on the former hall stairs into a doorway, with a pair of oak panelled doors (now known as the 'garden

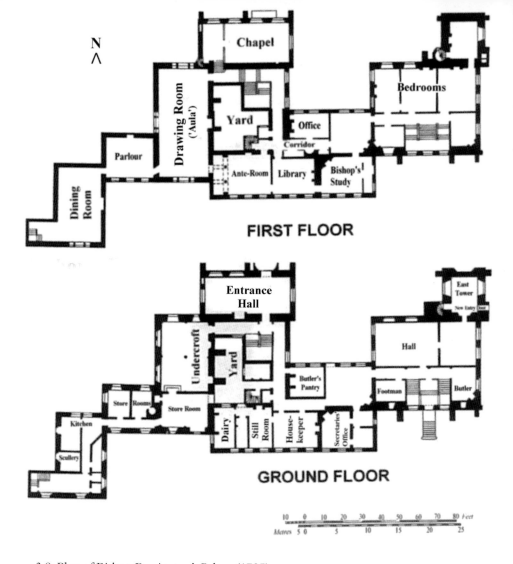

3.8: Plan of Bishop Barrington's Palace (1785).

door'). This allowed access to the gardens directly from the gallery staircase to the south of the Ward hall. The service area at the east end of the Palace that used to serve Bishop Ward's dining hall was demolished. It is worth noting how much space was given to the Palace servants. Apart from the new entrance hall, the whole of the ground floor now became a huge working zone to maintain the life of the bishop, his family and his guests. The extent of these rooms and the large number of staff give us a very good idea, not only of the luxurious life style of an eighteenth-century bishop, but also the enormous personal wealth needed to maintain this organisation **(3.8)**.

With the removal of Seth Ward's dining hall, it was necessary to create a new grand dining room. Barrington's solution was to use the West Wing of the Palace for this purpose. The library was shifted from here to the rooms

90

Sir Robert Taylor (1714-88)

Born at Woodford, Essex, Taylor followed in his father's footsteps and started work as a stonemason and sculptor (**3.6**). Despite some important commissions, he enjoyed little success. He turned instead to architecture, ultimately being appointed architect to the Bank of England, a post that held until his death. From 1769 until his death, Sir Robert served as a vice president on the board of the Foundling Hospital, a prominent charity dedicated to the welfare of London's abandoned children. The Taylor Institution, Oxford University's centre for the study of medieval and modern European languages and literatures, takes its name from a bequest from Sir Robert for the purpose of 'establishing a foundation for the teaching and improving the European languages'

next to the Bishop's study on the first floor of the south range. Below the new dining room, a new kitchen was installed and this connected with all of the usual storerooms and service rooms: all running in a line east–west with the housekeeper's room ending the sequence. A small service lift was inserted to connect this room with the private apartments above. This was in use until quite recently and can still be seen behind cupboard-type doors on the ground floor and first floor. To ease the movement of servants between their quarters on the second floor, the kitchen and stores on the ground floor, and the Bishop's rooms on the first floor, a new wooden spiral staircase was put in, going right through the walls at the west end of the south range.

At the north front, Taylor changed the layout of the lower chamber. This had been a parlour in the time of Bishop Sherlock. The windows in the north wall were blocked in and new large windows were inserted at each end of this room. It seems likely that, in inserting the new window at the west end of this chamber, an old fireplace was removed (the whole line of a chimney can be clearly seen in the external stonework of this end of the building. A new porch was cut through, so making the whole room a grand entrance hall. This porch is in pure Romantic 'Gothick' and clashes in style and scale with the rest of the building. One decorative feature of the porch was the arms of Bishop Barrington carved into the stone over the new front door (**3.7**). One of the fifteenth windows was destroyed to insert this porch – the carved heads that would have been on each side of this window were transferred to the sides of the tall new window at the west end of this room. The Palace as Barrington left it, is seen in Buckler's drawing of the north front (1809) (**3.10**). The north chamber recently has been cut in two by a very ugly modern screen of wood and glass to make the lobby to what is

today the School Music Room. Fortunately, the Sherlock ceiling has been retained, but it is difficult to take in the whole effect of this because of the screen. The main door to the east tower was blocked up and a small new entrance made on the east side of the tower. This cut through what was the base of the medieval garderobe shute. This door can still be seen in the ground floor of the tower, even though this is no longer used as an entrance (**3.9** and **2.5. p. 50**).

The Palace is built in such a low-lying situation that it is subject to problems of rising damp as the water-table is very near the surface. Bishop Barrington had several drains dug to end at a 'canal' that crosses the area to the south of the Palace: Some of these drains pass through the grounds, others under the house, by which means stagnant waters are carried off. The lines of these drains can often be seen today in dry summer weather as 'crop marks' running across the playing field from the Palace to the lake.

3.9: The Wren Hall clock, an 'Act of Parliament' or 'tavern' clock by Daniel Keele of Salisbury, *c.* 1760. It used to hang over the fireplace of the Big School Room of the Cathedral School's former residence in Wren Hall. It has been recently restored in memory of John and Kenneth Sankey (two former Cathedral choristers). The clock now hangs in the anteroom to the music room, just beyond the Barrington entrance porch.

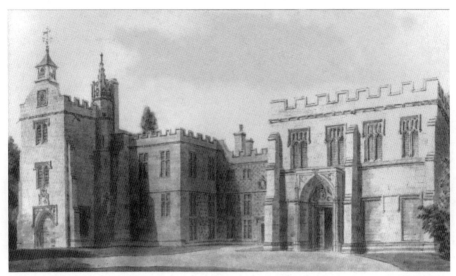

3.10: The north front of the Bishop's Palace in a drawing by S.J.Buckler, 1809. Note the blocked-up windows in the north-west block (on the right): these are next to the new 'Gothick' porch. The door of the east tower is also blocked up.

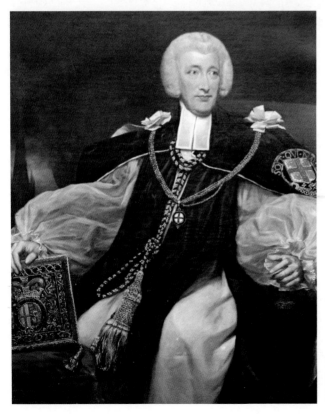

3.11: Bishop John Fisher by James Northcote, R.A., 1816.

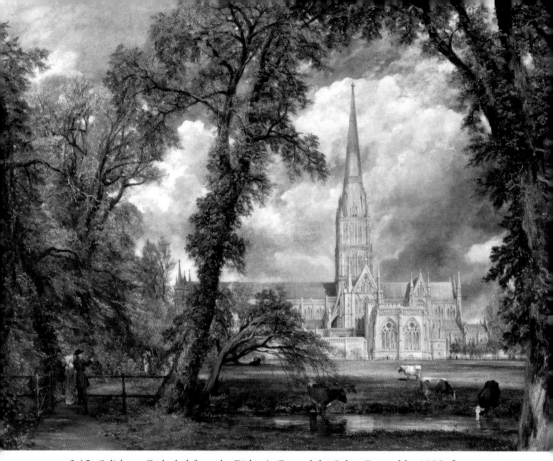

3.12: *Salisbury Cathedral from the Bishop's Grounds* by John Constable, 1823, first version with dark clouds (*Victoria & Albert Museum*).

Bishop John Fisher (1748–1825, Bishop 1807–25)

Bishop Fisher served as a chaplain to King George III and, in 1786 he was made Canon of St George's Chapel, Windsor **(3.11)**. He became closely connected with the royal family, and gained the nickname 'the King's Fisher'. In 1780, he was appointed preceptor to Prince Edward, afterwards Duke of Kent (the father of Queen Victoria) and gave drawing lessons to him and his sisters. He was a keen amateur artist and has left some landscape drawings. In 1803, he was appointed Bishop of Exeter, and two years later became involved with the education of Princess Charlotte, the only child of the Prince Regent. It had become a regular habit with King George III to appoint bishops of Salisbury from among the men he had known and approved of at Windsor. When the see fell vacant in 1807 after the death of Bishop Douglas, Dr Fisher was chosen to succeed him. As Bishop of Salisbury, he was also Chancellor of the Order of the Garter. With this went an official residence in Windsor Castle (still known as 'Salisbury Tower'), which he used as a stopping-off point when travelling to London.

Whereas Fisher's predecessor, Bishop Douglas, had done nothing to

refurbish the Palace, Fisher did much to make it a more comfortable place to live in. He also enlarged the collection of portraits of his predecessors. One of Bishop Fisher's projects was to make the extensive grounds of the Palace more 'picturesque'. To achieve this, the Bishop had some of the trees cut down to open up views. He also removed the formal gardens between the Palace and the Cloisters (seen on Donn's map of 1797) **(3,16, p. 99)**. Summerhouses were built at each corner of The Close wall around the Palace grounds. All of these have now disappeared (the one at the south-east corner vanished under a concrete anti-aircraft gun platform built during the Second World War).

Bishop Fisher was the patron of several artists of differing talents, as can be seen by a list of artists who portrayed him: John Constable, James Northcote, George Dawe and J.J.P. Kendrick. Constable was as obscure as the last two have remained. He must have met Fisher for the first time in 1798 on one of his first visits to Dedham (at the heart of 'Constable Country' – Suffolk). In the autumn of 1811, Bishop Fisher invited him to stay at the Palace in Salisbury. In a later visit, Constable made a series of sketches of the Cathedral from the Palace grounds around 1820. From these sketches, the Bishop commissioned the painting *Salisbury Cathedral from the Palace Grounds*. This view of the Cathedral from the south-west is an enlarged version of the open-air oil sketch that Constable made of the scene. The result of Bishop Fisher's new landscaping can be clearly seen in Constable's view of the Cathedral where there is nothing but an open

3.13 *Salisbury Cathedral seen above the Close wall* by John Constable, 1829, View from the end of the central Marsh Close ditch, with the arch of the conduit to the Palace lake in the foreground (*The Fitzwilliam Museum, Cambridge*).

3.14 *Salisbury Cathedral from the Close* by John Constable, August, 1820. Framing
the left-hand side of the picture is part of Bishop Beauchamp's building containing
the Chapel. The east window of the Chapel is just visible at the extreme left. In the
centre is just a glimpse of the wall of the cloisters with a more substantial aspect of the
Chapter House appearing through the trees. The building at the extreme right now
no longer exists. The estate map of 1827 shows a stable block here, later demolished
and replaced by Bishop Denison (*Victoria & Albert Museum*).

green between the viewer and the south wall of the Cloisters. Constable
introduced into the composition the figures of the Bishop pointing out
the spire of the Cathedral to his wife: another figure, presumably one of his
daughters, is advancing along the path towards them under a parasol. These
were regarded as good likenesses. John Fisher, Archdeacon of Berkshire
and the Bishop's nephew, wrote to his wife on 4 June 1823, 'Constable has
put the Bishop & Mrs F. as figures in his view very like & characteristic'.
Constable was pleased with the result and thought his patron was too. He
wrote to Fisher after the opening of the Royal Academy exhibition on 9
May saying,

> My Cathedral looks very well. Indeed, I got through that job uncommonly
> well considering how much I dreaded it. It is much approved by the

3.15 *The Bishops' Palace, Salisbury* by Joseph Mallord Turner, *c.*1795. One of a set of ten watercolours commissioned by the historian, Sir Richard Colt-Hoare of Stourhead. This part of the Palace is very difficult to paint without ending with a line of buildings that are plunged into gloom. Turner gets around this problem by allowing a shaft of midday sunshine to break across the central area of the Palace (*Higgins Art Gallery, Bedford*).

> Academy and moreover in Seymour St. [that is, by the Bishop and his family] though I was at one time fearfull it would not be a favourite there owing to a dark cloud–but we got over the difficulty…It was the most difficult subject in landscape I ever had on my easil. I have not flinched at the work, of the windows, buttresses, &c, &c, but I have as usual made my escape in the evanescence of the chiaroscuro.

Constable was rather optimistic in his belief that the Bishop was unreservedly in favour of his rendering of his cathedral. The 'dark cloud' to which Constable refers had been part of the original sketch, and he had carried it into the large version as an atmospheric feature, which gave movement and contrast to the scene, in accordance with his views on landscape. The Bishop, whose taste had been formed in the late eighteenth century, did not agree. Fisher reported his continuing objections to the artist in a letter of 16 October 1823: '[If] Constable would but leave out his black clouds! Clouds are only black when it is going to rain. In fine weather the sky is blue' **(3.12)**.

About a month after the Academy exhibition of 1823 had closed, the Bishop wrote to Constable to say that his daughter Elizabeth was to get married. She wanted a recollection of Salisbury in her London house: 'I mean, therefore, to give her a picture, and I must beg of you either to finish the first sketch of my picture, or to make a copy of the small size. I wish to have a more serene sky'. In the picture, as it emerged from all this repainting, the light comes from behind the spectator on the left, and with the light blue sky and white clouds behind the spire. In the context of the gift, it may be assumed that the single figure advancing along the path towards the Bishop and his wife is that of Elizabeth Fisher, the bride to whom it was to be given. The Bishop continued to object to the sky in his own version, and it was returned to Constable's studio for alteration. Rather than repaint it, the artist decided to make a full-scale replica with a sunnier sky and incorporating the other changes for which the Bishop asked. This new version was not finished until after Bishop Fisher's death in May 1825. When it was ready in the following year, Constable sent the new version to his widow. He then sent the first version to his friend, Archdeacon Fisher (Bishop Fisher's nephew). Acknowledging the safe arrival of the picture, Fisher wrote: 'The Cathedral looks splendidly over the chimney piece. The picture requires a room full of light. Its internal splendour comes out in all its power, the spire sails away with the thunderclouds. The only criticism I pass on it, is, that it does not go out well with the day. The light is of an unpleasant shape by dusk.'

In *Salisbury Cathedral from the Palace Grounds*, The Bishop and his wife are shown standing on a small footbridge near to the Palace wall on the western edge of the 'canal'. This little bridge spanned a ditch that led to the 'canal' running across the south of the Palace (see Naish's map, (**3.3**, p. 85) and the estate map, 1827, (See **7.5** p. 162), the end of this watercourse can be seen at the bottom right of the picture. The 'canal' was fed from the River Avon on the west of The Close via large ditch that spanned Marsh Close and passed under the Palace wall by a conduit. This ditch no longer exists, although some remains of the old conduit to what later became the Palace Lake have been found in recent times. In 1820, Constable made a small painting on Marsh Close that shows the entry point of the conduit that went under the Palace wall. The top layer of stones in the picture can still be seen to this day next to the walk leading to Harnham Gate (**3.13**).

Constable made several paintings and sketches in and around the grounds of the Palace. In 1820, he painted the south-east view of the Cathedral from the forecourt of the Palace. It is interesting to compare the picture with that made about 20 years earlier by J.M.W. Turner of the north front of the

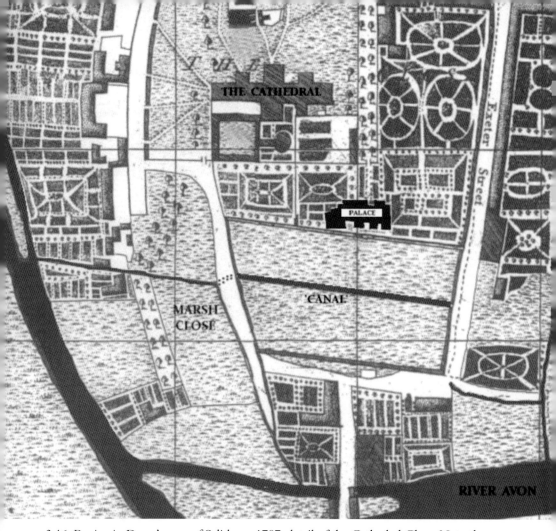

3.16: Benjamin Donn's map of Salisbury, 1797: detail of the Cathedral Close. Note the ditch crossing Marsh Close, taking water from the River Avon to the Palace grounds. Here the water passes under The Close path and the Palace wall via a conduit and then into the 'canal' crossing the area to the south of the Palace. This drained into the Avon via a ditch shown at the bottom south-east corner of The Close wall. Also of note are the elaborate gardens to the east and west of the Palace. Benjamin Donn, sometimes spelled 'Donne' (1729-98), was a cartographer, surveyor, and mathematician.

Palace. Oddly, the two pictures are at variance with contemporary criticism of the two artists, in particular the opinions expressed by John Ruskin. He disliked Constable's gloomy skies, and praised the bright optimism of Turner's paintings. The two pictures from the Palace forecourt seem to reverse this idea! Constable's picture shows the Cathedral in brilliant light, the sky showing no gathering storm. Turner's buildings seem that much darker, especially in the foreground, by the contrast between the north front and the sunlit courtyard (3.14 and 3.15).

4

The Palace in the nineteenth century

The Palace became a much-loved family home in the Victorian era. No pictures could sum up that tranquility better than William Gray's painting of the south side of the building **(4.1)**.

Princess Victoria's visit to the Palace, 1819

Prince Edward, Duke of Kent and Strathearn (1767-1820), was the fourth son of King George III **(4.2)**. He married Princess Victoria of Saxe-Coburg-Saalfeld in 1818. They had one child, Princess Alexandrina Victoria of Kent. The Duke and Duchess sought to find a place where they could live inexpensively, considering the Duke's great debts. After the coast of Devon was recommended to them, they took a lease on Woolbrook Cottage in Sidmouth. In 1819, the Duke and his family travelled to Sidmouth, where they intended to spend the winter for the Duchess's health. The Duke with the Duchess and their little child (now seven months old) were glad to break their journey at Salisbury on 20 December 1819, where they stayed for two nights at the Palace with the Duke's old tutor and devoted friend, Bishop John Fisher. The now aged Bishop must have been extremely pleased to see the great happiness of the Duke and Duchess. It was his delight to take the little child into his arms, and to toss her in the air, to the detriment of his powdered wig, which once little Victoria clutched so vigorously that she not only pulled it off his head, but with it came a lock of the poor man's hair! She slept in one of the large bedrooms (today a classroom), named in her honour 'The Queen's Room'.

After Christmas at Sidmouth, 1820, the Duke and his secretary, Captain Conroy, went for a walk in the rain. On his return to the house, in his

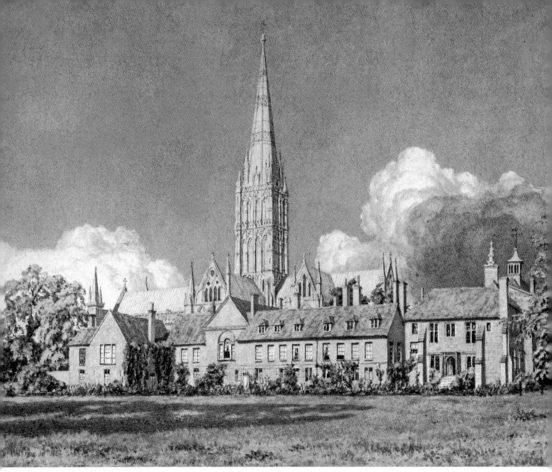

4.1: *The Cathedral with the Bishop's Palace*: watercolour by William J. Gray, 1842.

wet boots, he sat playing with his baby daughter until it was time to dress for dinner. The following day the Duke awoke with a fever, which led to pneumonia and he died ten days later at his Sidmouth cottage. The Duchess left Sidmouth and, after breaking her journey at Ilminster, reached Salisbury. Here she was glad to be able to rest at the Palace for a couple of nights, and to avail herself of the loving consolation and help of her husband's dear friend. The body of the Duke reached Salisbury in early February. It was brought into the Cathedral, where the Cathedral clergy and choir received it in state. He died only six days before his father, George III, and less than a year after his daughter's birth. The Duke of Kent predeceased his father and his three elder brothers, but, since none of his elder brothers had any surviving legitimate children, his daughter succeeded to the throne on the death of King William IV as Queen Victoria in 1837. On his appointment as Bishop of Salisbury in 1885, Bishop John Wordsworth was presented to Queen Victoria at Balmoral. He reminded the Queen that she had once been a visitor to the Bishop's Palace. She immediately agreed, though she could not recollect it, which was hardly surprising as she had been an infant

in arms at the time of her visit. However, she was able to tell the Bishop the main details of how she and her parents came to be at the Palace and the tragic event of her father's death so soon afterwards **(4.3)**.

Bishop Walter Kerr Hamilton (1808–69, Bishop 1854–69)

Walter Kerr Hamilton was the son of the Venerable Anthony Hamilton, Archdeacon of Taunton **(4.4)**. In 1837, he became chaplain to his friend, Bishop Denison and in 1841, he was appointed as Precentor and Canon-Resident of Salisbury Cathedral. 1853 saw the publication of his hugely influential pamphlet on Cathedral reform. He married Isabel Lear, a daughter of Francis Lear, the Dean of Salisbury. It was a very happy marriage and they were blessed with eight children. On the death of Denison, Hamilton was appointed Bishop and continued his predecessor's episcopal reforms. He increased the number of confirmations and raised the standard of ordinations. He also founded the Theological College at Salisbury. In the administration of the Diocese, he secured the respect and affection both of the clergy and of the laity, even of those who differed from his high-church opinions. Bishop Hamilton was a tall, rather portly man, with a pleasant countenance and winning manners. He was always prepared to give a warm welcome to all who called upon him at the Palace. He disliked ostentation, but he was

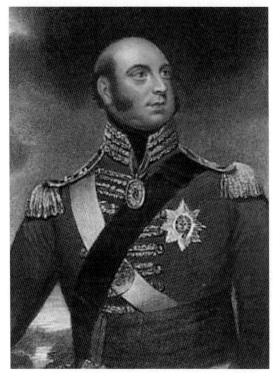

4.2: Prince Edward, Duke of Kent & Strathearn: engraving by William Skelton, 1815.

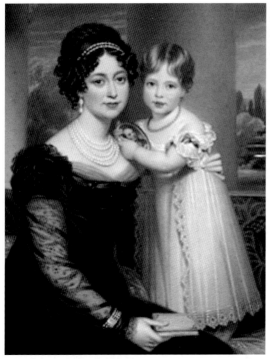

4.3: The Duchess of Kent &
Princess Victoria (later Queen
Victoria): print based on por-
trait by Sir William Beechey,
1821.

constantly happy to offer hospitality to all, even at great personal expense.

He was the Bishop not only of the upper classes, but also of the poor. He felt that they had a first claim upon the clergy, and that the aristocratic nature of so much of the Church of England was something of a misfortune; he was to make the poor one of his main responsibilities. An example is the 'Epiphany Dinner' that was held every year at the Palace as near as possible to the Feast of the Epiphany. About 100 people were invited, having been selected by the clergy of the various parishes in the city from among the poorest of their flocks. The dinner consisted of roast beef with all the 'trimmings' and plum pudding. The Bishop and his family looked forward to waiting upon their guests on this occasion as one of the pleasures of Christmas-tide.

Bishop Hamilton was never absent from Salisbury, except on diocesan business or for a short holiday in the late autumn. His life at Salisbury was marked by a regular routine. He generally attended the early morning prayers in the Cathedral at 7.30a.m.; he then read until 8.45a.m., when prayers were said in the Palace Chapel. This was followed by breakfast, after which the Bishop was continuously occupied until the afternoon service in the Cathedral, either in interviews or correspondence with his clergy. When the service was over, he often paid visits, or took a short ride or country

walk; but after dinner, he would again frequently retire to his study and read or write until 10p.m., when prayers were again said in the Palace Chapel. Afterwards he disappeared, sometimes to rest, but more often to read and write again until a late hour. No one could be a visitor at his Palace without feeling it was the home of a pastor of the Church of England rather than the house of an English nobleman. His conversation at table, in his study, or during walks, was always centred on the one interest of his heart and thought. His actions, even when their motives were not apparent to all, were regulated by the total conviction of his duty to God and to his diocese.

His expenditure was conducted on the same principle, often leading people to think that he cared little about the social aspects of his position. In order to increase the comfort of his servants, he laid down asphalt throughout the whole of the ground floor. He restored the ancient bell-turret to the Palace Chapel and always hoped to do something towards beautifying it. During the year before his death, some friends erected in there a reredos to the memory of his brother-in-law and chaplain, the Rev. Sidney Lear. There were vague intentions of filling the windows with stained glass and of decorating the bare south wall of the chapel with a fresco. Unfortunately, these plans were never carried out.

Bishop Hamilton was greatly influenced by the work of John Keble, in particular his *The Christian Year*. In fact, Keble was his great living ideal of

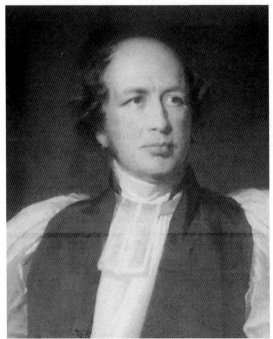

4.4: Bishop Walter Kerr Hamilton by George Richmond R.A., *c.* 1860.

4.5: Anthony Trollope in the 1870s.

saintliness. The book was one of the two studies by which Bishop Hamilton's mind and character were chiefly formed, the other being Wordsworth's poems. To him, as to Wordsworth, nature was a great mystic parable: he recognised and felt her strange, undefined powers. It is an interesting coincidence that there are links with Bishop Hamilton's next two successors: Bishop Moberly was a close friend of Keble, and Bishop Wordsworth was the poet's direct descendant. Bishop Hamilton saw much less of Keble than might have been anticipated from the fact that he lived at Hursley, a village no great distance from Salisbury. Three days after Keble's death at Bournemouth, the Bishop's Easter sermon in Salisbury Cathedral, revealed to the Diocese something of his sense of the blow that had fallen upon himself and upon the whole Church of England. On 6 April, in the churchyard of Hursley, the Bishop of Salisbury wept like a child at the grave of Keble. This 'immeasurable loss', as he deemed it, coloured his whole thought and action, and appeared permanently to depress him during the remainder of his active life.

The first symptoms of Bishop Hamilton's last illness showed themselves just before Easter 1868, during a walk in the neighbourhood of Salisbury. He became breathless when mounting Harnham Hill and the difficulty of breathing was accompanied with 'strange feelings unlike anything he had ever felt before in his life'. The Bishop was informed that the illness was based on a weakness of the heart and it was suggested that he should rest and not exert himself too much. However, his health did not improve and the

weakness and depression appeared to gain upon him day by day. Following treatment by his doctors in London, he returned to Salisbury. Here, in his beautiful home, within the sight of the spire of his cathedral, he died on 1 August 1869.

Anthony Trollope (1815–82)

Trollope was one of the most successful, prolific and respected English novelists of the Victorian era **(4.5)**. He first visited Salisbury in 1851 and, as he says, 'stood for an hour on the little bridge in Salisbury, and had made out to my own satisfaction the spot on which Hiram's hospital should stand.' The bridge was Harnham Bridge, and the hospital he was looking at was St Nicholas' almshouse, which he made the centre his first Barchester novel, *The Warden*, published in 1855. It is worth looking at some extracts from Trollope's *Barchester Towers,* the second of the Barset novels, published in 1857, to see how well the descriptions of Bishop and Mrs Proudie's Palace match up with the Palace at Salisbury: in chapter 5, 'A Morning Visit', he writes:

His lordship was at home, and the two visitors were shown through the accustomed hall into the well-known room, where the good old bishop used to sit. The furniture had been bought at a valuation, and every chair and table, every bookshelf against the wall, and every square of the carpet, was as well known to each of them as their own bedrooms. Nevertheless, they at once felt that they were strangers there. The furniture was for the most part the same, yet the place had been metamorphosed. A new sofa had been introduced! A horrid chintz affair, most unprelatical and almost irreligious; such a sofa as never yet stood in the study of any decent high-church clergyman of the Church of England. [It had become the custom for the incoming Bishop of Salisbury to purchase the contents of the Palace from his predecessor].

Our friends found Dr Proudie sitting on the old bishop's chair, looking very nice in his new apron. They found, too, Mr Slope standing on the hearthrug, persuasive and eager, just as the archdeacon used to stand; but on the sofa they also found Mrs Proudie, an innovation for which a precedent might in vain be sought in all the annals of the Barchester bishopric! Dr Grantly without much ceremony he turned his back upon the sofa, and began to hope that Dr Proudie had found that the palace repairs had been such as to meet his wishes.

'Yes, yes,' said his lordship; upon the whole he thought so-upon the whole, he didn't know that there was much ground for complaint; the architect, perhaps, might have – but his double, Mr Slope, who had sidled over to the bishop's chair, would not allow his lordship to finish his ambiguous speech. 'There is one point I would like to mention, Mr Archdeacon. His lordship asked me to step through the premises, and I see that the stalls in the second stable are not perfect.'

'Why – there's standing there for a dozen horses,' said the archdeacon.

'Perhaps so,' said the other; 'indeed, I've no doubt of it; but visitors, you know, often require so much accommodation. There are so many of the bishop's relatives who always bring their own horses.'

Dr Grantly promised that due provision for the relatives' horses should be made, as far at least as the extent of the original stable building would allow. He would himself communicate with the architect.

'And the coach-house, Dr Grantly,' continued Mr Slope; 'there is really hardly room for a second carriage in the large coach-house, and the smaller one, of course, holds only one.'

The Palace coach house and stables had been built in 1843 during the period of Bishop Denison. Whilst being substantial buildings, they would not have been large enough to accommodate the large number of horses that the Proudies seem to want. Nor would the coach house have been able to cope with more than one substantial coach.

In chapter 10, 'Mrs Proudie's Reception', we read about the preparations for the Proudie's first great party at the Palace:

There were four rooms opening into each other on the first floor of the house, which were denominated the drawing rooms, the reception-room, and Mrs Proudie's boudoir. In olden days, one of these had been Bishop Grantly's bedroom and another, his common sitting room and study. The present bishop, however, had been moved down into a back parlour, and had been given to understand that he could very well receive his clergy in the dining room, should they arrive in too large a flock to be admitted into his small sanctum. He had been unwilling to yield, but after a short debate had yielded.

The layout of the south range of first-floor rooms in the Palace matches this description perfectly. The entrance from the landing at first-floor level on the western staircase leads to a succession of rooms, all of which have inter-connecting doors. These lead eventually to the Anteroom with ornate Corinthian columns framing the large entry doors into the grand Drawing Room (the Aula). There are a number of rooms on the ground floor that would have allowed Bishop Proudie a 'small sanctum'. The Dining Room then was situated in the remote west wing; far enough to keep such lower clergy well away from the more distinguished visitors! Trollope continues:

Mrs Proudie's heart beat high as she inspected her suite of rooms. They were really very magnificent, or at least would be so by candlelight; and they had nevertheless been got up with commendable economy. Large rooms when full of people and full of light look well, because they are large, and are full, and are light. Small rooms are those which require costly fittings and rich furniture. Mrs Proudie knew this, and made the most of it; she had therefore a huge gas lamp with a dozen burners hanging from each of the ceilings.

When standing in the Big School Room today, it is easy to imagine this as the magnificent centrepiece of Mrs Proudie's reception. A scene so perfectly planned, but so quickly shattered by the sofa and the torn dress that ends the tussle between Mrs Proudie and the Contessa Vincineroni! One of the huge ceiling gas burners can just be seen in the 1939 photograph of the Aula in Chapter 1 (See **1.2** p. 38).

There is a further interesting reference to the Palace in the last of the Barchester novels, *The Last Chronicle of Barset* published in 1867. In chapter 66, 'Requiescat in Pace', Mr Thumble, a local clergyman, was sent to the rather distant Hogglestock at the command of Mrs Proudie to take the services there in the place of the curate, Mr Crawley, who was accused of the theft of a cheque:

> Mr Thumble returned to Barchester that day, leading the broken-down cob; and a dreadful walk he had. He was not in a good humour when he entered the palace yard. Here the footman from the palace told him he was wanted. It was in vain that Mr Thumble pleaded that he was nearly dead with fatigue. John was peremptory with him, insisting that he must wait first upon Mrs Proudie and then upon the bishop. Mr Thumble might perhaps have turned a deaf ear to the latter command, but the former was one which he felt himself bound to obey. So he entered the palace, went up a certain small staircase which was familiar to him, to a small parlour which adjoined Mrs Proudie's room, and there awaited the arrival of the lady. That he should be required to wait some quarter of an hour was not surprising to him; but when half an hour was gone, he ventured to ring the bell. Mrs Proudie's own maid came to him and said that she had knocked twice at Mrs Proudie's door and would knock again. Two minutes after that she returned, running into the room with her arms extended, and exclaiming, 'Oh, heavens, sir; mistress is dead!' Mr Thumble, hardly knowing what he was about, followed the woman into the bedroom, and there he found himself standing awestruck before the corpse of her who had so lately been the presiding spirit of the Palace.

This extract indicates that Trollope was very well acquainted with the Palace. On entering the doorway in the East Tower, there is a small spiral staircase in the hallway beyond. This led directly to the bedrooms above. On the first floor, there are two inter-connected rooms. If we imagine the one leading from this tower spiral to have been Mrs Proudie's parlour, then the one leading from it would have been her dressing room. From this, there is a direct access to the great staircase installed by Bishop Seth Ward, as well as a door to Mrs Proudie's bedroom. The same pattern of rooms is repeated on the floor above.

Bishop George Moberly (1803–85, Bishop 1869–85)

George Moberly was educated at Winchester and Balliol College, Oxford **(4.6)**. After a distinguished academic career, he became Headmaster of Winchester College in 1835. After 31 years, he retired to the Isle of Wight. However, in 1869 the Prime Minister, William Gladstone, asked him to take up the post of Bishop of Salisbury. Despite being 66 years old, he accepted it. He followed on from the traditions of his predecessors, Bishops Hamilton and Denison, his chief addition being the summoning of a diocesan synod.

The Palace now became the centre for a truly typical upper-class Victorian family. Bishop Moberly and his wife had fifteen children, all of whom lived beyond childhood, and 41 grandchildren. It is easy to imagine that the Palace must have been swarming with Moberlys during family reunions! We are fortunate to have some very useful eyewitness accounts of the Palace and the life of the Moberly family. The bishop's daughter, Charlotte Anne (known as 'Annie'), collected these in a book that has become a Salisbury classic, *Dulce Domum,* published in 1911. In 1869, she wrote:

> The drawing room is a delicious room, 60 feet long, but not a bit too big. There are three large Queen Anne windows, at the two ends and on one side. At the north end, there is a beautiful view of the Cathedral standing on the green shaven lawn with large cedar trees in front, and above them, the spire rises in great peace and dignity into the blue sky. ...
> The house is large, with long passages, and at one end is an old oak double staircase having two open landings. Before the floors were put in, it formed one side of the original entrance hall.
> The Palace is a strange house of broad stairs and long passages, the great drawing-room a huge place, with three doors and three enormous windows, but charming ones - one looking on the spire, one over the garden, one across the paddock and pond to the green hill; not an atom of town to be seen. The north and west ones always full of choice plants, among which may specially be remembered the delicate iris.
> Dusty and fusty was that big room at first, but it must be confessed that the shading of the dust in the corner of the ceiling, totally undisturbed, was so softly graduated that if one had not known it to be sheer dirt one would have called it admirable. ... Over the fireplace was the peculiarly hideous portrait of poor good George III in the robes of the Garter. But his red bluff face and white feathers recall many a delightful association! The room became thoroughly home-like and characteristic with all the dear old properties - the emu's egg set in silver, the piano, the well-known chairs, and the tables loaded with all the books one wanted to read, and the special corners for conversation; by the fireside-one delightfully situated between the hearth and the Bishop's arm-chair, a nook for a daughter to nestle in and be caressed. The easy chair on the other side was a place for all sorts of discussions, from the Revision to the last joke! Mrs Moberly's chair was on the other side, and there were many delightful conversations with her. The good times were the lingering

4.6: Bishop George Moberly in 1880.

after breakfast, sometimes a space before and after the early dinner, the five-o'clock tea, and the evening.

Annie Moberly clearly depicted the Palace as a family home. This is how she described Bishop Moberly's Golden Wedding celebrations at the Palace on 22 December 1884:

This was the Golden Wedding day – a bright, beautiful winter's day. When our mother came to breakfast in her sitting-room she found her wedding-dress laid out over the sofa upon which she was to lie all day. As she lay on her sofa, looking flushed and a little tearful, letters and presents came showering upon her, and the Bishop, taking his wife's hand, said, in his arch way, 'Mary, will you marry me?' She laughed merrily, but answered, 'I am afraid I have no choice'. At teatime, the drawing room was arranged for a reception, and Dean Boyle and other friends came in. A wedding-cake, with the initials and dates 1834-1884, stood on the table, and the bride, obedient to orders, put the knife into it, and then deputed a son to finish cutting it. All the servants of the house and grounds, and every old servant who was within reach, came and shook hands with the parents and joined our party, whilst the Cathedral Choristers, clustering round the piano, sang 'Auld Lang Syne'; then, not wishing any one to break down, we told the choristers to sing Christmas carols.

My mother, who had not been into Chapel for some time, was well wrapped up and almost carried up the stairs for evening prayers, which were offered by a very large congregation. The Bishop clearly enjoyed the service greatly, and delighted in hearing the full chorus of his children

again in the hymn 'The King of Love my Shepherd is.' He was singing the tenor part himself, gazing meanwhile with his dim eyes at the dark east window opposite him.

In 1885 Annie described he father's last days at the Palace:

> During the spring of 1885, my father was perfectly well, but very feeble. ... On June 28th, my father became a little confused in his words, and was not able to go to church. The moment the afternoon service was over ... I sat with our invalid in the window, where he felt the air on his head. The Choristers were running about the field, and every now and then a boy's merry laugh was heard. My father smiled and said, 'The laughing of boys is a very familiar sound to me.'

> On Sunday morning, when the bell rang for service, the Bishop's Chorister came as usual to fetch him to Cathedral, passing under the open window with careful step to avoid making any sound on the gravel walk. From the room we heard the organ accompanying all the Services, the chanting, the hymns, his favourite anthem (Stainer's 'Lead, kindly light'). ... The great fugue of Bach's played as a voluntary, pealed out and came floating into the silent room. ... The lovely summer night came on again. Those of us who had ventured to go and rest for a time had joined the watching company by 4a.m. I remember the look of the dawn breaking, and the sky gradually brightening behind the spire into full daylight, and the feeling of the fresh morning air. What a glorious summer morning it was – the birds in full chorus, the sweet flowers and the colour of the blue sky. When the last, almost imperceptible, sigh came, Robert led the 'Nunc Dimittis'; this was the signal for the entire household to enter the room and join in the 'Te Deum' at the end of which George pronounced the Blessing. So he went forth with the blessing of all his children, which he had asked for just a week before.

Charlotte Anne ('Annie') Moberly (1846-1937)

During the last months of the Moberlys at the Palace, Annie had two experiences that show that she was especially sensitive to visions (4.7). The first was a week before her father died when she was going with one of her sisters to tea with some friends in The Close. As they were leaving the Palace garden, its great gates were thrown open, and the sisters saw two men carrying a coffin and who passed them, apparently on their way to the Palace. 'At the time it did not seem unnatural,' said Miss Moberly. 'Things never do.' However, she did wonder about it, as no one had died in the immediate neighbourhood. She spoke about it to the Misses Vaux with whom she was going to tea. These ladies immediately wrote it down and when the Bishop died a week later, they showed what they had written. The story of the 'Bishops' Birds' is a well-known local legend in Salisbury: to announce the death of a bishop, large white phantom birds, larger than

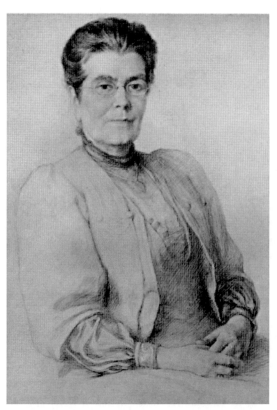

4.7: Charlotte 'Annie' Moberly (*c.* 1900): crayon drawing by Leslie Brooke (*Edith Olivier,* Four Victorian Ladies of Wiltshire *Faber & Faber, 1946*).

swans circle the Cathedral spire. An hour or two after her father's death Annie Moberly walked alone into the Palace garden, and there saw two great white birds, which rose from the ground before her. The spread of their wings was immense and their feathers dazzlingly white. They were unlike any birds she had ever seen, and she watched them fly over the Cathedral and disappear towards the west. At that particular time, she must have had too much on her mind to seek for evidence as to the appearances of these birds in the past; but she did not forget it and she collected all the stories that had come down from the previous century. Some years later, when she was on a holiday in Constance, she remembered that Bishop Hallam of Salisbury had died there during the Council of Constance in 1414. She hastened to the Mairie and examined the town records. Eventually she found the account of the dead bishop lying in state in the great hall of the town. There followed these words: 'then came the great sign of the birds'. She seemed to have found the original source of the legend of the Salisbury bishops' birds. The record said that a great flock of strange birds had then alighted on the roof of the hall where they stayed all night making harsh discordant cries. At morning, they vanished.

At the invitation of Miss Elizabeth Wordsworth, Annie Moberly took charge of St Hugh's Hall, Oxford. Miss Wordsworth was herself the first Principal of Lady Margaret Hall at Oxford and founder of St Hugh's Hall.

Bishop John Wordsworth (1843-1911, Bishop 1885-1911)

John Wordsworth was a nephew of the great poet (**4.8**). He was born into a clerical family: his father was to become Bishop of Lincoln; his uncle, the Right Reverend Charles Wordsworth, Bishop of Saint Andrews, Dunkeld and Dunblane; and his grandfather, the Revd Dr Christopher Wordsworth had been Master of Trinity College, Cambridge. He studied at Winchester College and New College, Oxford. From 1883 until 1885 he held concurrently the positions of Oriel Professor of the Interpretation of Holy Scripture and Fellow of Oriel at Oxford and a canon of Rochester Cathedral. In 1885, at the early age of 42, he was appointed Bishop of Salisbury.

The centre of his interest was his own home and its surroundings. A bishop has very limited authority within the walls of his own cathedral but, fortunately, Bishop Wordsworth was happy in his relations with successive deans and canons. The Bishop's sister, Elizabeth, has contributed a sketch of their home where, as she says, 'it was his fate, as it is that of many other Bishops who have beautiful and venerable abodes, to spend comparatively little time there': the following was quoted by E.W. Watson in his *Life of Bishop John Wordsworth* (1915):

> The Palace is a curious architectural patchwork, and illustrates what Ruskin said of the medieval builders, that when they wanted to make additions to, or alterations in, their houses, they just made them as it suited them, without any regard to symmetry. ... The north front of the house is somewhat unattractive, unless we people it with the events of some busy moments of arrival or departure-the Bishop's carriage and pair of greys, or in later days, his motor, waiting, usually until the last moment, while he has that final interview or hastily subscribes that one last note or letter! Then in all haste, he is whirled off to the railway station for the London train, or more likely to a church opening or confirmation at some remote point of the diocese.
>
> However, if the northern front of the house is somewhat forbidding, the southern more than atones for it. ...Among the windows that look out on the terrace and garden are those of the Bishop's study. If we had approached it from that side, we probably should have seen his head surrounded with a halo of light, feathery hair, and the big black-coated figure, with its back to us, bending over the writing table, a pile of books of reference on either side and the right hand hastily tracing in that familiar writing a few brief but carefully considered lines. Every bookcase was full to overflowing, but all was in careful order. ... The

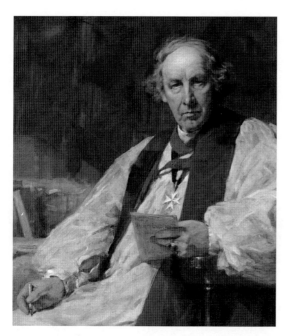

4.8: Bishop John Wordsworth: by Sir George Reid, 1905.

large central writing-table, an heirloom from Bishop Hamilton's days, having been a present to him from his uncle, 'Single speech Hamilton,' was covered with methodically arranged papers; and many more were carefully stowed away in receptacles under the table. A sofa faced the fire, probably occupied by a couple of worn leather travelling bags, which were generally primed with the literature or maps necessary for diocesan visits. Other interesting souvenirs were old-fashioned chairs that had belonged to Dr Pusey and Bishop Moberly. A cupboard full of pigeonholes, the gift of Mr Gladstone to Bishop Hamilton, was near the further door. On the top of the bookcase, facing the study chair was a bronze helmet with an archaic Greek inscription 'To Olympian Jove' which had belonged to the Bishop's father.

The drawing room, a large and handsome apartment, is, like the dining room, full of portraits of earlier bishops, most of them wearing the insignia of the Order of the Garter … .

The dining room [in the west wing], like the drawing room, extends the whole width of the house: in either case, one window overlooks the garden; the other gives an unforgettable view of the Cathedral spire and the Chapter House, with a foreground of rich turf and cedar trees. To the spectator's left, as he gazes through this window, is the door into the cloisters; the door, which in his last illness tradition says Bishop Hamilton saw in a dream, with our Saviour standing there and calling him in. Along the gravel walk which leads from the garden into the cloisters, the Bishop might habitually be seen at 7.25 every morning, when at home, on his way to early Mattins, and on Sunday at 10.30, preceded by a choir boy, known as the 'Bishop's Boy,' whose office it was to summon him. The black-robed figure with white sleeves and rochet and scarlet hood made a striking point of colour among the soft greens and greys of the garden

and the weather-stained architecture, especially when accompanied by
the boy in surplice, bareheaded, and with the ruff round the neck, which
is a distinctive characteristic of the Salisbury chorister **(4.9)**.

The Palace soon became like a home for the diocesan clergy and their
families, as well as for the many men and women who were devoting their
lives to the work of the Church. The happy home life was enlivened by the
light-hearted nature and sense of humour of Mrs Wordsworth. Life at the
Palace was very informal, and after some meeting or diocesan gathering,
those staying in the house would share in the high tea. Mrs Wordsworth
presided, at which she would often give a racy account (with plenty of fun
but never a word of malice) of what had been taking place, for the benefit of
the Bishop and others who had not been at the meeting. Many who came
to Salisbury to take part in diocesan meetings came to love the quiet services
held in the Palace Chapel, when it would be filled with guests and when at
times the Bishop would give a simple yet profound address upon the Gospel
for the week, or perhaps upon one of the lessons for the day. Those happy
gatherings at Salisbury were an untold help and refreshment to those who
took part in them.

The Bishop's day began with the plain Cathedral prayers at 7.30, when
his loud responses could be heard from the Trinity Chapel far down the
nave. He did not enjoy elaborate services. During a long *Te Deum* or
anthem, he could barely conceal his inattention. He kept a small library of
books of reference in his throne, and might be seen consulting, perhaps, a
Hebrew lexicon; or if his thoughts suggested something worthy of record,
there would be a struggle with his robes, his fountain-pen would emerge
and a note would be made. At the Palace, too, all was natural. There was
plain fare and silver plate and the tone of conversation was plain and natural
too. The ability to concentrate his whole attention on one subject at a time
to the exclusion of all else, enabled him to work with a thoroughness and
speed which left his subordinates far behind. He was not methodical in
his approach to his routine work. Although he frequently requested his
secretaries to tear up letters and papers, he rarely destroyed one himself, and
never attempted to sort them. Every return from a journey brought into
the study bundles of letters, important and unimportant, which had been
forwarded to him during his journey, to remain untouched, perhaps, until
another absence from home gave someone an opportunity to deal with
them. Accumulations of ancient correspondence of various dates were at
times to be found under every book or heap of books on the study table. In
later years, his secretary used to conceal letters concerning the more lengthy

4.9: Bishop's Palace, north front (1885), engraving by Joseph Pennell (*Mrs Shuyler Van Rensselaer,* Handbook of English Cathedrals, *Century, New York, 1895*).

extra-diocesan matters, when possible, until the more numerous but more easily disposed of diocesan letters had been completed. If the Bishop was first in the study, he had a perverse way of picking out the lengthy subjects, and leaving the secretary with no letters to write until a good part of the morning had passed. On the other hand, if one got him in a 'diocesan' frame of mind, a great pile of correspondence would be worked through in a wonderfully short time. Certainly, the diocese was not allowed to suffer because of outside interests. The very large part in the life at the Palace occupied by the services in the Cathedral and the Chapel, of course, affected all the routine work of chaplains and secretaries and others. The Bishop's genuine deep piety and his faith in prayer formed the basis of all work in the study of diocesan correspondence as well as work for the larger interests of the Church.

The Bishop's first wife, Susan, died at the palace in 1894. Two years later, he married Mary Williams of Bridehead House, Dorset. There were four sons and two daughters to this second marriage. The Bishop undertook three major foreign visits during his episcopacy, the first to New Zealand as he recovered from the death of his first wife and the others to Sweden in 1909 and to America in 1910. He died at the Palace on the 16 August 1911, working right up to the very end. Despite all of his great qualities as a

leading academic of his time, he will, perhaps, be remembered above all for his care for and love of children **(4.10)**.

Bishop Wordsworth's School

Three years into his term of office at Salisbury, Bishop Wordsworth inaugurated the Salisbury Church Day School Association. Salisbury had reached a time of educational and political crisis and the Association set about the task of raising the £14,000 necessary to build three new primary schools and to add an infants' department to the existing St Thomas' School, thus accommodating another 1,121 children.

A friend, Canon Woodall, remembering a conversation held some years before recalled: 'Some years ago...when walking with him on the site of the present St Mark's School he said 'I should like to see Salisbury a great

4.10: Bishop John Wordsworth, *c.* 1910.

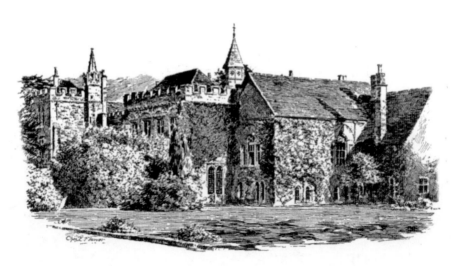

4.11: The Palace from the west: engraving by Charles Flower (*Edward Earle Dorling,* A History of Salisbury, *Nisbet, 1911*).

educational centre. I should like to found a school which shall be equal to the greatest and best of our public schools'.

The Bishop resolved to found his own school in The Close at a cost of £3,000, entirely at his own expense. A site of half an acre, adjoining the grounds of the Palace, was purchased from the Dean and Chapter. Building started in 1889. Bishop Wordsworth did not wait until the new school buildings were completed; he decided to start the school at once in the Palace. As the first Headmaster, he appointed Reuben Bracher. At 9a.m. on Monday, 13 January 1890, 45 boys assembled in the Undercroft. On 16 April 1890, the school building was ready and was dedicated by the Bishop himself. The school was known at the time as the 'Bishop's School', being renamed the year after the Bishop's death as 'Bishop Wordsworth's School' (the name it still holds). The school's motto *Veritas in Caritate* (Truth through Charity), remembered from his father's epitaph in 1885, survives him to this day **(4.11)**.

5.1: Bishop Frederic Ridgeway, 1920.

5

The end of the Palace as a bishop's residence

The nineteenth century had seen the Palace in its greatest use, mainly as a family home. In the following century, the problem arose as to whether the Palace could survive if the bishop had no large family to house. In addition, the huge staff needed to maintain the Palace and to serve the bishop and his family's needs could only be provided if the bishop had the requisite financial resources. Bishop Moberly had a staff of twelve indoor servants plus three gardeners and a coachman; Bishop Wordsworth employed ten indoor servants plus three gardeners, two coachmen, a groom and a gatekeeper. As the twentieth century progressed, the maintenance would pose an increasingly worrying problem for a bishop with no great personal wealth or income in an age when domestic service became increasingly more expensive.

The additional problem centred on the moral issue. Was it right for a bishop to occupy a building that symbolised the power and separateness of a great lord? This argument continues today within the Church of England. Some clergy believe the palaces send out the wrong image, and that the millions spent on their upkeep should be given instead to poverty-stricken parishes. At Salisbury, this problem later developed into a considerable debate. On the one hand, many argued that the Palace was a central and focal point for the community of the diocese and thus a natural and historic meeting place. The counter-argument was that the Palace was an out-of-date and expensive legacy of a past age and should be swept away to concentrate on more modern methods of communication to spread the ideals of the Christian faith.

The three bishops who occupied the See of Salisbury from 1911 to the

end of the Second World War all demonstrate the different aspects of these issues. Bishop Ridgeway did not have a large family to house nor did he possess a huge personal fortune. He preferred a much smaller residence and for much of his time at Salisbury he chose to live instead in a house he purchased at Broadstone, since he and his wife considered the Palace an intolerable place to live in. His arguments about the status of the Palace as a Diocesan centre will be described below. His successor, Bishop Donaldson, was a bachelor and only occupied the Palace after having been almost bullied into living in what he must have seen as a vast and uncomfortable residence. The whole problem concludes with Bishop Lovett. He had a substantial family and, in addition, there were large numbers of people living in the Palace during the Second World War. It provided a useful haven for evacuees and accommodation for some of the people posted to the area to do necessary wartime work. After the war, problems of finance would lead to the end of the Palace as a bishop's residence. Whilst this may have been something remarkable at the time, it would be an indication of the way in which many such palaces in England would change their traditional function. This transition continues to our own time as the debate over bishops' palaces continues.

Bishop Frederick Ridgeway (1848-1921: Bishop 1911-21)

Frederic Ridgeway was educated at Tonbridge School and Clare College, Cambridge (**5.1**). From 1890, he was the Vicar of St Peter's, Kensington, until his appointment as the inaugural suffragan Bishop of Kensington. He succeeded Bishop John Wordsworth as Bishop of Salisbury in 1911. As time went on, he found the administrative work an increasing burden. He wrote:

> It is not the spiritual work of a bishop that oppresses me. There is not too much of that. I look back with gladness to my suffragan days when I did the real work of a bishop, and little else. It is a different matter to be what a diocesan bishop is expected to be – an accountant, an ecclesiastical lawyer, a dilapidation expert, a sanitary inspector, an architect and builder, and an authority on drains.

The continual increase of a bishop's work-load under modern conditions caused Bishop Ridgeway to reflect with a certain degree of envy 'the calm, unruffled composure' of the bishops of former days as he looked at their portraits on the Palace walls. How could he fulfil all that was expected of him? One way of easing the administrative problems lay in hiving off a bishopric for Dorset. However, with the diminished income for the Salisbury bishopric that division would mean, as Bishop Ridgeway realised, the choice of future bishops would be limited to men with substantial

private means, especially if the Palace at Salisbury was to be retained as the episcopal residence. In addition, it would be very difficult to find the money to endow a Dorset bishopric. The Bishop's first concern was that the poorer benefices should be improved before anything involving expenditure was done to relieve his own financial problems. On the other hand, the wide extent of the diocese and the consequent long distances from the centre underlined the need for change. This meant that people could only attend meetings at Salisbury at the cost of much time and money, which some might not be able to afford.

On the question of bishops' palaces, generally, Bishop Ridgeway felt the matter centred round three points. First, would the poorer clergy gain if the bishop left his palace? If so, he was certain that no one would oppose the change. 'I will clear out of the palace tomorrow,' he said. This would lead to the sale of the Palace but such a sale would present great difficulties. At Salisbury, where the Cathedral stands partly in the Palace grounds, it was hardly conceivable that the house should pass into hands over which the Diocese could have no control. In this connection, the bishop was rather nonplussed when, in 1913, he was approached by an agency to purchase the Palace on behalf of a wealthy American. He replied that he might consider it if the offer would be extended to include the 'little church' in the garden!

Secondly, were bishops' palaces responsible for alienating people from the Church? 'Would the bishops, by leaving them, be removing a barrier between the Gospel and the masses? If so, then the bishops must clear out of their residences with the utmost speed.' He did not think it was so. As far as he himself was concerned, he had purchased a small house in Broadstone in Dorset soon after his arrival at Salisbury. He lived half the year there to make it easier to carry on his work in the area of Dorset. He was prepared to live the other half in a small house in Wiltshire. However, he feared that to substitute villas for palaces would only be pandering to an unreal demand. He felt that that the criticisms were founded on an excuse rather than on a genuine difficulty. Thus, it followed that, if the objection was met, another would take its place, since it emanated from those who were antagonistic, not to the houses, but to the cause for which they stood.

Thirdly, would the diocese gain? Not if, when the bishops' incomes were reduced – as they ought to be on removal to smaller houses – they should be reduced to a point that would make it impossible for them to maintain and increase their private benefactions to the poorer clergy, and numerous other donations and subscriptions. The power to give such help was one of the joys of a bishop's position, even if his private income was small or nothing. A new fund to fill the place of such donations would not wholly meet the

5.2: Bishop St Clair Donaldson c. 1930: artist unknown.

case, as no committee could ever know what the bishops privately came to know, and the personal touch would be lost.

There were other considerations too. Some 4,000 people had been welcomed to the Palace and its grounds every year before the war. With disposal of the Palace that would have to cease, and a break with the associations and traditions of 700 years could not be made without loss.

In short, his conclusion was that the objection to bishops' palaces was not widespread, representative, or entirely genuine, and he could not discover any compensating advantage which would justify the proposed change. Latterly, however, in his own case, he found himself obliged, on economic grounds, to decide to live in his smaller house at Broadstone for much of the time. It became necessary to find a suitable tenant for the Palace, but the end came before any arrangement had been made.

Throughout the First World War and in the difficult years that followed. the amount of work that he undertook was causing a noticeable decline in his health. In 1920, he decided, reluctantly, to take an extended holiday in the south of France. This did not work out well as the weather was not good. The journey home – fifteen hours in a hot and crowded train to Paris – put a considerable strain on his health. On reaching London, he was taken seriously ill. In the following days he grew rapidly worse and, on 4 May 1921, he died shortly before midnight. After a journey by road, the Dean received his body into the Palace Chapel at Salisbury with the cathedral clergy and the bishop's chaplains. The funeral service in the Cathedral was memorable, if only by reason of the presence of so large a body of clergy, some from distant and out-of-the-way places in Wiltshire and Dorset. The stately procession formed an unforgettable picture of uplifting dignity as, to the singing of *For all the Saints*, it wound its way slowly into the glorious setting of the sunlit cloisters where the Bishop of London performed the last rites.

Bishop St Clair Donaldson (1863-1935: Bishop 1921-35)

Bishop St Clair Donaldson was born in London, the third son of Sir Stuart Alexander Donaldson (**5.2**). He was educated at Eton (where he rowed in the eight) and at Trinity College, Cambridge. At only 41 years of age, he was chosen to be Bishop of Brisbane, was consecrated on 28 October 1904, and arrived at Brisbane on 19 December. During the following year the five dioceses in Queensland and New Guinea were formed into a province, and Donaldson became Archbishop of Brisbane. He interested himself especially in the development of the theological college, in religious instruction in schools, and in the founding of church schools. He gave attention to moral causes of industrial unrest and the 'inward spiritual significance of the Labour movement', and he offered to mediate in the 1912 Brisbane strike. He spoke strongly on the question of justice to the aborigines, urging that a large tract of land should be handed to them which whites should not be allowed to occupy. During his episcopate of seventeen years the number of clergy increased from 55 to well over 100.

Chapter 5

Following the death of Bishop Ridgeway, the Prime Minister, David
Lloyd George, offered the Diocese of Salisbury to Archbishop Donaldson.
He accepted the offer very reluctantly, and arrived in England in December
1921. The necessary legal preliminaries were completed in time for his
enthronement on St Thomas's Day (21 December). The ceremonies used
at Salisbury on these occasions have certain peculiar features not found
elsewhere. Outside the north gate of The Close, called the High Street Gate,
is a house, now used as a hairdresser's shop, which bears the name of 'Mitre
House', and is traditionally associated with Bishop Poore, the founder of
the Cathedral. Here in a small upper room the new Bishop is officially
introduced to his Chapter by the Archdeacon of Canterbury, and is then
conducted by them to the Cathedral. On entering The Close, he is met by
the choristers. The senior chorister then greets the new bishop in a Latin
oration, to which he replies in the same tongue. This is heard by many
critical ears, but Bishop Donaldson's speech was worthy of one who had
taken a First Class in the Classical Tripos at Cambridge (5.3).

The Bishop lost little time in taking up the question of his place of
residence. The Palace at Salisbury was a great contrast to 'Bishopsbourne' (the
residence of the Archbishops of Brisbane). The Palace was a pleasant place
to view by a casual visitor, but it was an unwieldy and costly dwelling for a
housekeeper to maintain. Considering the amount of ground covered, the
amount of accommodation was surprisingly small, providing comparatively

5.3: Latin speech of welcome to Bishop St Clair Donaldson, 1922.

126

Bishop Donaldson's welcome to The Close at Salisbury was described in the recollections of Clive Jenkinson, then a Cathedral chorister

Bishop Ridgeway was a small man who looked like an intelligent monkey and who always looked very ill. He made Norman de Gruchy the Bishop's Chorister in the Autumn Term of 1920. We all went to the Palace Chapel where the little Service was held. I remember seeing the Bishop once or twice in the Cathedral. Not long after he died, a new Bishop was appointed, St Clair Donaldson, who was Archbishop of Brisbane. He was duly welcomed by the Bishop's Chorister at the top end of Choristers' Green with a memorised Latin speech of welcome. I remember that de Gruchy got through it safely, but I remember even more vividly that some of the younger of us were most impressed to see what a real Archbishop looked like, but what made it more impressive was one who was a saint already! I was his Chorister four years later but I never dared to tell him. The Palace must have been a somewhat desolate place for a bachelor bishop and his Chaplain, even though domestic staff was easier to obtain then. There was one happy time when the Rogationtide procession, having been round The Close, went in through the Palace Gates and round the back of the Palace. A pair of vivid coloured pyjamas was hung over the veranda, which amused the Choristers. This joy was complete when two swans emerged from the lake and attacked the front of the procession. Ecclesiastical policemen are not well equipped for warding off angry swans, though Messers. Pearce and Thorne poked their verges at them. Fortunately Precentor Carpenter decided it was the proper time to sing something else and this, once we were properly started, soothed them, or frightened them.

few rooms. These were connected by intricate passages in which the experiences of guests are best described in the phrase of Milton, as 'finding no end in wandering mazes lost'. A gathering of ordination candidates, even in a quite moderate number, soon overflowed the space available, and the hospitable intentions of the Bishop of Salisbury had always to reckon with lack of rooms in which to give them effect.

Immediately after his arrival the Bishop discussed the question at the office of the Ecclesiastical Commissioners. Three courses were considered – to alter the Palace, to let it, or to sell it. The third proposal, it was felt, would meet with strong local opposition from many people in the Diocese, who looked to the Palace as a centre. Moreover, the selling of a house that is close to the Cathedral, if it is possible at all, can only be effected under conditions that would still leave it under the control of the Church. With these difficulties in view, Bishop Donaldson determined to investigate how the house could be altered and modernised to attract a possible tenant. If

that proved impracticable he speculated on the possibility of persuading the Ecclesiastical Commissioners to buy it, and let it to the County Council. A month later, he sounded his clergy and discovered considerable divergences in opinion. Many were convinced that diocesan opposition to a sale would be formidable. Archdeacon Dundas was a notable exception who predicted that, as the canons would soon be unable to continue to live in their great houses, one of them might very suitably hand over his house to the Bishop. The rural deans of the Diocese, the Bishop recorded in his diary, received his statement about the Palace 'with apparent friendliness, and no opposition'.

The Bishop's desire to find another home had deeper roots. He distinguished sharply between episcopacy and prelacy, and a Palace was, to his mind, a symbol of prelacy, suggesting that a Lord Bishop is aloof from both his clergy and the greater portion of the flock in his diocese. For a while he lived in two houses in The Close, firstly at no. 35, and then at 'Loders' in Rosemary Lane. However, eventually he felt compelled to accept the Palace. Leading laymen in the diocese offered no support to any scheme that would release the Bishop from residing in the Palace, and at an interview with the Ecclesiastical Commissioners he obtained only the cold comfort of being told, 'After all, the Palace is your Palace.'

The Palace was not only an official residence, it was also a home. There the Bishop was master of the house, and the manager of his staff, taking a deep interest in them, and on terms of friendship and affection with them. On their side, besides affection there was a reverence and respect, which lifted the life of the house on to a high level. Perhaps it was because of Donaldson's general shyness that it was those who lived closest to him who appreciated most his goodness and greatness of soul. The house must have had its worries and trials for him, but no one ever saw him put out or impatient. There was always the harmony of a real family feeling. Every morning he took prayers himself in the Chapel for the whole Palace staff. If it was possible, he reproduced something of the service to which he had been brought up in his old home, giving a little informal exposition of some passage from the Bible, and singing a hymn.

The Bishop played tennis on his private court at the Palace, in a pair of ancient and much-shrunk flannels. It was a delightful performance, for he was ambidextrous, and avoided all backhanders by rapidly changing his racket from one hand to the other. He threw himself so entirely into the game and enjoyed it so much, that it was a great pleasure to play with him. He continued to play until he was 67, when increasing weight made it inadvisable. He used to boast that he had beaten in a single a certain distinguished professor, very much his junior, who was staying at the Palace

for some lectures, 'but', he would add, 'he is the world's worst tennis player'.

He always went for long walks whenever possible and was not satisfied with anything under four miles. In his diary, he kept a record of his walks, with a note of the distance in each case. They were not anything in the nature of a grind to him, but, as with all that he did, they had to be thoroughly done. He would sometimes take a car to some distant point and walk home, though he regarded this as a concession to weakness. He liked to walk from one distant point to another, and so discover fresh scenery, but he did not often do this, giving a reason that was characteristic: 'I don't like to keep George [his chauffeur] hanging about; it spoils his afternoon.' For his age and build he was very vigorous and active. On his 65th birthday, he walked to Whiteparish, eight miles, in under two hours, and was proud of it. Just two days before his death, he took the car to Burcombe and walked back by the Race Plain, a distance of six or seven miles, with a long hill to climb at the start by the 'Punch Bowl'.

His humour was of the robust sort, and any misdemeanour into which a friend might inadvertently slip was certain to meet its just reward at the Bishop's hands, and he rejoiced when anything gave him an opening for chaffing his staff. A confused correspondent once addressed a letter to a chaplain with 'The Right Reverend XY ..., The Palace, Salisbury.' This was forwarded by a secretary to the Bishop, who was then at Lambeth, and came back with: 'Not yet, my boy,' in the Bishop's handwriting across the envelope. It was his habit to give full responsibility to those whom he trusted. Mr. Taylor 'farmed' the garden, and saved the Bishop endless worry. His journeys were left in the hands of George, who was expected to get him to his destination in time, in spite of desperately late starts. To his credit, that he always did so, thanks to his unremitting care of the car, which in consequence seemed to be immune from liability to breakdown. The household work was left in the tireless and capable hands of Miss Webb, and went like clockwork, which apparently never ran down. 200 people would have tea in the crypt after the Lent Lectures, nine or ten ordinands would stay in the house for the best part of a week, but the domestic machinery went smoothly on. This was fortunate for everybody, for the Bishop was always inviting people to the Palace for a rest. Some sick clergyman would come for a week to convalesce, or one who was on the verge of a nervous breakdown would pay a visit to recover his balance. Such visitors often spoke of the peace of the Palace, and peace there was, but it might be compared to the calm that is in the centre of a whirlpool.

Possibly the home of a bachelor Bishop was more of a diocesan house than it would otherwise have been. The Bishop himself had little time for

We have a rather different view of the Bishop and his Palace from the recollections of Stephen Clissold who went on to become a noted author and diplomat. In 1927 he was the Bishop's Chorister to Bishop Donaldson:

I later heard the theory that the Bishop's Boy was a survival of the picturesque custom of the Boy Bishop, but to me it seemed that he was in reality intended to serve only as a sort of Episcopal Page. It was his business to look out the tomes containing the anthem and the setting for the day's 'Te Deum' or 'Magnificat', mark the place with a velvet marker, and leave them conveniently but not too conspicuously by the Episcopal Throne. The Bishop's Boy had to precede the Bishop in procession at the beginning and at the end of every Service, or whenever His Lordship needed to move to the Pulpit or to the Lectern. Most important of all he had to fetch the Bishop from his Palace and escort him through the garden and Cloisters to the Vestry. This was the most interesting and remunerative of his duties. Ten minutes before Service began; he would arrive in the hall of the Palace. On the table, he would find a bowl containing a handful of delicious chocolates glittering irresistibly in their silver-papered splendour. These were his legitimate spoils of office. He would munch as many as he could before he heard the Bishop approaching, then he would deftly empty the remainder into his handkerchief and stuff them into his pocket before composing himself for the sedate walk back through the Cloisters. This rather undignified procedure was hallowed by custom. It dated back to the rough days when the Bishop's Boy would find a tankard of ale, instead of this bowl of sweets, awaiting him in the hall. So, if the Bishop happened to notice a trace of chocolate about his page's mouth, or the hurried adjustment of a surplice as he entered the hall, he would discretely let it pass. The Bishop's Boy, for his part, would have to exercise due restraint in not attempting to blow his nose until the precious cargo, often squashed to a sticky pulp after its journey, had been carefully removed in the boys' vestry, to await a leisurely disposal after Service.

social amenities. Occasionally there was a dinner-party, but it was usually to give the opportunity for meeting some distinguished guest, who was staying at the Palace. The Bishop was a delightful host, and liked entertaining people, but had little small talk to help things out, and social functions tired him more than a day's work. He would sometimes be found asleep in the midst of his guests after dinner, and would apologise profusely on awaking. He did not reveal the fact, which has become known to those who have seen his diaries, that his weariness was often due to persistent insomnia.

Sometimes the party at the Palace was of an international kind, as when it consisted of a young Indian professor, who was a student at Cambridge, a Japanese lawyer from the Temple, a Chinese medical student from Guy's, who knew more about English literature than some of the British present,

and a Japanese candidate for Holy Orders. These were all unknown to one another, and there was some speculation as to how they would mix, but from the start, there was no doubt about that, and when Christmas evening came they were all dancing in the servants' hall! The home party which delighted the Bishop most was the gathering at the Palace at Christmas time of young Australians from Oxford and Cambridge, many of them Rhodes Scholars. Some of these were in their first year at university, and the Bishop was anxious that they should feel that they had a home to which to go at Christmas. They brought a breath of young life into the old Palace. When the first party of this kind was held there was deep snow on the ground, and the ice on the Palace lake was thick enough for skating. Some of the guests had never seen ice or snow before, but this did not deter them from sliding and skating with such zeal that there were soon a number of casualties.

At the Palace, the Bishop's work began at 7a.m. or earlier, and would go on until eleven or twelve at night, with time off for a walk, when he could manage it. He often made journeys of 100, or 120 miles, with three or four engagements. From these he would return home at an hour when most people had gone to bed, and would cheerfully content himself with a few sandwiches in place of the dinner, for which he had had no time. He was very simple in his way of life. His bedroom was the smallest and least pretentious in the house. He had to be compelled to get new clothes, and would go about, if he was allowed to do so, in old favourites which were green and patched and threadbare. He was always anxious that luxury should be avoided in the Palace, and demanded that the food should be plain.

The one thing which Bishop Donaldson dreaded was going on with his work when he was no longer capable of it. He once said, 'Tell me at once, if you see any signs of failing power.' Such signs never showed themselves, for, up to the last, he worked with full vigour, and after his death, many wrote that never had he seemed to be more competent than in those last days. If he had any intimation of serious heart trouble, he did not tell anyone. He signed his will the day before his death, and he made a jest about it: 'Poor X knows that I have left him nothing,' he said at luncheon (X being there), 'because he had to witness the will!'

In his last meditations the day before he died, he wrote of death as 'the appearing of Christ which relieves us'. But if he was aware of any weakness he would not give way to it, but would go on as usual to the last, walk his five or six miles, be the life and soul of any company, be in his place in Chapel in the early morning, perform every duty with the utmost care. 'I am a bit tired, I'm off to bed. Good night chaps,' were his last and characteristic words. When the maid called him next morning she could get no answer.

Alarmed, she fetched one of his chaplains. The Bishop was half kneeling by his bedside and must have died some hours before. It was the end which he would have desired, and for which those who loved him could be thankful. He died on 7 December 1935.

Bishop E. Neville Lovett (1869-1951, Bishop 1936-46)

Bishop Neville Lovett was educated at Sherborne School and Christ's College, Cambridge (**5.4.**). He was ordained in 1892 and was appointed as the first Bishop of Portsmouth in 1927. This was the same year in which the Diocese was created and the new Cathedral consecrated. He had been associated with the ecclesiastical district which is the See of Portsmouth for many years and had held appointments in the Diocese of Winchester since 1898. He was married in 1894 to Evelyn Brock whose brother, Admiral Sir Osmond Brock, was Commander-in-Chief at Portsmouth at the time Lovett was appointed to the bishopric of Salisbury. He remained Bishop of Portsmouth for almost nine years. There is a school in Fareham, Hampshire, named after him – the Neville Lovett Community School – and there is also a Bishop Lovett School at Ryde on the Isle of Wight.

At the time of his wife's death, the Bishop had one daughter living with him. After she married in 1938 he faced a rather solitary life at the Palace, which would have only been occupied by domestic staff and (in working hours) his own staff. To ease this situation, Bishop Neville Lovett's daughter, Myra and her husband Tom Morony, came from their home in Winchester

5.4: Bishop Neville Lovett: portrait, artist unknown, c. 1939: contemporary copy in the Bishop's Palace, Salisbury; original in the residence of the Bishops of Portsmouth.

In 1946, following his retirementm Bishop Nevill Lovett wrote in a memoir:

From Lambeth I went to Salisbury to see there the historic house of the Bishops in long succession. I had indeed been in it when a lad of sixteen with my father. That occasion was for the evening party which was then part of the Bishop's hospitality when transport was less facile and the Diocesan Conference lasted two days. When I now found myself entering the same Drawing Room of the Palace it brought back to my mind that evening in 1883 when my father said to Bishop John Wordsworth, "This is one of my boys". The Bishop laying a hand on each of my shoulders said, "My boy, follow in your father's footsteps". It was queer after fifty years to find myself in the same room about to become an unworthy follower in the footsteps, never likely to be obliterated, of one of Salisbury's greatest Bishops, after having forty years previously been in my father's steps at Bishop's Caundle. When, in February 1936, I went over the old Palace my heart sank. Its façade had all the dignity and beauty associated with an old medieval building, but the empty rooms within seemed gaunt and unwelcoming.

Having viewed what was to be my future residence, I returned to beautiful and convenient 'Bishopsgrove' [The residence of the Bishops of Portsmouth] with a perplexed mind. I told my wife that I could not ask her to take control of such a house. She, however, insisted on losing no time to see it for herself. She, with a daughter, returned next day and with her clear and characteristic judgement, insisted that we could make the house a nice home. So, in due course, she made it a delightful home admirably adapted to social purposes provided always that sufficient domestic staff was available. This we found possible until the War in 1939 that cancelled out domestic service and rendered it extremely difficult and practically impossible to maintain sufficient domestic service in that house.

to live with him at the Palace. Myra Morony kept house for him and her husband attended to the accounts. She was a briskly efficient but unfailingly friendly and hospitable person. Tom Morony was much older than his wife and was not called up to fight when war broke out in 1939. Instead, he enrolled as an air raid warden. During the infrequent air raid warnings, he would be seen patrolling The Close and the High Street, clutching a formidable A.R.P. rattle.

Following the Munich Crisis in 1938, the Palace Undercroft was converted into an air raid shelter. Iron sheets were fitted across the windows and felt curtains provided across the doors. These curtains were a precaution against gas attacks. Buckets of water were provided to dampen the curtains should such an attack happen. There were air raid warnings in 1940, and

5.5: Bishop Neville Lovett in his office in the Bishop's Palace, *c.* 1946. This is probably the last photograph to be taken of a bishop while still resident at the Palace in Salisbury.

the residents of the Palace duly took shelter in the Undercroft. However, air raids on Salisbury were rare and it seems that this only happened twice.

During the Second World War, institutes were set up to give refreshment and some relaxation for troops on active service. The Church provided such institutes at the various camps. Three of them had originated during the earlier war and the Bishop now arranged to provide five more. An institute for the use of the Auxiliary Territorial Service (A.T.S.) and other members of the women's services was established in the grounds of the Palace. This was nicknamed the 'Palace Hut' and was of incalculable value in Salisbury. During the war, Queen Mary visited Salisbury and expressed much pleasure in looking in at the 'Palace Hut' and seeing the girls enjoying a little leisure. They, of course, were delighted with the honour of such a visitor and of the cheering words spoken by Her Majesty. During the war, the Bishop held services on Thursday evenings in the Palace Chapel for the A.T.S. stationed in The Close. The Chapel was generally full of those able to come. Regular services were held every morning at 8.15a.m. (except Sunday) in the Chapel. These services were attended by the family and household staff. At that time the pews were along the north and south walls – the family sat on the north side and the domestic staff in those on the south.

It was during the winter of 1945-6 that a dance was held at the Palace. Although Britain was only just starting on a long post-war period of austerity, the Moronys had turned the grand Drawing Room into a well-lit and festively decorated ballroom for the evening, with ample space available for a small band and 20 or 30 waltzing couples. That evening was to be a foretaste of fun and laughter to come, marking the end of the horrors of the Second World War. However, with the Bishop retiring in 1946, this dance was also a grand finale to the days when bishops and their families would reside in the Palace.

In 1944, Parliament passed the Episcopal Residences Act, under which the Ecclesiastical Commissioners (now the Church Commissioners) took over the episcopal residences and the income of the dioceses. That income was to be divided between a fixed salary for the bishops and all the official expenses incurred. At Salisbury, the Bishop found that the Palace was far too large for any reasonable hope of a domestic staff sufficient for it, except at an impossible cost. The continued occupation of the Palace was not a new one, of course, and had usually arisen at a change of bishops. Now, just at the right moment, the opportunity arose to transfer the episcopal residence to Mompesson House on the north-east side of The Close. Mompesson House is a perfect specimen of a Queen Anne house, 250 years old but in perfect order. It also had every modern convenience and as many bedrooms as the Palace, while the reception rooms were large and beautifully decorated. This move provided a most attractive solution. The Bishop would have a beautiful house with sufficient accommodation and with convenience for a small staff. He would also still be within the Cathedral precincts. The Commissioners very quickly fully agreed to this move and, with the warm approval of the Archbishop of Canterbury, it was immediately implemented **(5.5** and **5.6)**.

By chance, at that time (1944) the Central Board of Education issued a

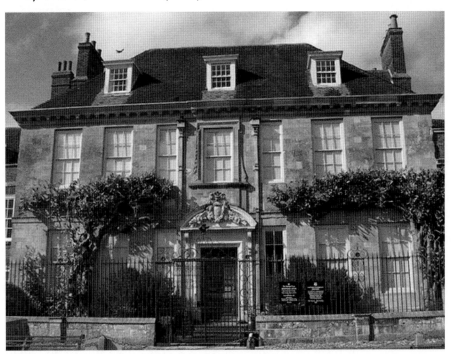

5.6: Mompesson House: the Bishop's residence from 1946 to 1951.

In January 1946, the Church Times carried the following report:

Mompesson House to become Episcopal Residence
The Bishop's Palace, Salisbury, will cease to be the home of the Bishop
of Salisbury after the retirement, on 31 March, of the present Bishop, Dr
E. Neville Lovett. It has been decided that Mompesson House, facing
the Choristers' Green in the Close, shall be the home of future Bishops,
and that the Palace shall be handed over to the Cathedral School. Many
times since his translation in 1936, Dr. Lovett has publicly referred to the
hardship of running the Palace and staff out of his official stipend and has
long been an advocate of smaller houses for diocesans. This new scheme
gives effect to his wishes. Principal authorities concerned in preparing
the scheme were the Ecclesiastical Commissioners, who own the Palace
(in common with all other Episcopal residences in the country), and
the Dean and Chapter, who are Governors of the Cathedral School, and
own all the property in the Close. As the Dean and Chapter will allow
Mompesson House to become the Episcopal residence, the Ecclesiastical
Commissioners as a quid pro quo have offered the Palace as the new home
of the Cathedral School. This change was sanctioned by the passing of an
Order in Council recently.
Though the Palace will be vacated by Dr Lovett and his family and staff at
the end of March, the School might not be in residence there for at least
a year. Any delay will depend on the expedition with which structural
alterations are carried out.
While there are at the moment 56 boys in the School, there is a waiting
list, and when the School is quartered at the Palace its strength will be
eighty. Choristers number about sixteen. The change will necessitate
extra baths and sanitation, and that is the principal works involved in the
alterations. No public statement has been made on the change.
The Diocesan Advisory Committee was asked whether in its opinion the
Queen Anne mansion known as Mompesson House in the Close would
be suitable for the residence of a Bishop. While sharing the general regret
that in the conditions of today a change is inevitable, stated the report of
the Committee issued yesterday, they could not but report, after viewing
the house, that it is well suited to become an Episcopal residence. It
appears that the Committee was not consulted on the future of Palace.

report that, such were the buildings and their condition of the Cathedral
School, that they could not recognise this ancient building as a School at all:
nor could anything be done to them to make them suitable for recognition.
The Bishop, therefore, put before the Commissioners the proposition that
the Dean and Chapter should take over the Palace to be the Cathedral
School. This would have the great advantage that the choristers' school
would remain under the control of the Dean and Chapter and be housed
on Church land.

5.7: 'Peaceful Party' – Bishop Lovett's grandchildren and wartime evacuees boating on the Palace lake. (Photograph by Sir Cecil Beaton in *The Sketch* – July, 1941)

It was believed that the Palace would be greatly improved by the changes to its structure that would be needed to convert it to a school. The outside of the old structure was remain unaltered; but the remodelling would open up the big doors in the East Tower. Certain partitions, when removed, would open up an arcade of pillars and arches in what was Bishop Seth Ward's Dining Hall, covered up in the eighteenth century.

6

The Palace as the home of Salisbury Cathedral School

The Palace today is the home not of bishops, but of Salisbury Cathedral School. The great change in the use came about in 1946-7. It has not been easy to adapt this magnificent old building to meet the changing demands of modern educational methods and the expansion of the School. Nonetheless, the buildings do have a deep, if quite unconscious effect on their young occupants – a 'feel' of timelessness and antiquity. Something now needs to be said about the history of this School whose core objective is to educate the choristers of Salisbury Cathedral.

Outline history of the School

Salisbury Cathedral School began life at Old Sarum in 1091. The first Cathedral choristers were educated to serve the new Cathedral created by the Norman administration some 20 years after the Conquest. The founder of the School was St.Osmund, nephew of William the Conqueror and Bishop of Salisbury. He simultaneously set up both a song school and a grammar school. The School gained its first royal charter from King Stephen in 1139.

After the completion of the new Cathedral in 1258, the choristers must have been moved to the new building to continue their duties and would have been lodged with various canons in The Close. Very soon, men, chiefly Italians, who had never set foot in this country and who were chosen by the Pope, were filling vacancies among the canons. By 1314, the choristers had no one to care for them and were reduced to begging for their food. Bishop Simon of Ghent made it his urgent business to put right this scandal by donating the rents of various shops in Salisbury for the care of fourteen choristers. His successor, Bishop Roger de Martival was able to carry on the

good work and, in 1319, he declared that the choristers were to be looked after by a warden who was to be a resident canon. In addition, the church of Preshute, near Marlborough, was appropriated and the tithes it received were used to support the choristers.

A new schoolhouse was built on Bishop's Walk (in the Cathedral Close). This was known as the 'Choristers' House' and had a practice room within it, referred to as the 'Song Room'. The School remained here for about 300 years. The senior boys were taught in the Chancellor's Grammar School (in Exeter Street) and the juniors by the 'sub-magister' in the Song Room. The Chancellor's Grammar School was closed in 1475. The Cathedral School itself now took on the work of educating all of its pupils, not only in music, but also in Latin. Christopher Benett was appointed as the first Head Master in 1554. The Chapter awarded him a house in The Close ('Braybrooke House') which remained as the residence of the Head Masters until 1947.

Following the Civil War and the execution of the King, Parliament disbanded the Church of England. The Dean and Chapter were expelled and with them went the choristers. The School, however, remained open and the Head Master, Arthur Warwick, continued to teach such pupils as came to the School. In 1660, with the Restoration of the monarchy, the Church of England was reinstated. At Salisbury, an entirely new choir was formed in the remarkably short time of just one year. In 1678, the Chapter put out a long series of injunctions to reform the system of education at the School. An excellent Head Master, Edward Hardwicke, was appointed. He held the post for 33 years and laid the foundations of the School's great reputation in the following century. Richard Hele was Head Master for an astonishing 50 years (1706-56). In 1714, the beautiful schoolroom, now known as 'Wren Hall' was built for the School. This remained the core of the life of the School for over 200 years. One of the School's greatest Head Masters, Dr John Skinner (1780-1801), built up its excellence so that it achieved national fame as a centre of learning.

In the early nineteenth century, the School's fortunes declined. John Greenly, once a naval chaplain and present at the Battle of Trafalgar, was appointed Head Master but much neglected his work. In 1854, the then Head Master, John Richards, was asked by the Cathedral Commission to give a report on the state of the school. He replied that the boarding accommodation was very confined and that the schoolroom was in need of renovation. However, the real problem was income. The Chapter organised a system of loans, which unfortunately failed, so the assistant master was dismissed, leaving Mr Richards to carry on alone. To make matters worse, the Chapter instructed him to take no more fee-paying boarders.

6.1: Laurence Griffiths, c. 1950.

Head Master George Bennett made marked improvements to the School leading to a rapid rise in educational standards. The first Old Choristers' Festival was held in 1890. That year Mr Bennett retired and Edward Dorling took his place. He was a keen and accomplished gardener and did wonders for the garden of Wren Hall. Games were introduced, especially cricket and soccer. At the turn of the century, Arthur Robertson was appointed Head Master. He guided the transition of the School into a modern preparatory school. He soon geared it to the Common Entrance Examination so that many boys could gain places at the public schools. His other great desire was to develop games but the only available ground was Choristers' Green, which was far too small. Marsh Close at the south-west end of the Cathedral had long been associated with the School. Earlier in its history, the School had been granted this large meadow as pasture for the choristers' cows. In 1901, Upper Marsh Close was converted into a more suitable sports' ground. The School held its first annual sports day here in 1902. As the number of pupils swelled, so extensions had to be made to Wren Hall. These were built in two stages, adding dormitories, classrooms, gymnasium and a sanatorium.

Owing to financial difficulties, cramped conditions and lack of facilities, the Cathedrals' Commission announced in 1927 that the School should be closed. If the School was to be saved, the only way out was to build another

141

extension to Wren Hall and the Chapter would not risk this when the cost was quoted. Instead, the School received the support of Bishop Donaldson, who approved the extra funding required. This extension was finished in 1928 providing extra boarding space as well as staff housing and further classrooms.

The move to the Palace:

Laurence Griffiths was appointed Head Master in 1933, and during the 26 years of his rule, the School went through many significant changes **(6.1)**. The most important of these was the move to the former Bishop's Palace. In November 1944, the Government Board of Education inspected the School. The inspectors described the existing accommodation as 'seriously inadequate; below standard in space, light and ventilation'. For example, a dormitory housed in an attic in the roof was considered completely unsuitable. Further, they remarked, the use of the living rooms in the Head Master's house as classrooms was obviously unsatisfactory. In reply to a question, they said they could not recommend the School as being approved for the purposes of the Fleming Report: this outlined how independent schools might be integrated into the state system (it was never implemented). It was the inspectors' definite opinion that it would be a useless waste of money to tinker with the present buildings.

Later that November, the Dean and Chapter agreed that, at some date to be settled later, the School should be removed to the Palace. The resignation of the Bishop took effect at the end of March 1946 and the governing body of the Cathedral School obtained possession of the Palace at the beginning of April. In the autumn of 1946, the School began to move across to the Palace. The Head Master reported to the Governors that, 'By the Autumn Term the number of boys had risen from 58 to 79. This has taxed our accommodation to the utmost and made the organization and administration very difficult. However, the consent of the Governors to the use of part of the Palace eased the position. We have ten boys sleeping there and a junior class in what was the bishop's study.' Laurence Griffiths nicknamed 1947 as the year of the 'Great Exodus'. At the beginning of the Easter Term (1948), the boys came back from the Christmas holidays to inaugurate the life of the School in the Palace.

Messrs Botham & Brown were appointed as the architects and drew up plans for alterations, which were considered essential. It was hoped that the alterations would be completed by the beginning of 1947. The fabric of the Palace would be untouched. Many of the rooms had been disused for some

Peter Hart, a Cathedral chorister in 1946, has written a re collction of this phase of the move:

When it came to mowing the grass at the Palace, we were paid sixpence an hour, and, believe me, we earned every farthing! After Bishop Neville Lovett left, there was no one to tend the Palace grounds. We picked a great deal of fruit in the kitchen gardens (where the new Classroom Block is situated). Most of the grass was left to grow, but Mr Griff wanted the grass around the Palace to be cut. The grass between the southern balustrade (i.e. the edge of Lovett field) and the building was long and the grass hard to cut. We used a blunt 14-inch mower and worked in pairs – one to push and the other to pull on a rope. We really sweated!

From September 1946 ten senior boys commuted to the Palace for sleeping, thus making space for ten more boarders at the old School. We slept in the two rooms on the first floor of the northeast wing. The four boys in the tower room were Derek Roberts, Hugh Woodhouse, Barry Salmon & me. We 'Palacites' were extremely lucky, for we were virtually unsupervised, and we had the run of the whole building. In our dressing gowns & slippers, we explored high & low – especially high. I recall walking along the roof-walk on the north side, and investigating the roof-space above the drawing room (the B.S.R.), where there were enormous gaslight fittings.

Wort & Way's men were making alterations to accommodate the school, and they left their plans in the present Head Master's study. I found these fascinating, and learned to read them. There were also electricity plans; I suppose the whole place had to be rewired. The biggest operation was on the Undercroft, which had been subject to regular flooding. They first dug the "moat" around the outside, and lined it. Then the whole of the floor was taken up, replaced and lined with bitumen: each pillar in turn had to be underpinned while they worked underneath it. I followed closely the progress of all the work, and the smell of fresh plaster still has a powerfully nostalgic effect on me.

time. This applied in particular to the east end of the Palace where part of the ground floor had become a store for fuel!

Ground floor

The large room beyond the East Tower that used to be the ground-floor area of Bishop Seth Ward's dining hall now became the changing room. All along its north side were showers and running from east to west were long benches with openwork screens holding pegs for the boys' clothes. Along the west wall were toilets in wooden box compartments: at the far end of these compartments was a washing machine. The east wall was lined with washbasins and the drinking fountain. Unfortunately, this was not a satisfactory arrangement. The room had a low ceiling and no extractor fans.

The result was that, on a winter games afternoon, the whole room became a noisome, steamy hell! Imagine the scene with, say, 80 boys, all arriving, sweaty and rain-soaked, from mud-laden rugby pitches. They all needed to change, shower, and talk to each other at the highest volume possible! Fortunately, in the 1970s, a new changing room was constructed as part of the new classroom block and this truly horrible room was later extensively altered. As it is today, most of the area has been cased around with new dividing walls within which are a common room, a locker-room and the accountant's office.

Beyond the changing room the next two south-facing rooms, opposite to the central entrance door, were used as classrooms. However, as the School continued to grow, they were just not large enough to accommodate increased class sizes. Today these rooms are the Bursar's office and the Head Master's study. The original Head Master's study was located in what was Bishop Barrington's entrance hall below the Chapel. It was created by constructing a very ugly screen to separate it from an anteroom for the School Secretary. This huge room and its anteroom were later converted into the music room with a lobby, as it remains to this day.

The architects' original proposal was that the Undercroft should become the kitchen area, with its service rooms in the area to the south-west of the Undercroft. This would have meant building an extension to house these rooms. Such an extension would not be permitted by any of the planning authorities. The architects also planned to place the dining room in the front hall area which would have meant that everything required for meals would have to be humped along the whole length of the Undercroft and then up the stairs connecting to the front hall. The obvious solution was to make the Undercroft the School dining room. However, this did mean that the partition across the Undercroft would have to be removed and the whole floor levelled. This is how it came to be and this remains the dining room today. The kitchen and its service rooms were then kept where they had been, to the southeast of the Undercroft.

First floor

The three south-facing rooms became dormitories until the new Head Master's house was built in 1958. After that, the eastern-most room became a classroom, the central one became the Staff Room and the anteroom to the Aula was used for some years as the boys' Common Room. The Library was placed in the room that acted as a junction between the former Palace bedrooms and the central corridor. Today, this 'junction room' is the

Information Technology Centre and all of these other rooms mentioned are classrooms.

Second floor

The whole of the top floor was given over to dormitories and resident staff accommodation until 2001, when the new School boarding house was opened in the old School campus behind Braybrook House to the northwest of The Close. Today the two large rooms at the top of the seventeenth-century staircase are now classrooms. Next to these is the sickbay and beyond this the area is devoted to apartments for foreign students who live at the School and act as assistant members of staff on a yearly basis.

All those involved in the move to the Palace were hugely optimistic as to the suitability of the building for the needs of a growing school. As time went by it became more and more obvious that the Palace was not quite so suitable to house a boarding school as it seemed. This was due to the ever-rising numbers of pupils. An even greater problem arose from the need to provide more specialist teaching rooms. The School had no science laboratory, no art room and no gymnasium. In the later years of the twentieth century, these would become regarded as necessities.

The School Chapel

From the outset, the Chapel was intended to support the School's long connection with the Cathedral. The Chancellor of the Cathedral, Canon Dimont, conducted the service of dedication on Michaelmas Eve 1949 and regular use of the Chapel began with a moving service on Michælmas Day. It remains as the School Chapel to this day. Its uses are many and varied and, apart from services, readings and the like, it provides a haven of peace and quiet in the midst of the busy and often noisy life of the School.

The School has always given special attention to its Chapel. Following the transfer of the School to the Palace, friends of the School and former pupils generously gave money for the installation of extra furnishings and fittings. Among these gifts were two wooden statues. These show the ways in which the pupils of the School can actively serve the Church. One is a chorister wearing a cape and holding a Tudor-style cap. The other is a Chapel warden dressed in the full robes of a server **(6.2)**.

In the nineteenth century, the east window was filled, as Canon Venables described it, 'with very painfully coloured glass' (*Episcopal Palaces of England* – 1895) A memorial panel dedicated to Head Master, Laurence Griffiths and his family, has since replaced it. The central rows of pews were installed in

6.2: Chapel statues.

the Chapel in 1972, having been purchased from the Church of Wimborne St Giles, Dorset. Sir Ninian Comper, who restored the church in 1908-10, designed these pews. The costs were paid for by friends and relatives of Canon Lindsey Bartlett (1898–1968), a former chorister of Salisbury Cathedral and vicar of The Close, in his memory.

In the Ante-Chapel is a picture given to the Cathedral School in 1929 by Miss Helen Kingsbury, shortly before her death that year. Miss Kingsbury was a great friend and benefactor of the School. It was painted for Dr George Bourne (a canon of the Cathedral and Head Master of St Edmund's

6.3: The Kingsbury picture.

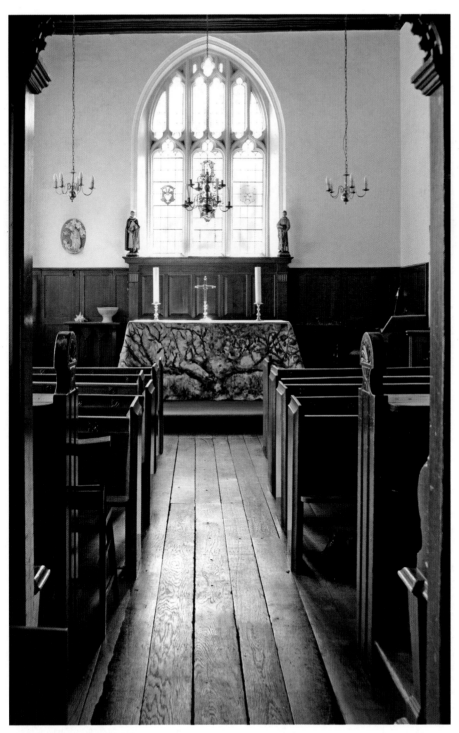

6.4: The School Chapel.

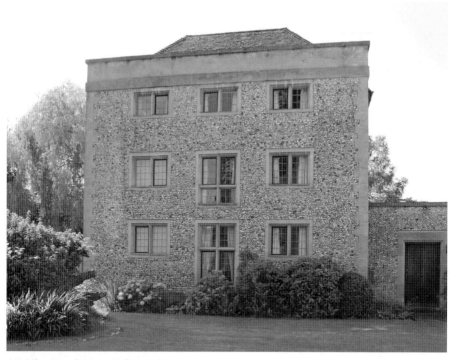

6.5: The Head Master's house.

College, Salisbury). Three of the boys are former Cathedral choristers, the other three being former pupils of St Edmund's College. Unfortunately, the artist is unknown (6.3).

In 1973, a gallery was added over the Ante-Chapel to accommodate the ever-growing Cathedral School. This gallery cannot be seen from the main body of the Chapel, but it has made the Ante-Chapel very much darker than was originally intended and makes the window at the north end look rather awkward, since this is cut off half way up by the gallery floor. On the south wall of the Chapel is the School's war memorial. This used to be on the north wall of the former schoolroom at Wren Hall. The First World War section was dedicated at the Old Choristers' Festival in 1921. By coincidence, the School lost twelve of its former pupils in each of the World Wars (6.4).

The Head Master's House

By the early 1950s, the numbers of boys attending the School rose above 100. Despite the much larger premises, once again the problems of

inadequate space began to loom large. When the School moved to the Palace there were only sufficient funds to provide what the Ministry of Education considered the minimum essentials for a school to exist. Now the School began to feel the shortage of classrooms and sickroom accommodation. It became obvious that the Head Master and his family would need a separate house. The apartments provided in the Palace for the Head Master and his family acted as a block to any further expansion of the School's facilities. As a result, in the 1950s, planning began to try to find a way of attaching a new house onto the east end of the Palace. This house would have to be very carefully designed to blend with the medieval buildings to which it would be attached. The accepted design was for the house to be attached to the Palace at ground-floor level only, with a short corridor leading to the changing-room. A local architect, Hugh Braun, designed this house and it was completed in November 1956 and thus became the first extra building to be added to the Palace for almost 250 years. It blends very well with the Palace: the facings are of flint nodules and the windows have stone dressings **(6.5)**.

The Swimming Pool

In 1952, Laurence Griffiths began raising funds for a swimming pool. When the School moved from the Wren Hall campus, it lost the use of the River Avon that flows across the end of the old School's garden. Generations of pupils had learned to swim in the river there, in spite of its currents and shallows. The lack of a swimming pool to take the place of the river was, to Mr Griffiths, unacceptable. The original idea was that the Palace lake should be cleaned out for use as the school pool, but this was considered a potential health risk. It was then suggested that a pipe be laid from the Avon to the west of the Palace, along the length of the Marsh Close ditch, under the Palace wall via the conduit and then to the pool. This would have involved building a small pump house beside the river and a purification plant next to the pool. The architect went on to suggest that the pool should be sited on open ground between the lake and the Cathedral workshops **(6.6)**.

Reed & Mallik, a noted Salisbury firm, were engaged to undertake the construction. They decided that it would be better to use water from the city's mains and provide a purification plant. This was a far more acceptable solution than using untreated river water. The pool, measuring 60ft x 30ft, was opened in June 1955. Its situation is idyllic, with a grand view of the Palace lake on one side, and the glorious backdrop of the Cathedral on the other. It remains one of the School's most popular facilities, not only for pupils but also for parents and families connected with the School who

6.6: The swimming pool under construction, 1955.

use it during the summer holidays as a much-appreciated source of fun and relaxation on long, hot summer days **(6.7)**.

The new teaching block

This plan **(6.8)** shows the number of buildings in the north-east area of the Palace grounds that had accumulated by the time that the School had arrived. All of the buildings on the south of the path to the Palace Gate were swept away to make room for the School's new teaching block. The area to the north of the path was transferred to the ownership of Bishop Wordsworth's School. Even the yew hedge fringing the path has recently been removed to allow for easier access by cars and delivery vehicles from Exeter Street through the Queensgate. The only natural greenery now left, apart from the Queensgate cottage garden, is the tiny copse at the western end of the path.

The first stage of this building, completed early in 1961, was designed to provide a gymnasium, the Griffiths Memorial Library and two dormitories,

6.7: The swimming pool complete, 1955.

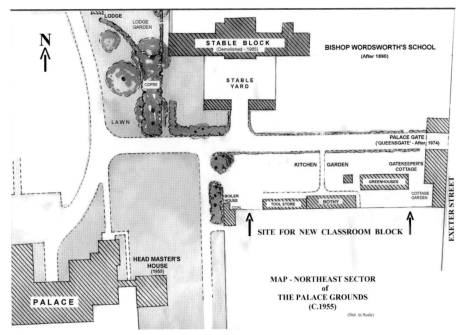

6.8: Plan of the north-east sector of the Palace grounds, 1950s.

each accommodating nine boys, together with bathroom, showers and lavatory facilities **(6.9)**. The site was a long narrow strip of kitchen gardens between the Bishop's Palace and the Queensgate, facing south across the school kitchen garden, but directly overlooked from the north by the new laboratories of Bishop Wordsworth School. This new, single-storey building was designed in an H-shape, the dormitories and Gymnasium running north to south, whilst the linking library faces south across the gardens over a quiet court.

This arrangement provided three separate areas of activity. The dormitories facing east, the central Library, and the Gymnasium, which opened onto a paved court on the west side of the group. The buildings were designed for future extension to the west, which would incorporate music practice rooms and additional classrooms, grouped around the western courtyard. The greatest care was taken to ensure that the new buildings, whilst being modern in design, should blend in with the Cathedral, the Bishop's Palace and the adjacent buildings in The Close, and the design was approved by the Royal Fine Arts Commission. The architects of the new classroom block, Robert Potter and Richard Hare, together with the builders, T. Holdoway & Sons Ltd., were awarded a Civic Trust Award in 1962 for this work.

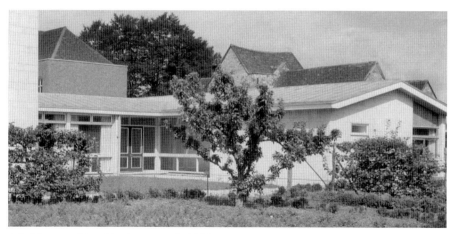

6.9: New teaching block, east end, 1961.

The teaching block was completed during the headship of the Revd Niale Benson. In 1968, the decision was made to build the western extension of this building. The most important room in this new building was the new Science Laboratory with its preparation room and a dark room for photographic work. Facing west were two large extra classrooms. Connecting this extension with the gymnasium was a wide corridor with small music practice 'cells' along its whole length **(6.10)**.

As the new buildings came into full use, so a number of problems began to appear. The dormitories soon proved to be awkward for the routine of the School. Having one group of dormitories here, and more in the Palace, meant having to keep two groups of staff to care for the boarders in both areas. In addition, the windows of the dormitories had been set too low. This was excellent for the provision of light, but all too tempting for the boarders to enter and leave the rooms as and when they wished! Very soon, the dormitories were all concentrated in the Palace and the east end of the new block was then used for classrooms and music teaching rooms.

The Griffiths Memorial Library, whilst being an attractive little room, was found to be too small and was also too remote from the centre of the life of the School in the Palace. The Library was moved to the room in the Palace overlooking the north central courtyard and later established in one of the south-facing rooms. Today the library occupies two large rooms that used to be bedrooms, built during Bishop Barrington's restoration, on the first floor of the Palace.

The gymnasium has worked well and its extra function as a drama centre also proved satisfactory for some years. Many School plays and musicals

6.10: The science laboratory, 1976.

were successfully staged here. However, the gallery above the south end posed a number of problems. Firstly, its front wall had been set too high. Only the front row of the audience could see what was happening on the stage! Behind the front row was the staircase into the gallery – this meant that anyone sitting behind this could see nothing at all of the stage. Later the gallery wall was taken up to the roof; this left a large room up there, which became the art room. It was a very inconvenient room for this purpose as the staircase cut into the middle of it. In the 1990s, the staircase was removed and replaced with an external metal stair on the east wall side. The area left was then converted into one large classroom, which is how it now remains **(6.11)**.

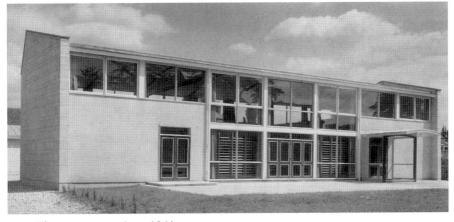

6.11: The new gymnasium, 1961.

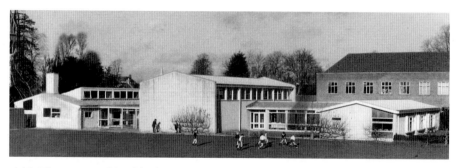

6.12: The new teaching block, 1976.

Two courtyards were included in the original design – one outside the gymnasium, the other in front of the Griffiths Library. The gymnasium courtyard was filled in during the 1980s. This was done to build a large changing room with showers and a store for games' equipment (later converted into the girls' changing room). The Cathedral School Pre-Preparatory Department was created in 1985. The whole of the east end of the new teaching block was used to house this new development. For the first time in its long history, the School was now responsible for the education of children aged from four to thirteen. Very recently, the other courtyard was filled in with an extension to the pre-preparatory central area. This has created a huge open-plan zone, giving the teaching staff a space that can be used for a variety of exciting activities.

A little-noticed feature of the long path that runs by the new teaching block is a line of very old espalier fruit trees. They are a living reminder of the days when the Palace was the home of bishops. They are all that is left of a time when this area of the Palace grounds was given over to the huge kitchen gardens – even leading to a long-gone carp pond at the furthest east end. These trees serve to remind that new growth and new fruits can grow from ancient stems – surely a fitting thought to end this review of a building that, even being so old, can still house and protect some of our new generation before launching them into the perils and possibilities of the world beyond its walls **(6.12)**.

7

The Palace grounds and outer buildings

On the move from Old Sarum in the thirteenth century, the precinct of the Bishop's Palace was laid out as part of the planned Cathedral Close. There were no problems of space for the number of residences that were to be built. Covering about seven and a half acres, the Palace occupied The Close's largest individual plot. The next largest in extent, Coldharbour Canonry (formerly between the Palace and the Close Wall to the south), was half that size. The Palace was the only house in The Close with a private entrance through the wall, which led into the Palace grounds from Exeter Street to the east. The Palace could also be approached from the north through The Close and additionally the bishop had his own entrance into the Cathedral, via a door in the south-eastern corner of the cloisters.

There are several surviving fifteenth-century surveys concerning certain buildings in The Close. Although the Palace was not covered, the surveys provide an idea of the variety of other outbuildings that might have been associated with the Palace. These were stables, fuel stores, barns for hay and straw, granaries, poultry houses, dovecotes and harrier kennels. John Speed's 1610 map of Wiltshire includes a map of Salisbury and this depicts a small building, presumably an outbuilding, immediately to the west of the gatehouse. The earliest detailed map of Salisbury, Naish's of 1716 (see **3.3**, p. 85) shows no other buildings within the Palace grounds that could be identified as outbuildings other than the gatehouse **(7.1)**.

The area to the south of the Palace was originally a meadow where the Cathedral choristers used to help with the hay harvest in the nineteenth century. Today this is the Cathedral School's principal cricket pitch. Bishop Jewel (1560-71) extended the Palace grounds by adding the whole area of

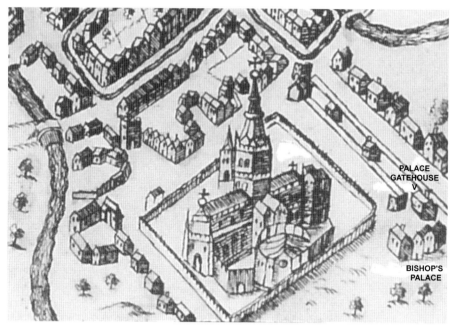

7.1: John Speed's map of Salisbury, 1610: detail of the Cathedral Close.

the Coldharbour Canonry, located immediately south of the Palace 'canal'. He also acquired the 'Glasshouse', a tenement that stood to the west of the northern entrance to the Palace.

The Close wall

This is a defensive structure approximately thirteen feet high with a walkway and battlemented parapet, lookouts and originally an external ditch (7.2). It has three main gatehouses, one being the Queensgate – leading to the Palace. In theory, the wall was built to provide protection in times of trouble either with the townsfolk or from further afield. In reality, it is not high enough to offer much of a threat to attackers. It was probably more likely to have been built to provide a solid boundary around The Close, showing its separation from the City of Salisbury and the area of the sanctuary rights granted to The Close in 1317. The clergy, wishing to display their status and lordship of The Close, could have also seen its construction as an act of pride.

The wall is built mainly of squared Chilmark stone, with some sandstone, rubble and even some brickwork where the wall has been repaired. Before 1327, the Close ditch, a deep drain carrying water from the River Avon as far as Catherine Street and then turning south to rejoin the river some way

downstream from Ayleswade Bridge, had defined the Cathedral precinct on the north and east. Between the north-east corner and St Ann's Gate, the eastern boundary of The Close is deflected by the ditch from its true alignment, suggesting that the ditch is older, and it is probably one of the earliest features of the new city. King Edward III gave permission for The Close to be walled in 1327, and in 1331, the Dean and Chapter were authorised to use the stone of the disused cathedral at Old Sarum. In 1342, the Chapter agreed to reduce the height of the existing graveyard wall to provide stone for the Close Wall. In the sixteenth century John Leland noted that 'the Close walle was never ful finished as yn one place evidently apperith'.

The wall bounding the Bishop's Palace grounds was built with regularly coursed ashlar and remains the best-preserved stretch. Medieval masonry remains to a height of six feet or more, and the wall generally retains its wall-walk and crenellated parapet, although there is evidence of eighteenth- or nineteenth-century reconstruction and alterations. There are a large number of masons' marks in this stretch of wall. In the wall opposite the road to Ayleswade Bridge, some fourteen feet of masonry has been replaced in stone rubble, which suggests that this was the entrance opened during the Commonwealth to give access to the Palace, then used as an inn. Between here and Harnham Gate, the battlements have been removed **(7.3)**.

7.2: The Cathedral Close wall, east side, looking north.

7.3: The Close wall, south-east corner: here an octagonal 'bastion' was destroyed by a falling tree in 1896 (rebuilt as a splayed angle).

In the east wall (about seventy yards from the south-east corner), there are two obvious vertical joints some seventeen feet apart that demonstrate the wall's rather erratic construction; the south one probably marks the medieval boundary between the Bishop's Palace and the former Coldharbour Canonry to the south. Many twelfth-century carved stones from Old Sarum have been built into the outer face of the wall. For some 60 yards south of the Queensgate, the wall is thinner; it is mainly of seventeenth-century date and contains the blocked windows and doorways of cottages demolished probably in the late eighteenth century **(7.4)**.

Estate Map (c.1780?)

Two previously unpublished plans of the former grounds of the Palace have been preserved in Salisbury Cathedral School. The earlier of the two is undated and offers no clue as to its author. It was made before the extensive changes made by Bishop Barrington (1782-91). We do have some clues to help with the dating. The Palace still has its large range of kitchens on the east end – these served the Seth Ward dining hall. We know that Barrington's architect obliterated that dining hall and with it went the east range of kitchens. It is worth noting that the land on the north-east of the plan is described as 'Mr. Harris's Option Meadow'. This is likely to refer to James Harris who built Malmesbury House in The Close. This beautiful mansion, next to St Ann's Gate, is just to the north of the Palace grounds. James Harris

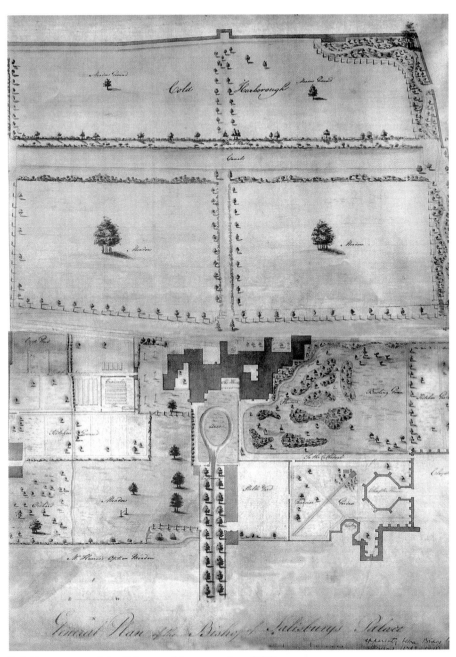

7.4: Estate map of the Palace and its grounds, *c.* 1780.

died in 1780. Across the front courtyard of the Palace is a line of dots which must depict the pillared portico constructed here as part of Bishop Seth

Ward's renovations (there are no known pictures of the Palace that show this portico).

The estate map, drawn with south at the top, shows the grounds around the Palace. The first impression is that the 'gardens' seem more like a formal park. There is no sign of the former 'grid'-patterned flower beds seen on the north-west side of the Palace in Naish's map (see **3.3**, p. 85); nor are there any herbaceous borders – so much a feature of the later Victorian layout. Instead, the concern seems to be concerned with vistas. Looking out from the central south-side windows of the Palace, the viewer would see the central tree-lined avenue extending to the 'canal' and then on to the 'Coldharbour'. The formal meadows would have had carefully placed clumps of trees and the whole effect would seem to have been rather more mathematical than natural. Continuing the theme of vistas, walks have been carefully laid out to allow the explorer to experience both the shade of trees and the contemplation of differing viewpoints. The long path running from the north-west end of the Palace shows this. Continuing on, an enlightened walker would have passed along the edge of the 'Pleasure Ground' with its irregular shrubberies, maybe to pause a while to watch the players sedately enjoying a game of bowls on the small green. This part of the journey would have allowed the walker grand views of the south side of the Cathedral and Chapter House. Turning south, the winding path now ambles through rows of trees, past the end of the 'canal' to the 'Gothick' summerhouse at the far south-west corner of The Close wall. Through the screen of trees, the whole view from here must have been one of the finest in any cathedral close in the whole country. Our eighteenth-century savant would now be able to see the whole south aspect of the Palace beyond the meadow and the canal – the entire view crowned with the glory of the Cathedral beyond. Along the south side of the canal is the 'Dark Walk' – simply a straight tree-lined path. This could well have gained its name from the avenue with the same name in the famous Vauxhall Pleasure Gardens that were at the height of popularity at this time.

To the east of the Chapter House, and adjoining the Cathedral, is the 'Paradise Garden'. The basic feature of this type of garden is a rectangular enclosure with a perimeter wall. This excludes the 'wildness of nature' and includes the tended, watered greenery of the garden. The contrast between a formal garden layout, with the informality of free-growing plants, provides a recurring theme to many paradise gardens. Another common theme is the use of water, often in ponds or rills, sometimes in fountains, less often in waterfalls. This water feature would have had enough of a flow to give it life and movement. There would also be a raised platform, often with a pavilion

to view the whole scene. Strictly aligned, formally arranged trees provide shade, and the perimeter wall provides privacy and security. In paradise gardens, the basic idea is to realise the symbol of eternal life – a tree with a spring issuing at its roots. If the long, straight double-line shown in the map is the water feature (probably a rill) then it would most likely have been fed by a natural spring (recently detected beneath the Cathedral School swimming pool – which stands today just to the southeast of what was the Paradise Garden).

East of the Palace buildings is a series of enclosed areas, including a 'carp pond' and a 'cucumber pen' which would have been something of a novelty at this period. In Britain, from about the seventeenth century until Victorian times, cucumbers were commonly known as 'cow-cumbers'. They were regarded as dangerous and 'fit only for consumption by cows', possibly due to their bitter taste and a belief that they were responsible for causing stomach upsets. In the 1760s, Dr Samuel Johnson remarked that a 'cucumber should be well sliced, and dressed with pepper and vinegar, and then thrown out as good for nothing.'

Of note is the Palace gatehouse – not named, but shown as two grey squares to the bottom left-hand side of the map. The gatehouse leads directly to Exeter Street and should have been the main entry to the Palace, especially for tradesmen. One rather peculiar feature of this map is that it shows no path continuing from the gate. It can be only supposed that the gatehouse was perhaps used as accommodation for the garden staff or that the tradesmen using this gate would have simply delivered to the kitchen garden area and gone on no further to the Palace itself. The main entrance to the Palace was, therefore, only through The Close via the avenue called 'Bishop's Walk'. The visitor would pass by the extensive stable block on the right-hand side and what would seem to have been a lodge on the left. In front of the Palace was a turning circle for coaches and carriages.

Estate Map (1827)

(The numbers in this section refer to those on the map - **7.5**)

John Tubb, a Salisbury surveyor, made this plan of the Palace grounds in 1827. It clearly shows the more 'natural' landscaping created on the orders of Bishop Fisher. It is very clear that the formality of the area to the south of the Palace has now been replaced with a wide meadow dotted with trees, instead of the central avenue with its tree-lined border. The tidy, carefully placed clumps of trees have also gone. However, the 'Dark Walk' remains, providing a straight border to the south bank of the 'canal'.

The Paradise Garden has now been cleared away to make a 'horse ground'

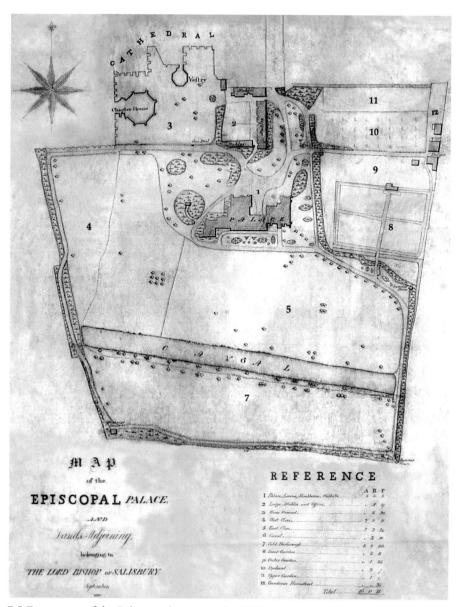

7.5: Estate map of the Palace and its grounds, 1827.

[3] – simply an open space. Gone too are the western kitchen garden and the bowling green to make an open meadow **[4]**. Much of the shrubberies that made up the former 'Pleasure Ground' have been kept – presumably, because their informal placing was much in tune with the over-riding informality of the whole scheme. However, there is a curious circle of shrubs

and small trees here, surrounding a tiny un-named building approached by a short path. From its layout, this could have been a bower, set aside for private contemplation. Now that the kitchens on the east end of the Palace have gone, there is space for additional shrubberies on this side. Across the south front of the Palace, is a new hint of formality – the appearance of regularly spaced and shaped flowerbeds. These would be the basis for the long range of herbaceous borders and flowerbeds that would extend along the whole south front to be created in the time of Bishop Denison.

The walk in and out of the tree-lined border along the west side of the meadow has been retained – leading to the summerhouse at the southeast corner. Now, it would seem there was a need for more exertion because this path has been extended around the whole perimeter of the Close wall. Should this be a little too energetic, then two new summerhouses were built at the south-west corner and near to the north-east corner. These would not only give a chance for the walkers to rest, but would also have allowed places where especially tasteful viewpoints could be enjoyed. John Constable's viewpoint of the Cathedral (see Chapter 4) can be seen today on the extreme western side of the Palace grounds next to the Palace wall. This can easily be located on the map, and the extreme western end of the 'canal' is clearly shown in the picture. The picture also emphasises the new open space between the bishop and his wife and the Cathedral Cloister wall.

7.6: Bishop Edward Denison, *c.* 1840, by H.W. Pickersgill R.A. (*The Warden and Fellows of Merton College, Oxford*).

7.7: The Palace lake: pupils of the Cathedral School pond dipping.

Approximately 50 years earlier, this area was the western kitchen garden.

By 1827, we can now see that the access to the outer world is now possible through the Palace Gate, as a new path has been constructed to it, in exactly the same position as it is today. The gardener now has his own 'homestead' [12] and would seem to have also gained some additional garden buildings in the kitchen garden areas [8, 9 and 11]. Direct access to the Palace from The Close was, as it still is, from Bishop's Walk, but without a lodge, although the stable blocks bordering this entry have now been greatly enlarged to form three sides of a square [2]. There is no longer a turning circle at the south front of the Palace – instead a much wider courtyard, clearly shown in Constable's picture (See **3.14**, p. 96) of the view of the Cathedral from this courtyard.

Both estate maps help to clarify Naish's map of 1716 (see **3.3**, p. 85) which would appear to show two watercourses running across the area to the south of the Palace. This map makes it look as if another one (running

north-south) joins the two watercourses from the south-west corner of the Cathedral Cloisters to Harnham Gate ('y' on map). In fact, the estate maps make it clear that the 'watercourse' across the south front of the Palace is simply a path. Either the one running north-south is a path, or more likely path and then a wall (see Donn's map, 1797 – **3.16**, p. 99). This brick wall still exists to this day – separating the Palace grounds from the wide path along the east side of Marsh Close, leading to Harnham Gate. The remaining watercourse is labelled 'The Canal'. This is clearly the watercourse that Bishop Denison converted into the Palace lake.

Bishop Edward Denison (1801-54: Bishop of Salisbury (1837-54)

Edward Denison was born in London (the son of John Denison M.P. for Chichester) **(7.6)**. He gained a reputation as a forceful preacher. The Prime Minister, Lord Melbourne, noted his scholarship and energetic character, and appointed him Bishop of Salisbury at the early age of 36. When cholera broke out in the city, Denison worked hard to ease the problems of those living in crowded and insanitary homes. He was both a hard-working teacher as well as being a sanitary reformer. He spent more than £17,000 on charitable work in the city. At the Palace, his main concern was to alter the layout of the grounds and to build new outer buildings.

The Palace lake

Bishop Denison would seem to have been influenced by the ideals of the 'Picturesque Movement'. This reaction against formal landscaping emerged

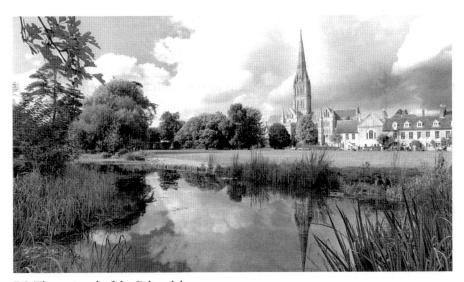

7.8: The east end of the Palace lake..

in the late eighteenth century following the writings of the Rev. William Gilpin. His theories were strongly advocated and put into practical form by Sir Uvedale Price, a wealthy Herefordshire landowner and, coincidentally, a nephew of Bishop Shute Barrington. Price was particularly contemptuous of the style popularised by the late Lancelot 'Capability' Brown, whose designs were tranquil and relatively formal. Price's gardens were wild, dramatic, and unkempt. In his 1794, *Essay on the Picturesque* (expanded editions followed in 1796-8 and 1801), Price argued that gardens should imitate landscape paintings and that the purpose of the gardener, like that of the painter, was to improve upon nature. Contemporary with Price, the great landscape gardener, Humphry Repton was also influential in his opposition to Brown's formality. During Bishop Denison's episcopate, the Scottish botanist John

[1869] The south window is embowered in magnolia and pomegranate trees, and looks out upon a formal garden, bright with geraniums; and a broad gravel walk, upon which pigeons were promenading, follows the whole length of the house. A low stone balustrade divides this garden from the field in which our three cows are tethered. In the field is a big pond surrounded with trees, and in the middle of it is a small wooded island. In the course of time, we found out now what a lovely garden the Palace has. Trees close it in and we have discovered where the delicious deep shadows are, filling the pond with green reflections. The horse chestnuts are in full bloom and the crimson and white thorns are coming out in the meadow and in the shrubberies.
Charlotte A. Moberly, *Dulce Domum*, 1911 (7.9).

The whole wall of the house is covered with magnolias, myrtles, pomegranates, pyrus japonica, and other creepers. The magnolias and pomegranates in particular flower here as they only do in very favoured corners of England. A flat terrace runs the length of the house, and is bordered on both sides by turf, in which are beds of the richest and most brilliant flowers expanding in the sunshine. Stone steps, stone balustrades, here and there a lichen-grown stone vase give an old-world air to the spot; as does a little fountain, with water-lilies and goldfish, in a stone basin beside the path and close to the balustrades. Beyond there is a field and a good-sized piece of water, the joy of winter skaters, and to the east a spacious kitchen garden. The starry celandine may be seen at the beech tree roots in the early spring, and the garden never loses its loveliness until the last autumn rose has yielded to November frosts. Various quaint little staircases run up to the house from the terrace; there is a porch covered with pale clustering roses and the doves may be seen and heard in its neighbourhood.
Memoir by the Bishop's sister, Elizabeth Wordsworth, in E. W. Watson, *Life of Bishop John Wordsworth*, 1915

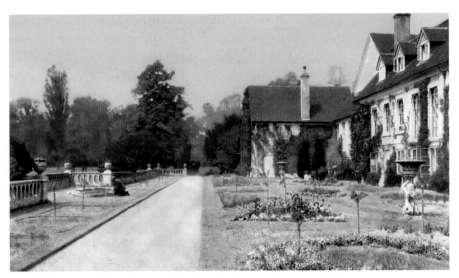

7.9: The Palace garden, south aspect, 1898 (colourised photograph).

Loudon published *The Landscape Gardening and Landscape Architecture of the Late Humphry Repton Esq.* in 1840.

Denison would seem to have been much influenced by these advocates of the 'picturesque' ideals. Before his time, the grounds of the Palace were divided into north and south areas by what is shown on old maps as 'The Canal'. This extended from east to west and drained, via a conduit beneath The Close wall into the ditch beyond and from thence to the River Avon. Denison had an informal lake constructed to replace the 'canal', complete with a small wooded island **(7.8)**. Often referred to as a 'water-table lake' it marks the lowest-lying point of The Close. Fed by groundwater from below its surface, it is on a level with the water table that lies so close to the surface of the grounds of the Palace and the Cathedral. Originally, it was also fed with water from the River Avon via a long ditch across Marsh Close (see p. 96). Owing to the fact that, today, water no longer drains from the River Avon across Marsh Close to the lake; it has consequently considerably shrunk in size. It has been much enhanced by the Cathedral School that has made it a managed wildlife habitat zone **(7.7)**.

The result of the work of Bishop Denison was that the grounds to the south of the Palace were then divided into two zones. Immediately to the back of the buildings was a long, wide path that ran through a beautiful garden, looking as though it had just been taken from the illustrations in Loudon's book. Indeed, the large stone urns on square plinths that can still be seen at the south of the Palace are exact copies of those shown in

Loudon's pictures (smaller versions of these also mark the north end of the School's car park on the north side of the Palace). The zone beyond this was a large field, then used as a hay meadow, beyond which was the lake with its island, forming the centrepiece of wide grass spaces and informally planted groups of trees. Today, this whole area can still be a haven of peace in the midst of the bustle and noise of the city **(7.9)**.

Two of the relations of successive Victorian bishops have left us almost poetic impressions of the beauty of these gardens in the late nineteenth century.

In addition to the ornamental gardens, the Palace also had a huge area of market gardens, an herb garden and greenhouses beyond the east end of the Palace. All of these gardens, both ornamental and practical, have now disappeared. The Cathedral School's beautiful 'Millennium Garden' occupies an area to the south of the west end of the Palace and is bounded on one side by the one remaining stretch of Bishop Denison's balustraded wall.

Other buildings associated with the Palace
The Palace lodge

Until Bishop Denison's time a large range of stables masked the approach to the Palace from The Close. These buildings were now removed and, instead, a long wall was constructed towards the Cathedral vestry – this divided the Palace grounds from what is now the Cathedral cemetery. A new large pair of gates now acted as a formal entrance to the Palace grounds from Bishop's Walk. Next to this, a new lodge was constructed. It was built in 1843 to the design of T. H. Wyatt, based on an example in Loudon's *Encyclopaedia of Cottage, Farm, and Villa Architecture and Furniture.* Loudon's book, published in 1839, contained several pictures and plans of lodges. The lodge is similar in design to the former Palace coach house (see below) and is mainly of ashlar, with brickwork in less conspicuous places. An old photograph shows the windows glazed with leaded octagonal panes complementing the terracotta roof shingles. Originally, the house only had a sitting room, bedroom and pantry, with a courtyard at the east end. Around 1890 this courtyard was built over to create a kitchen with a bedroom over it. This whole entrance layout is how it remains today, the only change being the iron gates which were replaced in 1977 by the parents of a former Head Boy of the Cathedral School **(7.10)**.

The Queensgate

The Palace grounds are linked to Exeter Street by an attractive medieval gatehouse at the extreme north–east corner. Known today as the Queensgate,

it would have been the tradesmen's entrance to the Palace **(7.11)**. It would probably also have served as an almonry to distribute charity to poor folk arriving for alms at the Palace. Until 1974, this gatehouse was known as the 'Palace Gate' or 'Bishop's Gate'. It was renamed in honour of Queen Elizabeth II, who used this gate as an entranceway to the Cathedral to distribute the Royal Maundy in that year.

This gatehouse was almost certainly built after 1377, when Bishop Ergham was granted a licence to crenellate the Palace. It contains three rooms, one on each floor. The upper chamber over the gate arch contains its original beams and floor. There is a small window to the west and a large east window, which could have been inserted later than the fourteenth century. The main feature of this room is its large Perpendicular-style fireplace. The first-floor room has a large original window to the north. It also has a large niche in the south wall that could have been a garderobe. The main feature of this room is its impressive original oak beams. The ground floor has two small windows and a huge fireplace. From 1859 to 1956, the Queensgate was used as the Diocesan Archive and to make this more secure, heavy iron window shutters and a massive iron door were inserted into the ground-floor chamber.

Originally, the Queensgate would have had conventional wooden stairs, reached by a door (now blocked) under the gate arch. In 1859, T.H. Wyatt, Diocesan Architect for Salisbury, planned the complete reconstruction of the interior of the gatehouse. A new floor was constructed, accessed by a

7.10: The Palace lodge.

7.11: The Queensgate: drawing by S.J.Buckler, *c.* 1805.

new stone spiral staircase cased in brick. This extra accommodation was to be used for the storing of the archives, previously housed in the topmost room of the east tower of the Palace but which became regarded as a fire risk. Where the new staircase reaches the upper chamber, there is a medieval slit window overlooking Exeter Street. The gatekeeper would have used this slit to check any visitors waiting on the far side of the defensive ditch that then passed below the east side of the gate. **(7.12)**.

Under the arch, next to the huge wooden gates, can be seen long grooves cut into the stone – probably caused by longbow archers sharpening their arrows before going on to practise at the butts set up on the Cathedral Green.. Above these are two well-carved graffiti, one by 'M. Brown 1708' and the other by 'IH 1751'. Also under the arch is a very unusual outer fireplace (now blocked with an ugly cement square) that would have been very welcome to the gatekeeper on duty on winter days.

Next to the Queensgate is an attractive cottage. On eighteenth-century plans, it is simply marked as 'gardeners' cottages'. This was originally a canons' hall, entered through a large doorway under the gate arch. In 1859, this doorway was filled in when the hall was adapted to make it a two-storey cottage. During the seventeenth century, the floor level of the upper room was raised. This left behind a curious little window in the west wall ,

with only the wall to be seen behind its glass, that now serves to mark the old floor level. Probably this window would have given light to a simple staircase. When the floor was raised this staircase was removed and a new one constructed where it remains today at the south end of the upper floor. This left the window stranded between the floors. During the 1960s, the cottage was divided into two flats, one on each floor. An extra room was added to the ground floor flat to give it a comfortable sitting room. However, its modern style clashes badly with the rest of the building.

Many people are fascinated with tales of the supernatural associated with old buildings. Despite many lurid tales recounted by pupils of the Cathedral School, the Palace itself has no record of any ghostly apparitions. In fact, the Palace has often been described as having a friendly and loving atmosphere. However, there is definite evidence of a strange supernatural effect associated with the Queensgate. I lived in the upper flat of the cottage throughout the 1980s. One November night I heard the sound of a coach and horses arriving at the gatehouse from the direction of the Palace. The sound was very distinct – the jingling of the horses' harness, the rumbling of wheels on gravel and the snorting of the horses could all be clearly heard. With a friend, who had also heard the sound, we dashed outside to see – nothing at all! The night was very still, and there was no traffic in Exeter Street that might have caused a distorted echo. On enquiring further from

7.12: The Queensgate, eighteenth-century century graffiti.

a former member of staff who had lived in the lower flat – she described the same sounds that she had heard on at least two occasions. She went on to say that the effect had been heard by many other former occupants of the cottage. I have often wondered what the circumstances were in the past that might have caused this carriage to slip through time – but so far, no evidence has come to light.

The Wardrobe (no. 58 The Close)

This building on the north-east side of The Close was built in the thirteenth century. Walter Scammel, on his promotion to Dean in 1277, presented this canonry to the Bishop. Seven years later he was consecrated Bishop of Salisbury. In 1568, Bishop Jewel exchanged The Wardrobe for the 'Glasshouse', owned by the Dean and Chapter, which stood in the Palace Grounds. The name 'Wardrobe' suggests that this was a store place used by earlier bishops either for their household goods or for tithings in kind.

It was then let to a series of non-clerical tenants. With the frequent visits to Salisbury of King James 1 and the Court in the early seventeenth century, it seems likely that this large building may well have housed courtiers in attendance on the royal family. It underwent many alterations in the eighteenth century. Further building work in the 1830s gave the east front its gables, bargeboards and Gothic portico. The first tenant following these renovations was Dr John Grove. His daughter Henrietta married James Hussey, a local JP. The house remained in the Hussey family until James and Henrietta's daughter Margaret (who was born in the house) died at The Wardrobe in 1941 (aged 90). Her ghost, seen as a 'grey lady', has been seen in the 'Regimental Room'. The ghost of a Cavalier can also be seen gliding around the building. The Wardrobe is now the home of the Rifles (Berkshire and Wiltshire) Military Museum **(7.13)**.

Buildings that no longer exist
The Coldharbour

On the estate maps of the Palace, this is the title given to the area to the extreme south-east of the grounds (often spelt 'Cold Harborough'). The documentary evidence for buildings in this area is very scanty. It must be assumed that it was at some time a hostelry for travellers arriving at Salisbury after curfew. (i.e. a 'cold harbouring' – where neither bedding nor food was provided). It was also a canon's house; but little is known of its occupants, except that it was lived in throughout the fourteenth century. Bishop Jewel took a 99-year lease of the 'Coldharbour Close' (the lease was continuously renewed until the freehold was gained by the Bishop in 1827). By 1649,

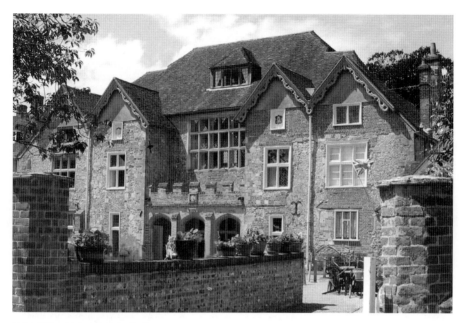

7.13: The Bishop's Wardrobe.

it was described as a pasture of approximately three acres with 40 trees growing on it. Therefore, it seems that any buildings here had been removed some while before this date.

The Palace Coach House and Stables

In addition to the Palace lodge, the coach-house and stables were also built to designs by T.H. Wyatt in 1843. As with the lodge, the design was based on Loudon's *Encyclopaedia*. They were in what was known then as 'Old English' style with windows having lattice glazing. The south side facing the Palace was of ashlar and the others of rubble, some stones with twelfth-century carving being built into the east wall. The central coach-house was taller than its wings and projected forwards. It had a triple entrance with a clock on a gable above, whose bell was housed in a square wooden turret on the north slope of the roof. This had louvered openings with pairs of pointed arches and a pyramidal lead roof. This turret was the old cupola, with its original wrought-iron weathervane, that had formerly stood on the east tower of the Palace (see p. 72). In the east wing, there were stables and looseboxes with a loft over and to the west were harness rooms and a cottage. The whole complex of buildings was cleared away in 1965 to be replaced by the swimming pool for Bishop Wordsworth's Grammar School

7.14: The Palace coach house and stables: reconstruction picture based on original photographs (*Richard Cusden*, A Salisbury Century, *Salisbury College of Art, 1971*).

(recently demolished to make space for the construction of that School's sports hall) **(7.14)**.

The Glasshouse

In 1568, Bishop Jewel obtained possession of the *'Placea vocata The Glasshouse'* by exchanging it for the Wardrobe. Its name comes from the fact that it was used by the Cathedral glaziers. A grant of 1691 refers to the earlier exchange with 'two messuages or tenements called The Glasshouse'. Its situation in 1568 was described as 'abutting the way leading to the Bishop's Palace on the east, the Chapter House on the west, the Palace garden to the south and the Cathedral and cemetery to the north'. Naish's map of Salisbury of 1716 shows two buildings on this site, one of which was a stable later demolished and replaced by Bishop Denison.

There may have been other buildings north of the Palace. In 1814, the antiquarian, John Britton wrote that the Palace previously had been 'shut out from the Cathedral by old houses and disfiguring buildings'. By this, he implies that Bishop Barrington had recently demolished these buildings. These included two vergers' houses that already existed in 1634 and were

still standing in November 1779, although one had already been demolished in 1773. These buildings stood adjacent to each other against the Bishop's orchard wall.

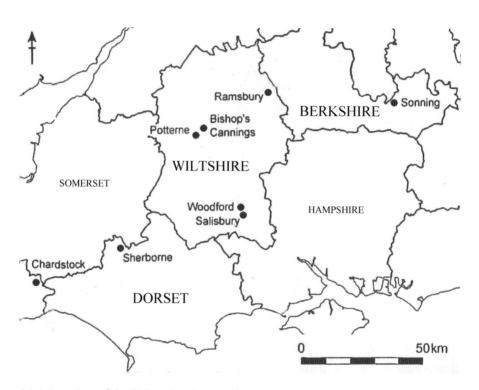

A1.1: Location of the Bishops' various residences.

Appendix 1

Other residences of the bishops of Salisbury

The forerunners of the bishops of Salisbury had no cathedral, but two bishop's palaces – at Ramsbury, Wiltshire, and Sonning, Berkshire **(A1.1)**. The parish church at each of these places would have been a kind of 'proto-cathedral'. These important churchmen were sometimes known as Bishops of Sonning ('*Episcopi Sunningenses*'), though more usually as Bishops of Ramsbury ('*Episcopi Corvinensis*'). Occasionally, they were styled Bishops of Wiltshire, or Berkshire, or both. The diocese based at Old Sarum (and later Salisbury) by the Normans covered the three counties of Berkshire, Dorset and Wiltshire, and consequently so did the estates belonging to the bishopric. In 1086, the wealth of the bishopric was concentrated in four of its five Wiltshire manors: Potterne, Bishop's Cannings, Ramsbury and Salisbury, in the Dorset manor of Sherborne and in the Berkshire holding at Sonning.

A study of the journeys made by the Bishops of Salisbury in the Middle Ages shows a consistent use of a small number of important residences. It was not until the late fifteenth century that any went out of use, although the smaller manors of Lower Woodford and Chardstock were probably in decline by then. There seems to be no evidence from the earlier bishops' registers that there were any small manor houses on the episcopal manors used for occasional accommodation purposes by the bishop, apart, possibly, from Sherborne before the castle came back to the bishopric. However, it is possible that on his occasional visits to Sherborne, the bishop would stay at an inn or at the monastery, rather than in the bishopric's administrative buildings.

The Diocese of Salisbury was large and geographically widespread. Its estates were extensive, but fairly well positioned for administering the

177

entire diocese. Central and eastern Berkshire was covered by Sonning; northern Wiltshire and western Berkshire by Ramsbury; central Wiltshire by Potterne; southern Wiltshire by Salisbury and Woodford and Dorset by Chardstock and Sherborne. Most of the other Episcopal manors were reasonably close to those that had residences, so it was perhaps not necessary to construct any more. As there was less involvement in government work in the fifteenth to sixteenth centuries, the bishops of Salisbury spent more time in their diocese. Ramsbury was the most popular residence throughout the Middle Ages, with Sonning and Potterne usually following. Sherborne was also popular once its castle had come back into the possession of Bishop Wyvil. Chardstock and Woodford were employed occasionally, the latter in preference to Salisbury until the episcopate of Bishop Richard Beauchamp.

The bishops' peripatetic lifestyles resulted in varying use patterns of the different residences, but it was very expensive keep up so many households. Many of the medieval bishop's possessions, including furniture and linen, would have been carried from one place to the next, rather than being stored at each household, in order to keep the costs manageable. The lifestyle was also physically demanding for the bishops, many of whom became old and infirm during their episcopates. The distances travelled were often very long for a single day's journey. For example, Potterne to Ramsbury (about 24 miles by modern roads) seems to have been a standard single journey, and the bishops would sometimes travel between Ramsbury and both Lower Woodford and Sonning, both journeys being about 38 miles by today's roads. Surviving household accounts from other dioceses reveal that 50 to 100 people might accompany medieval bishops on their journeys, the bishop and senior officials on horseback, with furniture and supplies following in carts and most individuals on foot. Those on horseback might reach their destination more quickly and some servants may have departed in advance in order to prepare for their lord's arrival, perhaps whilst the bishop paid some shorter visits en route.

Ramsbury Palace

Ramsbury is a Wiltshire village in the Kennet Valley near the Berkshire boundary. The nearest towns are Hungerford and Marlborough. The village dates back to Saxon times with evidence of a settlement during the fifth or sixth centuries. It was considered such an important settlement that a bishopric was established and a cathedral built. Ramsbury belonged to the Bishops of Ramsbury in the tenth and eleventh centuries, and their successors kept it following the move of the See to Salisbury between 1075 and 1078.

Bishop Herman (d.1078):
There is some doubt as to Herman's country of origin. One chronicler says that he was a native of Lorraine, another that he came from Flanders. He was probably one of the clerks of the Royal Chapel under King Canute. He was still holding that post when, in 1045, King Edward the Confessor appointed him Bishop of Ramsbury & Sonning, in succession to St.Britwold. Unfortunately, the Bishop was not satisfied with the small income paid from the lands of his diocese. His predecessors, he told the King, were Englishmen and had relations to help them, but he, as a foreigner, could not get a livelihood. In 1055, on the death of the Abbot of Malmesbury, Herman asked the King for the abbey and for permission to move his see there. The King assented, but the monks objected to the arrangement and sought the aid of Earl Godwin of Wessex. Godwin persuaded Edward to retract his consent three days after he had granted it. Indignant at his defeat, Herman left England and became a monk of St. Bertin's Abbey at St. Omer. In 1058, on the death of Bishop Elfwold of Sherborne, Herman returned to England and received this bishopric. This appointment brought about the unification of the two Sees of Sherborne and Ramsbury & Sonning, and he became bishop over all of Berkshire, Wiltshire and Dorset.

Herman did not lose his bishopric in consequence of the Norman Conquest and, in 1070 assisted at the consecration of Archbishop Lanfranc. The Council of London (1075) ordered that all Episcopal Sees must have their base in cities that previously had been in villages or small towns. He removed the see of his united diocese to the then thriving town of Old Sarum and began the building of the first Cathedral within the ancient hill-fortress. He died in 1078 before the completion of the Cathedral.

A tomb of Purbeck marble near the western entrance of the present Salisbury Cathedral could be his. This tomb slab came from Old Sarum when Bishop Richard Poore moved the see. Whilst the Dean, William de Waud, records the translation of the bodies of other bishops in 1226, he does not mention the body of Herman.

From the Domesday Book of 1086, we can establish that there were around 800 people, including the officials from the Bishop's Palace and Cathedral, living in the Ramsbury area at that time. In the early to mid twelfth century, the Bishops of Salisbury moved their Ramsbury residence to a site now within Ramsbury Manor Park. Prior to that time, the episcopal residence was probably located within the settlement, adjacent to the 'Cathedral', although there is no archæological evidence to confirm this. A possible site for this component may lie to the west of the present churchyard, between the church and Burdett Street. This street was known in the medieval period as 'Castle Wall' or 'Castle Street', and in this context 'castle', rather than denoting a defensive stronghold, may be derived from the Latin *castrum* or Old English *caester* or *ceaster*, denoting an early political centre or seat

of administrative power. Throughout the Middle Ages Ramsbury was one of the Bishop of Salisbury's principal palaces. The house stood beside the River Kennet in a park. At the house, the bishops had a chapel and a cloister, mentioned in 1320. Bishop Robert Wyville gained licences to crenellate in 1337 and 1377. Bishop Capon granted the manor to Edward Seymour, Duke of Somerset (Protector of the Realm 1547-9). In 1974, the bishopric became a suffragan to Salisbury.

Sonning Palace

Sonning (Berkshire) is a village on the River Thames, a few miles east of Reading. There was a bishop of Sonning and Ramsbury from 909 to 1058. The manor of Sonning belonged to the church from the earliest times, and for many years, the bishops of the divided diocese of Winchester resided there. However, Sonning declined in importance when Bishop Herman moved the bishopric to Sherborne in 1058. Domesday recorded that it was part of the lands owned by Osmund, Bishop of Salisbury. Although Sonning was no longer a bishopric, the Bishop of Salisbury kept a large house there, for use when he was travelling around his diocese. The former episcopal palace of the bishops of Salisbury at Sonning was in what is now Holme Park near the River Thames.

A large archæological excavation in 1912 revealed the extensive remains of the palace **(A1.2)**. The main buildings had a moat on three sides, the western portion of which is still traceable. Bishop Robert Wyville of Salisbury added further defences in 1337, when he obtained permission to crenellate the building. The palace was of a size and grandeur appropriate for such an important English bishop. Although there must have been a bishop's house in these early times, it was not on the site of the later building, but nearer the parish church. Nothing remains of the later palace earlier than the thirteenth century except a few reused twelfth-century stones. The thirteenth century house was parallel to and on the steep southern bank of the Thames and, though altered by later works, is traceable in the northern range of the later building. The house was above a sub-vault and closely resembled the palace built at Salisbury by Bishop Richard Poore about the same time. (The Sonning building had a hall 55ft by 25ft – in the Salisbury Palace the 'Aula' is 54ft by 24ft).

A second great rebuilding of the palace happened in the middle of the fifteenth century, and with its new hall, entrance porch, oriel, and staircase, must have been a magnificent piece of work. The date of this building and its details so closely resemble those of St George's Chapel at Windsor that it is probably the work of Bishop Richard Beauchamp, who was Surveyor

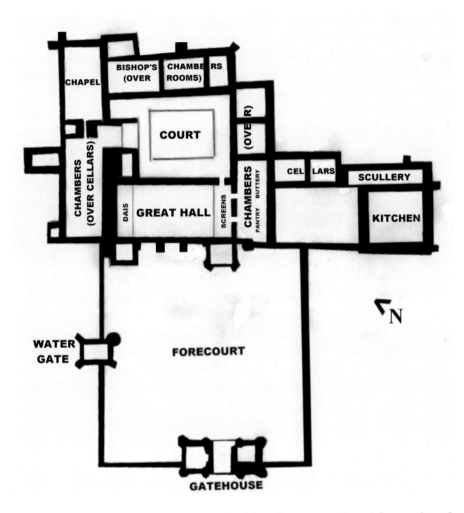

A1.2: The Bishop's Palace at Sonning in the fifteenth-century: adapted from a plan of the foundations uncovered during archæological excavations, 1912-14.

of the King's Works at Windsor in 1473. He also built the great hall at the Palace at Salisbury. (The Sonning hall was 74ft by 36 ft – the Salisbury hall 75ft by 38ft). The great gatehouse was rebuilt in Henry VII's reign with the walls surrounding the forecourt, and possibly the water gate on the north. John Leland visited Sonning in 1541, when 'yet remaineth a fair olde house there of stone even by the Tamise ripe longging to the Bisshop of Saresbyri and thereby is a fair parke.'

The Palace buildings formed an irregular group surrounding two courtyards, defended by a ditch on three sides. Visitors to the Palace entered

through the main gateway, which was on the west side of the large forecourt. On the north side of the forecourt there was another smaller (and older) gatehouse – the 'Water Gate'. The great hall was on the east side of the forecourt. The main entry to the hall was through a grand door from the forecourt, then into the screens passage. At the other end of the hall was a slightly raised dais on which was the bishop's table. The kitchen was located to the south of the great hall. The kitchen was an unusually long way from the hall – whilst very sensible to avoid fire risk, it must have meant a great many cold meals. The inner court lay behind the great hall and surrounded by a covered walkway, rather like a monastic cloister, a secluded place for reflection and refreshment. The eastern part of the northern range contained the bishop's chapel built during the fourteenth century enlargements. It was probably on the ground level and one storey in height, entered from the central court. It is just possible it was over a sub-vault, like the Bishop's Chapel at the Salisbury Palace. The Bishop's Chambers were adjacent to the chapel, probably on the upper floor, while servants probably lodged below.

It was from Sonning Palace that Bishop Roger (of Salisbury) left for the funeral of Henry I at Reading Abbey in 1135. He travelled up the Thames in a state barge accompanied by many churchmen and worthies of Sonning. Edward, the 'Black Prince' often visited the Bishop at Sonning while he was supervising his local estates. In about 1354, it is recorded that 'a fish called a whale' caught in Mounts Bay was delivered to him there. In 1396, Isabella, the seven-year-old daughter of King Charles VI of France, married King Richard II. Three years later, after the King's deposition, she was sent as a prisoner to Bishop Richard Metford of Salisbury who kept her confined in royal splendour at Sonning. The bishops of Salisbury continued in residence until, in 1574 Bishop Edmund Gheast gave the manor of Sonning to Queen Elizabeth in exchange for some manors in the Diocese of Salisbury. To what use the Queen put the house is impossible to say, as nothing of this period appeared during the archæological excavations. It fell into decay and a new house built to the south with the old materials. This in its turn has disappeared. The site for many years has been marked by considerable mounds, but not a stone remains above ground. It is in a grass field used as a cow pasture between St Andrew's Church and Sonning Lock.

Salisbury Court, London

Salisbury Court was the London house of the bishops of Salisbury who used it when summoned to attend Parliament. It was sited on Fleet Street between St Brides and Whitefriars. The grounds extended south to the Thames and the area covered was amongst the largest of all the episcopal

inns in London. In 1188, Bishop Herbert Poore acquired the land for the building of the house from St Giles' Hospital. In 1206, he obtained further nearby property from the Bishop of Winchester, which had been in the possession of the Knights of St John of Jerusalem until 1185 **(A1.3)**.

The bishops' registers show that they all spent time at their London inn, from days to weeks at a time. In the fifteenth century, nobles and their guests and visiting royalty often used the house in preference to other nearby mansions. There are occasional documentary references to Salisbury Court during the Middle Ages, although there is little detail about the buildings. In the register of Simon of Ghent (1297-1315), there is mention of a chamber. The bishop's London house was included on the two fourteenth-century licences to crenellate, but this particular work may not have taken place here. In 1376 and again in 1393, the great chamber was mentioned and in 1401, the porch of the great hall. In 1385, the bishop granted a small portion of his land to the rector of St Bride's, to add to the grounds of the recently completed rectory. There was probably a barn and great stable within the grounds of the medieval Salisbury Court and the bishop had wharves for loading and unloading ships on his Thames frontage. In 1986-7, excavations by the Museum of London on part of the site revealed a mid-fourteenth-century riverside wall.

A1.3: Salisbury Court, 1670: detail from the map of London by Wenceslaus Hollar from the Atlas by Dirk Van der Hagen.

In 1564, Richard Sackville purchased Salisbury Court from Bishop Jewel, (the Sackvilles were later created earls of Dorset in 1603). The house was then renamed Dorset House. The Salisbury Court Theatre, erected in 1629 between Fleet Street and the Thames, was in a building converted from a barn or granary in the grounds of Dorset House. It was the last theatre built before the closing of the theatres in 1642 during the Puritan era. After that, Salisbury Court sometimes staged theatrical performances in contravention of the local authorities. In January 1649, the London authorities raided all four of the London theatres simultaneously and arrested the actors at the Salisbury Court Theatre. In March that year, they destroyed the interior of the theatre, making it useless for public performances. At the Restoration of Charles II in 1660, theatrical performances began again. The Salisbury Court Theatre was refurbished and used for a time by the Duke's Company, patronised by the Duke of York (later James II), from November 1660 to June 1661. Samuel Pepys recorded visiting it several times in his diary for early 1661 (often calling it the 'Whitefriars Theatre'). The building burned down in the Great Fire in 1666 and it was replaced in 1671 by the Dorset Garden Theatre, which was built slightly further south to a design by Christopher Wren. Today, a blue plaque commemorates the theatre site.

Potterne Manor

Potterne (Wiltshire) is a village slightly to the south of the market town of Devizes and is the second-most populated village in Wiltshire according to the census of 2001. The Bishop of Salisbury's estate of Potterne, as listed in the Domesday Book, included the manors of Worton and Marston, and possibly Poulshot. It was a large and flourishing estate with six mills on the estate and the total population would have been between 420 and 460 people. The village increased in importance during medieval times owing to the residence there of the bishops. They lost the estate around 1139, during the civil war between King Stephen and the Empress Mathilda, but it was returned to them in 1148. A manor house, built here in the thirteenth century, became the residence of the bishops. This was a substantial house and housed eminent visitors when the bishop was in residence. A deer park, attached to this residence, was to the south-east of the village. This area is now Potterne Park Farm. In spite of its importance to the village of Potterne in the medieval period, there has never been a large-scale archæological excavation of the manor house. Existing evidence shows the existence of a manor house in Potterne by 1236, with successive bishops of Salisbury and their households staying here for varying periods over at least two centuries. The resulting trade and employment opportunities must have had

a significant impact on the surrounding communities, including Devizes. According to their registers, some bishops lived there for several months at a time, others only for a night or two. No bishop is recorded as residing there after 1452, and the manor was leased out in 1508.

The house fell into disrepair by the sixteenth century and gradual robbing of timber and stone by tenants of the manor and the local people resulted in its disappearance. In 1648, the Commissioners for the Sale of Ecclesiastical Lands sold the estate. The bishops regained the estate on the Restoration of the monarchy in 1660. A survey of 1639, taken by the Commissioners for the sale of Ecclesiastical Lands, speaks of a manor house with orchard, garden and hop yard. The only surviving description of the building is in 1647:

> built for the most part of it with free stone thoroughly tiled containing seven rooms below the stairs: i.e. one hall and kitchen, one parlour, one larder, one milke house and pantry house and one cellar, and seven rooms above ye staires. i.e. one faire chamber over the hall, another faire chamber over the parlour and over the kitchens and other chambers with it and two chambers more in the new buildings.
>
> Item: a large house or building well walled and well covered with stone for the most part of it which contayneth in breadth about 25 foote and in length about 80 foote which is called ye chappell. And one faire barne containing 8 baies or rooms of building built with free stone with timbers covered with tyle ... And one orchard well stored with fruit trees containing by estimation one acre. Item: the backside and yards about the same house containing about 2 acres.

A1.4: Tiles from excavations at Potterne. Left: green background, fleur-de-lis in white pipeclay (fourteenth-century). Right: orange background, animal pattern in white pipeclay (thirteenth-century).

BISHOP RICHARD METFORD
(Bishop of Salisbury: 1395-1407)

Richard Metford was born in Hakebourne (modern name East Hagbourne, Berkshire). He spent much of his life at the royal court, starting probably as a chorister in the Chapel Royal and continuing as a clerk of the household under Edward III. His training during his time as a Fellow at Kings Hall, Cambridge from 1352-74 prepared him for service in the royal bureaucracy, where he eventually rose to become Secretary of the King's Chamber to Richard II (1385-88). The senior household members of Richard II were politically important, and his position gave Richard Metford considerable influence. He was one of the members of the royal household arrested by the 'Lords Appellant' in late 1387 for treason, and was imprisoned first in Bristol Castle and then in the Tower of London. However, he was eventually released without penalty.

While Bishop of Salisbury, Richard Metford spent much of his time at one or another of his Episcopal manors. He spent 139 days at Potterne in 1403, 99 in 1405 and probably close to 200 between the start of 1406 and his death in late May 1407. The household accounts for the early fourteenth century survive, covering his stay at Potterne for the last seven months of his life. These give day-by-day records of members of his household and his visitors, the amounts and prices of the food provided for everyday meals as well as the feasts given at Christmas. Christmas was marked by a special mass and by many other customs including performances by visiting minstrels and players. Bishop Metford received a host of visiting players. Of particular note were the preparations made by Metford's own household for writing out interludes and playing at Christmas, along with red lead and other colours bought for the 'disgisinges' **(A1.5)**.

The household accounts also give the details of his funeral, such as his charitable gifts, the fee for his doctor and how much serecloth was provided for his funeral are also included. Following a long illness, he died on 3 May 1407. The funeral of Bishop Metford at Salisbury in 1407 was a major occasion. The Palace at Salisbury was the centre for the ceremonial feast. More than £68 was spent on the day on this funeral feast, the hire of 39 cooks and the construction of temporary buildings, tents or marquees, for the spits and dressers. A customary payment ('crook-penny') was collected from the Bishop's tenants on his death; and there was black cloth for livery at the funeral, amounting to a charge of more than £40. He was buried in the south transept of Salisbury Cathedral, where his tomb survives.

By this time, the tenants had 'demolished and carried away much material from the house'.

In 1974, preliminary archæological excavations on a series of ridges in the Great Orchard of Potterne revealed traces of foundation trenches, post-holes, broken limestone masonry, limestone clay roofing tiles, nails and patterned encaustic floor tiles. Domestic pottery shards of the thirteenth and

A1.5: A feast in a great hall in the fifteenth-century: adapted from an illustration by Valerie Bell (Picture Reference Book of the Middle Ages, *Brockhampton Press, 1967*).

fourteenth centuries were present, together with many animal bones, some very large, and numerous oyster shells. The conclusion drawn was that this was the site of a medieval outbuilding, attached to a wealthy house probably with ecclesiastical connections (the tile patterns were similar to some in Amesbury Priory and in Salisbury Cathedral), which had been extensively robbed. Also discovered was a flight of steps leading downhill from the site to a spring. It is probable that there had been a large fishpond here.

At Potterne, the style of decoration of some of the tile fragments found during excavation, with white clay inlaid on a red tile background in patterns of scrolled vines with trefoil leaves and heraldic beasts, is typical of the Wessex school of tilers. The tilers also laid floors in Salisbury Cathedral, and the style later spread to other parts of Wiltshire. This type of tile may indicate a major rebuilding of the manor in the 1250s. Other tiles, with an imprinted fleur-de-lis design in white on a dark green background, were attributed to the fourteenth century. The fleur-de-lis is the symbol of the Virgin Mary, the patron saint of both Salisbury Cathedral and of the church at Potterne **(A1.4)**.

Almost all of the Bishops of Salisbury in medieval times, especially Roger Martival (1315-30), regularly resided there for varying periods and enlarged the manor house. It may have been during this period that the fleur-de-lis patterned floor tiles were laid - probably in the chapel.

Appendix 1

Bishop's Cannings Manor

Bishops Cannings (Wiltshire) is a village in the Vale of Pewsey. It had belonged to the bishopric of Ramsbury before the creation of the Diocese of Sarum, although how and when it came into episcopal ownership is not known. It may once have formed part of a large multiple estate together with the neighbouring manor of Potterne, which was given to the bishopric of Sherborne by King Offa of Mercia (757-96). Bishop's Cannings formed part of the Domesday estate of the Bishop of Salisbury. The bishopric briefly lost control of the manor in 1139, when the manors of Bishop Cannings and Potterne were seized by King Stephen, along with Devizes Castle, which was on the border of the two holdings. The land was returned to the bishop in 1146.

The medieval bishops of Salisbury had a manor house at nearby Potterne from at least the late twelfth century (see above). It is surprising that the investment would be made to build another manor house so close by of a sufficient size and quality to accommodate the bishop and his entourage. Two documents in the register of Simon of Ghent (1297-1315) place the bishop at Bishop's Cannings, but they do not indicate that the bishop was likely to have been staying at a residence on the manor. No other bishop signed or received documents at Bishop's Cannings, although most of the medieval bishops used the house at Potterne fairly regularly. However, two fourteenth-century licences to crenellate appear to indicate that there was an episcopal manor house at Bishop's Cannings. In 1337 and 1377, the Bishop of Salisbury applied to the king for licence to fortify his see palace at Salisbury and eight other residences, including Bishop's Cannings. It is possible that Bishop's Cannings was included on the lists of properties in the fourteenth-century licences to crenellate in order to keep the possibility open of developing a residence there.

In the sixteenth century, the lessee of the manor of Bishop's Cannings apparently held his annual courts on the site of an ancient manor house. Traces of a ditch and rampart could still be seen in 1860, possibly suggesting the presence of a moat. On the tithe map of 1841, land called 'Court Close' (part of Court Farm), was shown just southeast of St Mary's Church. In the absence of other evidence, this seems to be the only obvious possible location of the manor house, although this building does not seem to have ever been used for residential purposes by the bishop.

Woodford Manor

Lower Woodford (Wiltshire) is a village in the valley of the River Avon just under three kilometres to the north-west of Old Sarum. Woodford was

part of the lands owned by the bishops of Salisbury. Until the early thirteenth century, as a bishop would have lived in the Palace at Old Sarum, a residence at Woodford so close by would have been unnecessary. The residence seems to have been used consistently through the later Middle Ages, although it was apparently more popular with the earlier bishops such as Roger Martival (1315-30). The manor seems to have been in use by the bishop until at least the late fifteenth century. Bishop Thomas Langton (1485-93) signed documents there in 1486, 1487 and 1488. This is the latest indication from the registers of the use of Woodford Palace by a bishop of Salisbury. John Leland notes that Bishop Shaxton (1535-9) pulled down the episcopal manor house at Woodford because 'it was already somewhat in ruin.'

Despite the disappearance of the bishop's house at Lower Woodford, the manor court continued to be held nearby. On the first edition of the Ordnance Survey map for Lower Woodford (1879), the 'Court House' was said to be 'on site of Bishop's Palace'. The present Court House was built in the eighteenth century and the west front which, can be seen from the road, was added around 1840, although it has been suggested that parts of the outbuildings date from the sixteenth century. Two medieval architectural fragments appear inside the house, a ceiling boss adorned with the initials R.P. and half of a carved stone quatrefoil. The initials could belong to Richard Poore, (Bishop of Salisbury 1217-28). The ruins of a small medieval building, referred to locally as a chapel, are supposed to have survived in the garden until circa 1875.

Until 2001, the precise location of the bishop's residence was unclear; the later house could have been built on the old site, or the medieval manor house could have been somewhere nearby. The plot immediately to the east of the Court House's back lawn seemed a likely candidate for the site of the episcopal manor house. Many pieces of roof tile and some fragments of medieval pottery have been found in the flowerbeds in this area. The two yew trees in the south-west corner of the plot are said to have marked the entrance to the bishop's chapel. The plot is next to the Avon.

A geophysical survey of the accessible parts carried out in June 2001, tried to locate the site of the episcopal residence and its service buildings. Notable levels of variation in resistance were observed on the western side of the plot and the high resistance features located appear to represent parts of the foundations of a large stone building. This appears extensive and is therefore most likely to be residential rather than a service building such as a brewhouse or barn. The small area surveyed on the far western side of the area suggests that the building does not extend any further to the west than the modern flowerbed. The impression gained is of a residence on a

less grand scale than that at Sonning. The particularly high area of resistance in the south-western area of the garden may reflect building rubble from the demolition of the palace. The two walls, which extend from here to the south, may have been part of a porch. The evidence gained shows that the main residential block of the medieval residence of the bishops of Salisbury was probably located to the east of the Court House in Lower Woodford, by the River Avon. The two courses of the river bounded the manor house to the west and east, and the artificial channel to the north may have been cut during the medieval period. Together, these watercourses formed a partially moated site. The convenient location close to the Avon meant that the bishops would have needed only to take a short boat trip down stream to arrive at the Cathedral and Bishop's Palace at Salisbury, which are close to the river. Although nothing survives of the manor house above ground, the indistinct features identified during the earthwork survey may reflect the remains of the building following its demolition. Where the palace's service buildings were is not clear. They may have been outside of the moated area, or further to the north or northwest.

Sherborne Old Castle

There are two castles southeast of the town of Sherborne (Dorset). Sherborne Castle is a sixteenth-century Tudor mansion within a 1,200-acre park now owned by the Wingfield Digby family. Sherborne Old Castle is the ruin of a twelfth-century castle in the grounds of the mansion. Roger de Caen, Bishop of Salisbury, built this original castle at Sherborne.

In 1330, King Edward III gave Sherborne Castle to the Earl of Salisbury, but this sparked renewed claims to the castle by the bishop. The struggle for ownership of Sherborne Castle began in 1355, when Bishop Wyville of Salisbury sued the Earl of Salisbury for the return of the old palace held by his predecessors. On the floor of the north-east transept of Salisbury Cathedral is a memorial brass to Bishop Wyville. The centre depicts a castle and represents Wyville's success in gaining possession of Sherborne Castle from the Earl of Salisbury. Bishop Wyville, shown standing in the gate of the first ward, is dressed as for the Eucharist holding his pastoral staff in his left hand. Below the bishop, standing in the gate of the outer ward, is his champion. At the top is the castle's keep showing the gateway, portcullis and two grotesque waterspouts. The story told in the brass is of the dispute over the castle and the method resorted to for a settlement. The bishop and the earl agreed to a battle of champions, at which time the bishop sent a letter around the diocese asking that prayers should be offered for his champion's success. On the appointed day, each side was called to the combat point and

Bishop Roger de Caen: (d.1139)

He was originally priest of a small chapel near Caen in Normandy. The future King Henry I, who happened to hear mass there one day, was impressed by the speed with which Roger read the service and enrolled Roger in his own service. Roger, though uneducated, showed great talent for business. On coming to the throne, Henry almost immediately made him Chancellor in 1101. He held that office until late 1102. In that year, Roger received the Bishopric of Salisbury at Old Sarum Cathedral.

Roger created the exchequer system, managed by him and his family for more than a century, and he used his position to heap up power and riches. He became the first man in England after the King. He ruled England while Henry was in Normandy. Following Henry I's defeat of his brother, Duke Robert of Normandy, at the Battle of Tinchebrai, Robert seems to have been put into Roger's custody. On the death of Henry I, though Roger had sworn allegiance to the Empress Matilda, he went over to Stephen, carrying with him the royal treasure and administrative system upon Stephen's accession in 1135. Stephen placed great reliance on him, but chafed against the overwhelming influence of the official clique whom Roger represented.

Bishop Roger was responsible for building a number of heavily fortified palaces. His greatest castle was at Devizes, built on land belonging to the Episcopal manors of Potterne and Bishop's Cannings. This was destroyed in 1648 and almost nothing of the original castle remains today. In 1131, Roger constructed the castle at Malmesbury in the grounds of Malmesbury Abbey. The castle was involved in the wars of King Stephen and Matilda. In 1216, the monks of Malmesbury Abbey were given permission to dispose of the site after King John had abandoned it.

At a council held in June of 1139, King Stephen began to suspect that Roger was plotting against him. Roger was arrested and, after a short struggle, all of Roger's great castles were sequestrated. The King was considered to have committed an almost unpardonable crime in offering violence to members of the Church. This quarrel with the Church had a serious effect on Stephen's fortunes. As the civil war turned against him, the clergy acknowledged Matilda. Bishop Roger, however, did not live to see the wrongs against him avenged. He died at Salisbury in December 1139 **(A1.6)**.

In 1226, his bones were moved to the new Salisbury Cathedral. What could be his tomb slab of black Tournai marble shows the full-length, low-relief sculpture of a beardless bishop holding a crosier and blessing his viewer. The head has been changed at some time and the new head is made of Purbeck marble. Until recently, this was accepted as the tomb slab of Bishop Roger. However, there is now some doubt about this. Recent thinking is that this could be the slab of Bishop Jocelyn de Bohun (Bishop of Salisbury: 1142–84). Whichever is correct, thousands of tourists and worshippers pass Roger's grave every year, mostly unaware that they are passing the remains one of one of England's greatest statesmen.

then told to go and prepare. Neither the bishop nor the earl would leave before the other, until sternly ordered to do so by the judges. At the next appointed time, the judges found several rolls of prayers and charms about the person of the bishop's champion making it, they said, an uneven fight. At the third time of asking, the Earl failed to turn up and was disqualified. At last, the Bishop paid the Earl 2,500 gold marks and regained possession of the castle. Amongst the lands returned to the Bishop was the chase at Bere in Dorset and for this reason rabbits are shown at the base of the brass **(A1.7)**.

There were a number of improvements made in the later fifteenth

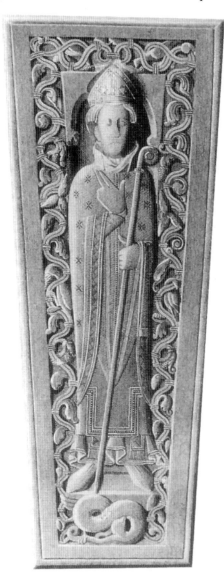

A1.6: An effigy in Salisbury Cathedral, possibly that of Bishop Roger.

A1.7: Bishop Wyville's memorial brass in Salisbury Cathedral.

century; however, the most important of these was the remodelling of the great tower after a serious fire: this may have been the result of a riot in 1450, when the Bishop's tenants broke into the castle and destroyed the manor records. Following the fire, the dividing walls separating the rooms in the upper part of the tower were removed to create a single room on each floor. At the same time, the basement rooms were given fireproof stone vaults. About 30 years later, in the 1480s, Thomas Langton, Bishop of Salisbury, added a new suite of private rooms to the south side of the Great Tower. These probably had large windows overlooking the park.

The bishops' interest in the castle ended in 1542, when pastoral care in Dorset was transferred from Salisbury to the new Diocese of Bristol. No

longer needing a residence at Sherborne, the bishops of Salisbury leased the castle and its estates to the Duke of Somerset and then, in 1578, to Queen Elizabeth I. In 1592, Sir Walter Raleigh took a liking to the castle, and first leased it and then bought it. After a few years, however, he decided that the task of modernising and restoring it was too great. Raleigh's property was forfeited to the Crown when he was imprisoned for treason in 1603, and the lands were eventually sold to Sir John Digby, an advisor to Charles I, in 1617. The Digby family took up residence in the adjacent hunting lodge, which they extended to become the mansion now known as the 'New Castle'. During the Civil War the old castle was besieged twice, the second time for some sixteen days, against General Thomas Fairfax. After its surrender, the Parliamentary army dismantled most of its defences. Further work was done in the eighteenth century to turn it into the romantic ruin we see today. Since 1984, it has been in the care of English Heritage.

Chardstock Manor, Devon

Chardstock is a village located on the eastern border of Devon, England between the towns of Chard and Axminster. The attractive village, surrounded by farmland and woodland, lies within the Blackdown Hills. By 1066, the manor of Chardstock formed part of the estates of the Bishop of Sherborne and then inherited by the bishops of Salisbury. Chardstock was seized by King Stephen in 1139 along with Bishop Roger's other estates. Bishop Herbert Poore (1194-1217) regained the manor in 1195, and it remained with the bishopric throughout the Middle Ages. The parish of Chardstock is on the borders of three counties, Somerset, Dorset and Devon. It formed part of the historic county of Dorset and was therefore within the diocese of Salisbury during the Middle Ages. During the reorganisation of the dioceses in 1896, the parish was transferred to Devon.

Today, Chardstock Court stands on the site of the former bishop's manor house. This house probably incorporated the surviving parts of the episcopal residence. This is on the south side of St Andrew's Church, in the centre of Chardstock village. The building contains some early fourteenth-century work, plus later additions and changes of the fifteenth and sixteenth centuries. The two-storey building had fallen into disrepair by the twentieth century and the south-west wing subsequently entirely rebuilt. There are a number of external medieval elements *in situ* within the south-east wing, including windows and doorways.

Chardstock was the bishopric's only residential base in Dorset between 1139 and 1354, during which time Sherborne Castle was in other hands. The manor house was certainly in existence by the episcopate of Bishop

Simon of Ghent (1297-1315); the manor house's chapel is referred to in one entry in his registers of 1312. Bishop Ghent spent a significant part of his episcopate in Dorset. Ghent's successor, Roger Martival (1315-30) also stayed at Chardstock and one of his register entries mentions the lord's chamber at the manor house. Bishop Robert Wyvil's register (1330-75) suggests that he may have been staying there whilst on his travels in Dorset. It was during Wyvil's episcopate that the bishopric recovered Sherborne Castle, so after 1355 Wyville and later bishops may have preferred to use the castle, which was located much closer to the rest of the diocese than Chardstock. The manor (and presumably the manor house) was leased out in 1501. The bishop had a deer park at Chardstock to the south west of the village. This area is still referred to as 'The Parks' on the modem Ordnance Survey map. King Edward I granted the right of free warren to Bishop Nicholas Longespée (1291-97) within the bishops' demesne. There is a reference to the park in a 1298 entry in the register of Bishop Simon of Ghent. This was a mandate issued by the bishop ordering the Archdeacon of Dorset to excommunicate some individuals who had trespassed into the park. In 1364, there was a reference to a fishery within the park, perhaps a weir or fishpond that utilised the River Kit. The park does not appear on Christopher Saxton's 1575 map of Dorset and it may well no longer have been in existence at this date.

Bishops' palaces at Old Sarum

Old Sarum, approximately 2½ miles from the centre of present-day Salisbury, is a hill fort, being originally an Iron Age settlement. At the centre of this site, the Normans constructed a large motte-and-bailey castle. The town of Old Salisbury grew up outside the gates of the outer bailey. Old Sarum became the centre of the Diocese of Salisbury under the general re-organisation of the Church in England. The first cathedral, started by Bishop Herman, was completed on the orders of St.Osmund (a kinsman of King William I). It was seriously damaged by fire within a matter of days of its consecration (1092). Bishop Roger repaired and rebuilt the cathedral and the castle of Old Sarum. He first turned his attention to the cathedral and, taking as his model the Abbaye-aux-Dames at Caen. He remodelled it with a central tower and transepts, which were aisled on both the east and the west sides. The quire and presbytery were to be much longer than the first cathedral and an imposing west front with twin turrets was another acknowledgment of French inspiration. Whilst usually placed to the south of the church, owing to lack of space, the cloister was built on the north-east angle of the cathedral.

CATHEDRAL

BISHOP JOCELIN'S PALACE

BISHOP ROGER'S PALACE

A1.8: Bishops' Palaces at Old Sarum (c.1135) in a reconstruction by Alan Sorrell (*English Heritage*).

Roger also obtained the king's permission to rebuild the royal castle of Old Sarum. As local materials were unfamiliar to him, he preferred to import stone from his native Caen. Originally, there was no great tower or keep, but comparatively low buildings on four sides of an open courtyard, with a projecting tower in the north-east corner, a concession to military requirements. The main part of the building was a palace rather than a castle, and it seems likely that the bishop normally lived there. Presumably, the family of Edward the Sheriff had found other quarters. In the civil war between Stephen and Matilda, the king took over the castle and soon

greatly strengthened in its inner bailey wall and by the addition of a strong gatehouse and an even stronger postern tower. The execution of this work may have fallen to Patrick, grandson of Edward the Sheriff, who became Earl of Salisbury in 1140 and, like his grandfather, father and brother before him, served as Sheriff of Wiltshire.

Bishop Roger's successor, Bishop Jocelyn de Bohun, who came to the see in 1142 and was bishop there for more than 40 years, built a new palace on the north side of the cloisters. Part of the northern end wall of the western domestic wing of this palace, built in greensand ashlar, still survives. Along the northern wall of the cloister was a corridor that led to the great hall, which would have been a magnificent aisled building with a porch halfway along the east side. Jocelin was buried in the chancel of Old Sarum Cathedral. His tomb was removed to the new cathedral in 1226.

Later, the atmosphere at Old Sarum was increasingly poisoned by a clash of authority between the governors of the castle, who held the keys of the outer gates, and the bishops who, in spite of a titular lordship of the manor, had little but spiritual authority and felt that they were almost like prisoners in their own cathedral. It is not surprising that their complaints, summarized by Pope Honorius III in his Bull of 1218, should impress by weight of numbers rather than substance. They read as follows:

> situated within a castle, the church is subject to such inconvenience that the clergy cannot stay there without danger to their persons. The church is exposed to such winds that those celebrating the divine offices can hardly hear each other speak. The fabric is so ruinous that it is a constant danger to the congregation, which has dwindled to the extent that it is hardly able to provide for the repair of the roofs, which are constantly damaged by the winds. Water is so scarce that it has to be bought at a high price, and access to it is not to be had without the governor's permission. People wishing to visit the cathedral are often prevented by guards from the garrison. Housing is insufficient for the clergy who are therefore forced to buy houses from laymen. The whiteness of the chalk causes blindness.

Royal and papal authority was granted in 1219 for the move and in the following year the new cathedral was begun (**A1.8**).

Appendix 2

King Richard II's 'Salisbury Parliament' (1384)

King Richard II visited Salisbury to attend a parliament held in the Bishop's Palace, which had been specially prepared for the occasion. This session met from 29 April until 27 May 1384. The House of Lords would have met in Bishop Poore's Aula (**A2.1**). We have no record as to where the House of Commons met. One guess would be that it could have held its meetings in the Chapter House of the Cathedral.

The most important subject for discussion was the policy to be adopted with regard to the war with France. The Commons were invited to give their opinion. They replied that they recognised that foreign policy was properly a matter for the King and Council; but they approved of John of Gaunt, Duke of Lancaster's policy. If 'peace with honour' could be had, the Commons would welcome it and with it a relief from war taxation, and were content to leave questions of detail to the King and his advisers. The Commons, after discussing taxation for whole month, decided to grant a tax to maintain the war with France. Despite the time they took over their decision, the tax was later found to be far short of what the King and his Council required.

Unhappily, discussion of policy was hampered by violent personal quarrels. Peers quarrelled with one another and with the King. The Earl of Arundel, the strongest man among the opposition and the most determined enemy of the King and the young Court party, chose the moment to launch a wholesale denunciation of the government and ministers, telling the King that his advisers were at fault, the administration was incapable and the country was going to destruction. Richard flew into a passion. White with fury, he gave the Earl the lie. 'If you say that I am at fault,' the King shouted,

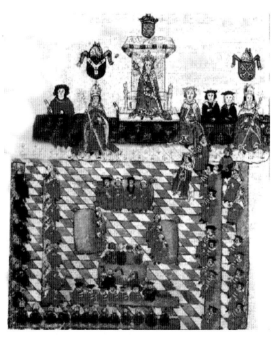

A2.1: A medieval Parliament in session, *c.* 1327.

'you lie in your throat: go to the devil!' The Lords of the Council and his intimates knew Richard's temper and were not surprised by this unseemly outburst, but Parliament was astounded at this public affront to a man of Arundel's position. There was an uncomfortable feeling in the House, until John of Gaunt (the King's uncle and Duke of Lancaster), who since his arrival had been doing his best to keep the peace, after a long silence, rose and tried to pacify the King and explain the Earl's words away.

Robert de Vere, the King's closest friend and advisor, made a reckless attempt to get rid of his rival, John of Gaunt. The means chosen, if discreditable, were ingenious and very nearly successful. One day, during the session of parliament, the King was in the chamber of the Earl of Oxford, when suddenly a Carmelite Friar, John Latemer, who had just been celebrating mass, came forward with a story of a conspiracy against the King's life. His story was that a widespread conspiracy was afloat, in which the citizens of London and Coventry and other cities were implicated, but which was organised and controlled by John of Gaunt. Richard ordered his uncle to be seized and killed forthwith. That was doubtless the result hoped for by the Earl of Oxford, but happily, there were cooler heads that prevailed upon the King to listen to reason. Sir John Clanvowe, Prior of the Hospital of St John of Jerusalem, an eye-witness from whom a most detailed account is derived, gave a graphic description of the scene which followed. Richard, nervous and highly-strung at all times, now completely lost self-control. He

behaved like a lunatic, took off his hat and shoes and threw them out of the window! When he became calmer, he was induced to order the informer to write down the story, giving the names of his witnesses. At this turn of events, the friar's face fell; de Vere and the accomplices had reckoned on some such hasty act as Richard had ordered on the impulse of the moment, and were unprepared for a calm sifting of evidence.

On the day of this affair, arrangements had been made for a solemn procession to be made to the Cathedral, King, Lords, Commons taking part, where mass was to be celebrated, and intercession made for the safety, honour and welfare of the Church and realm. The clergy had taken their places in the Cathedral and everyone was waiting for the King's arrival. As he did not appear, John of Gaunt went to find out the reason. So soon as the Duke entered de Vere's chamber, where the King was, the friar shouted, 'There is the villain! Seize him and put him to death, or he will kill you in the end!' The Duke's astonishment can well be imagined. When the plot was explained to him, he indignantly denied all knowledge of it, and offered to prove his innocence through a trial by combat.

Richard, completely swayed by his emotions, in a sudden revulsion of feeling, convinced by his uncle's bearing, turned his fury on the informant and ordered him to be put to death. The Duke managed to prevent this. Failing the success of their manœuvre, the friar's death was the next best thing for those who had hatched the plot. Dead men tell no tales, but the Duke's anxiety was that the tale should be told. The Carmelite was obviously a mere tool, and Lancaster wanted to expose his enemy. The friar was told to repeat his story, and did so, naming Lord la Zouche as a witness. The witness denied all knowledge of the story, and, like John of Gaunt, offered to defend his honour with his life. A second witness named by the friar was equally ignorant. The friar was then removed into the custody of John Holland, and the solution of the mystery was as far off as ever.

What would have happened had the proposed judicial inquiry been held is a matter for conjecture – but it did not come about. Sir John Montague, the King's Seneschal, and the Chamberlain, Sir Simon Burley, led the prisoner away, intending to take him to Old Sarum Castle. At the door of the King's lodging, Sir John Holland and four other knights met them. John Holland, Duke of Exeter was the King's half-brother and one of the premier nobles in the kingdom. He became one of the principal props of Richard II's régime in its later years, and a military figure of some renown with a considerable territorial base in the South-West. He came increasingly under the influence of John of Gaunt. The Salisbury Parliament saw the first indication of Holland's violent temper. Acting as they thought in the

King's interest, they determined to get at the truth. A mortal feud between Richard and his uncle was clearly not in the interests of King or nation. In the presence of the King's Chamberlain and Seneschal, they proceeded to torture the friar with a brutality too foul to be described, in order to make him disclose the real movers in the plot. The friar remained silent and incriminated no one. Mutilated and dying, he was handed over to the warden of Old Sarum Castle. When the King heard what had been done he wept for pity. Neither he nor John of Gaunt had known of the torture: callous cruelty was not part of the nature of either.

The dying man had made one last request – to be allowed a secret interview with Lord la Zouche. The interview was granted, but not in secret. Six of the King's knights, three of Gaunt's and three from the Commons, were present. However, the mystery was not cleared up. Asked if he knew anything against Lord la Zouche, the friar replied that he knew him to be a brave and true gentleman. Then words failed him, and after lingering for a few days, he died without making any further statement.

Whatever the interest in which Latemer had spoken, it was certainly not that of the Carmelite Order. The usual attempts were started to make capital out of the man's death. Miracles were invented; it was said that the dead wood of the crate on which his body had been dragged through the streets of Salisbury put forth leaves; that a blind man had got back his sight by touching it and that a light had been seen shining over the martyr's grave. However, the Carmelites refused to sanction the fraud. When a month later a Carmelite of Oxford tried to preach inflammatory sermons on the subject, he was promptly suppressed by orders from the Provincial. This shows the extent of John of Gaunt's influence with the Carmelites that they should thus readily support him against one of their own brotherhood. Whilst his death prevented the friar giving very convincing testimony, it had the effect of placing on John of Gaunt the odium of having caused the death of an awkward witness. It is doubtful whether parliament dealt with the matter at all; it was perhaps either disposed of before the King in Council, or allowed to fall through on the death of the accuser.

Appendix 3
The Portrait Collection

The Big School Room is the centre of the extensive collection of portraits of former bishops of Salisbury started by Bishop John Douglas (1791-1807) **(A3.1)**. In September 1796, Sir William Musgrave listed the portraits already collected and added: 'The Bishop of Salisbury has succeeded thus far in procuring portraits of his predecessors from the Restoration; & hopes soon to complete the collection; the portraits of Bishops Hyde, Earle, Willis, Gilbert, & the two John Thomas's, being still wanting, but in the way of being procured'. Douglas had most of his predecessors represented as

A3.1: Bishop John Douglas by Sir William Beechy, c. 1800

chancellors of the Order of the Garter, an office then attached to the See of Salisbury. The badge was on one side a rose, on the other a George cross; the chancellor also held a purse for the seals. Before being translated from Carlisle to Salisbury, Douglas became registrar of the Order in 1788. After his translation, he appears as chancellor in portraits by George Romney (1792) and by Robert Muller (1797). The painting by Muller (lost since 1954), which had hitherto been in the Palace, was given to the City of Salisbury by his daughter in 1820. This revived an old tradition, whereby portraits of notable bishops were hung in the Salisbury Guildhall. Douglas made use of these for his collection.

In 1795, Salisbury City Council received the Bishop's acknowledgements for its gift of the portraits of Bishops Humphrey Henchman, Gilbert Burnet and William Talbot. Copies of the portraits of Burnet (by John Riley) and Talbot (by Sir Godfrey Kneller) had been given to the city by the bishops themselves. The City Council agreed to lend the portrait of Bishop Seth Ward to the Bishop in order to be copied. Bishop Henchman was translated to London in 1663, but Salisbury did not forget him.

One of the smaller portraits is of one of Salisbury's more eccentric bishops.

BISHOP JOHN THOMAS II: (1681 – 1766)
 (Bishop of Salisbury: 1761–66)

He was the son of a drayman in the City of London. He was then educated at Merchant Taylors' School (**A3.2**). He studied at Catharine Hall, Cambridge, and granted D.D. in 1728. He became chaplain of the English factory at Hamburg. He attracted the notice of George II, who offered him preferment in England. He accompanied the King to Hanover at the king's personal request. His knowledge of German had commended him to the king. He became Dean of Peterborough in 1740. In 1743, he was nominated to the bishopric of St. Asaph, but was immediately transferred to Lincoln in 1744. He was translated to Salisbury in 1761.

Bishop Thomas had a noted sense of humour. He was married four times and in an article in 'The Gentleman's Magazine' (1783) he was reported as having once said, "Perhaps you don't know the art of getting rid of your wives. I'll tell you how I do. I am called a very good husband, and so I am, for I never contradict them. But, don't you know that the want of contradiction is fatal to women? If you contradict them, that circumstance alone is exercise and health to all women. But give them their own way, and they will languish and pine, become gross and lethargic for want of this exercise!" An unfailing optimist, he had as the motto on his fourth wedding ring the words: 'If I survive, I'll make them five'. (He did not!)

A3.2: Bishop John Thomas II (artist unknown).

In 1673, the Council recorded:

'Christopher Gardiner of the Citty of Bristoll Paynter ... promiseth to drawe for this place one faire Picture of the right reverend Father in God Humfrey nowe Lord Bishop of London. The portrait is surpassed in interest by that of Seth Ward, who was painted by John Greenhill [pupil of Sir Peter Lely and a former pupil of Salisbury Cathedral School], whose father had been the Registrar of Henchman, and who was himself a native of Salisbury'.

On 30 October 30 1673, it was recorded: 'Also it is ordered that Mr John Greenhill of London is to be desired to attend the now Lord Bishop of Sarum in order to the drawing of his Lord picture to be sett up in this Counsell house.'

In addition, at Midsummer 1675: 'Paid for His Lords Bishopps picture xxviij'.

Bishop John Fisher (1807-25) continued this collection and made the following comments about it: 'Most of these portraits are copies. That of Bishop Burnet is an original. It was sent to the Palace about six years since ... The portraits of Bishop Hyde, Bishop Sherlock, Bishop Barrington, and Bishop Douglas are original.' The pedigree of Burnet's portrait, apparently different from the one obtained by Douglas by 1796, was traced back by Fisher to Bishop Lisle, who was educated at Salisbury during Burnet's episcopate.

There are two portraits of Bishop Thomas Sherlock (1734-48) in the

collection. The first is a copy of Jean-Baptiste Van Loo's painting of 1740, later engraved without the Garter robes after Sherlock was translated to London. Other versions with the Garter robes include those at Benacre Hall, the seat of his heirs, the Gooch family, and at St Catharine's College, Cambridge, of which he had been Master. This last was traditionally ascribed to a painter called 'Jones', to whom must be given the credit for painting the portrait of Sherlock at Salisbury, which was engraved by Lelius in 1737. It is presumably to this last that Fisher refers. There may have been just three portraits in the Palace when Douglas arrived: John Jewel, Thomas Sherlock and Shute Barrington. Since Musgrave's visit in 1796 those of Bishops Robert Willis, Benjamin Hoadly, John Gilbert and the two John Thomases were added. These half-length portraits were probably acquired by Fisher, as on 19 January 1808, Joseph Farington, the noted diarist, records that there were only nine or ten portraits to be seen at the Palace. Fisher intended to enlarge Douglas's half-lengths so that they would all be three-quarter lengths, but he never did this. He received the second Burnet. However, his main contribution was his own portrait by James Northcote (1808) (see fig **3.11**, p. 93). Finally, he acquired the portrait of Bishop Alexander Hyde (1665-7) which 'was rescued from an obscure cottage in Wilts', but which Archdeacon Fisher called 'spurious'.

Bishop George Moberly (1869-85) did more for the collection. He presented his own portrait by Sir W. Blake Richmond in 1881. In 1870, he had a copy made of the head and shoulders section of the portrait by Pickersgill of Bishop Edward Denison's portrait. He gave a portrait of Bishop Martin Fotherby (1618-20) to the Palace. However, his greatest coup was when he exchanged with Bishop John Hume's family Douglas's Garter portrait of him for an original by Thomas Beach painted in 1777 **(A3.3)**.

Dame Elizabeth Wordsworth, Bishop John Wordsworth's sister, commented about the collection: 'The best is Beechey's [sic] portrait of Bishop Hume, who used the patronage of the see for the advancement of his family. The Bishop would often point out his keen and acquisitive features.' Wordsworth himself bought the portrait of John Davenant (1621-41) and had John Earle (1663-5) copied from a picture now in the National Portrait Gallery. His own imposing portrait by Sir George Reid was added in 1905 (see fig. **4.8**, p. 115).

When the Cathedral School took over the Palace in 1946-7, the collection was split up. Some of the smaller portraits were eventually displayed in the South Canonry when this house became the Bishop's residence in 1951. Following an inspection by representatives of the National Portrait Gallery in 1962, portraits of Benjamin Hoadly, Robert Drummond, Thomas Burgess

A3.3: Bishop John Hume by Thomas Beach, 1777.

and Edward Denison were scrapped. These needed restoration and it was decided that the artistic merit of the pictures did not justify the expense involved. Unfortunately, six of the portraits were destroyed in a fire at the South Canonry in 1963. Those lost this way were: John Jewel (small painting on a wooden panel); John Davenant (small portrait – a copy of original by Daniel Mytens, 1621); Brian Duppa; John Douglas (small picture of him as a young man, not the Beechy portrait); a pencil drawing of Gilbert Burnet; and the silhouette of Thomas Burgess. The portrait of Shute Barrington, having been damaged in this fire, was reduced to the head and shoulders only. This now hangs in the Big School Room (the Aula) today: the full size version of this portrait can just be glimpsed in the 1939 photograph of the Aula (see fig. **1.12, p. 38**).

In 1946, the plaster busts of Shute Barrington, John Fisher and Thomas Burgess were reported to be on pedestals in the grounds of the Palace. The Church Commissioners decided that these busts should remain *in situ*. However, during an inspection made for the Commissioners in 1973, it was discovered that the busts had disappeared. Nobody at the time seemed to know anything about them, except for one elderly gardener who seemed to remember seeing a 'bishop' in a stable! Presumably, he was referring to the stable block demolished in 1965. The fate of these busts remains a mystery.

Portraits in the Palace

The following is transcript of a manuscript list compiled by Clifford Holgate (Bishop Wordsworth's Chancellor) in 1890, now held in the School archives. ★ As at 2012, these are portraits which can still be seen at the Palace.

John Jewel, 1560-71. Two, a poor one on canvas and another on a wood panel. On the latter is *Ve Mihi Si Non Evangeliza Vero.*

Edmund Gheast, 1571-6. Marked with his coat of arms, and *Edmvndvs Geste* and *Ætat. LXIII. anno domini 1576.*

★Robert Abbot, 1615-18.

★Martin Fotherby, 1618-20. Marked with his coat of arms, and *Anno domini 1618. Ætatis 58.* This picture was presented to Bishop Moberly for the Palace.

Brian Duppa, 1641-60.

★Humphrey Henchman, 1660-3. By or after Dahl. [This is probably *not* by Michael Dahl who was a significant portrait painter of this period. He did not arrive in England from his native Sweden until 1684 and Henchman had died in 1675].

★Alexander Hyde, 1665-7. 'There is a portrait of Bp. Hyde in the Palace at Sarum which was rescued from an obscure cottage in Wilts, and presented to our present excellent Diocesan, Bp. Fisher' (Cassan's *Lives* [1824] pt. iii, [p. 31).

★Seth Ward, 1667-89. By or after John Greenhill, a pupil of Sir Peter Lely.

★Gilbert Burnet, 1689-1715. An original sent to the Palace about 1818 by the executor of Mrs Bouchiere of Swaffham, Norfolk. The picture had been in the possession of Samuel Lisle, Bishop of St Asaph (1744-8) and of Norwich (1748-9). He left it to his chaplain and executor, Mr Bouchiere, who bequeathed it to his widow, with directions to his executor to send it, upon the death of his wife, to the Palace at Salisbury.

***William Talbot**, 1715-21. After Godfrey Kneller?

***Richard Willis**, 1721-3.

Benjamin Hoadly, 1723-34. 'There is also a fine portrait of him in the great room in the Bishop's Palace at Salisbury.' (Cassan's Lives (1824), pt. iii, p. 237).

***Thomas Sherlock**, 1734-48. Two, both on canvas. Copies of Van Loo's portraits?

***John Gilbert**, 1748-56.

***John Thomas I,** 1757-61.

***Robert Hay Drummond**, 1761. Copy of Sir Joshua Reynolds' picture painted in 1764.

***John Thomas II**, 1761-6.

***John Hume**, 1766-82. By J. Beach, 1777. A fine picture exchanged with the family, during Bishop Moberly's episcopate, for one in the Garter robes.

***Hon. Shute Barrington**, 1782-91. Painted in 1785.

***John Douglas**, 1791-1807. By Sir William Beechy, R.A.

***John Fisher**, 1807-25. By James Northcote, R.A.

Thomas Burgess, 1825-37. By William Owen, R.A. Also the original of the silhouette which is reproduced in Harford's Life (opp. p. 475) given to the present Bishop by the late A. Harford Pearson.

Edward Denison, 1837-54. Head only, copied in 1870 from the picture by H.W. Pickersgill, R.A., at Merton College, Oxford.

***Walter Kerr Hamilton**, 1854-69 by George Richmond, R.A.

***George Moberly**, 1869-85 By William B. Richmond, A.R.A. Painted by subscription raised throughout the diocese.

*** King George III.**

Henry Lawes, the Musician.
'In 1784, in the house of Mr. Elderton, an attorney in Salisbury, I saw an original portrait of Henry Lawes on board, marked with his name and '*Ætat. Suæ 26, 1626*' [Sic: but the picture itself is dated 1622]. This is now in the Bishop's Palace at Salisbury. To the back of the picture is affixed a card on which is apparently in Bishop Barrington's handwriting, 'This original portrait of Henry Lawes, a native of Salisbury, the most distinguished musician of his time and the intimate friend of Milton, is left as an heirloom to the

Palace at Salisbury by Bp. Barrington, July 1, 1791. It is not ill painted; the face and ruff in tolerable preservation; the drapery a cloak, much injured.' (Rev. Henry John Todd M.A., *Milton's Works,* 1801, vol. 5, p. 208). [Since 1995, the portrait of Henry Lawes has resided at the South Canonry.]

Bibliography

Bishop's Palace, Salisbury

Braun, Hugh, 'Notes on the Bishop's Palace at Salisbury', *Wiltshire Archæological Magazine*, 57, 1957, pp.405-407.

Brentnall, Harold Cresswell, 'The Bishop's Palace', *Wiltshire Archæological Magazine,* 51, 1945-7, pp.352-3.

Emery, Anthony: *Greater Medieval Houses of England and Wales, 1300-1500: Vol.3, Southern England,* Cambridge, 2006.

Payne, Naomi, 'The Medieval Residences of the Bishops of Bath & Wells and Salisbury', Ph.D. thesis, Bristol University, 2003.

Royal Commission on the Historical Monuments of England, *Salisbury – The Houses of The Close*, HMSO, 1993.

Salter, Alicia, *Sir Robert Taylor (1714-88): the Bishop's Palace and the Guildhall, Salisbury, Wiltshire,* M.Phil.dissertation in Architectural History and Theory, Bath University, 2003.

Thompson, Michael: *Medieval Bishops' Houses in England and Wales,* Ashgate, 1998.

Venables, Edmund, *Episcopal Palaces of England*, Isbister, 1895.

Wordsworth, Christopher, *Some Stray Notes related to the Bishop's Palace at Salisbury,* privately printed booklet, 1923.

Wordsworth, John, & Reeve, Arthur, *The Bishop's Palace at Salisbury: Notes on the Archictectural History of the Palace,* (from a combined lecture given by the authors at Salisbury Museum, 27 January 1890), privately printed booklet, 1890.

Bishops of Salisbury

Aubrey, John, *Brief Lives* (ed. Barber, Richard), Boydell, 1982.

Beckett, Ronald Brymer, *John Constable and the Fishers (The Record of a Friendship)*, Routledge, 1952.

Carpenter, Edward, *Thomas Sherlock (1678-1761)*, S.P.C.K., 1936.

Cassan, Stephen Hyde, *Lives and Memoirs of the Bishops of Sherborne & Salisbury (705-1824)*, Brodie & Dowding, 1824.

213

Clarke, Thomas Elliot Simpson & Foxcroft, Helen Charlotte, *A Life of Gilbert Burnet, Bishop of Salisbury*, Cambridge University Press, 1907.

Cross, Ernest, *Frederic Edward Ridgeway: Bishop of Salisbury, a Memoir*, Mowbray, 1924.

Dimont, Charles Tunnacliffe, & de Witt Batty, Francis, *St. Clair Donaldson*, Faber, 1939.

Dobson, Clifford, *The Jewel of Salisbury*, Dean & Chapter of Salisbury Cathedral, 1996.

Gibson, William, *Enlightenment Prelate: Benjamin Hoadly, 1676-1761*, James Clarke, 2004.

Harford, John Scandrett, *The Life of Thomas Burgess, D.D. Lord Bishop of Salisbury*, Longmans, 1840.

Jones, William Henry Rich, *Fasti Ecclesiæ Sarisberiensis (Calendar of the Bishops, Deans, Archdeacons & Members of the Cathedral Body at Salisbury from the earliest times to the present)*, Simpkin, Marshall & Co., 1879.

Kealey, Edward, *Roger of Salisbury*, University of California, 1972.

Latham, Robert, *Seth Ward Bishop of Salisbury (1667-89)* (address delivered at the Annual Festival of the Friends of Salisbury Cathedral, 8 July 1982, in celebration of the tercentenary of the foundation of Ward's College of Matrons), Friends of Salisbury Cathedral, 1982

Liddon, Henry Parry, *Walter Kerr Hamilton : a Sketch*, Rivingtons, 1869.

Moberly, Charlotte Anne Elizabeth, *Dulce Domum (George Moberly – His Family & Friends)*, John Murray, 1911.

Olivier, Edith, *Four Victorian Ladies of Wiltshire*, Faber, 1945 (esp. Chapter 2: 'Miss Annie Moberly').

Pope, Walter, *The Life of Seth, Lord Bishop of Salisbury*, William Keblewhite, 1697 (ed. Bamborough, John Bernard, Basil Blackwell, 1961).

Southgate, Wyndham Mason, *John Jewel and the Problem of Doctrinal Authority*, Harvard University, 1962.

Watson, Edward William, *Life of Bishop John Wordsworth*, Longmans, 1915.

Yates, Nigel, *Bishop Burgess and his World*, University of Wales, 2007.

Background research sources
Britton, John, *The History & Antiquities of the Cathedral Church of Salisbury*, Longman, 1814.

Barrett, Philip, *Barchester: English Cathedral Life in the 19th Century*, SPCK, 1993.

Brakspear, Harold, 'The Bishop's Palace, Sonning', *Berkshire, Buckinghamshire and Oxfordshire Archæological Journal*, 1916, Vol.22, pp. 9-21,

Cherry, Bridget, & Pevsner, Nikolaus, *The Buildings of England: Wiltshire,* Penguin, 1975.

Chandler, John, *Endless Street: a History of Salisbury and its People,* Hobnob Press, 1983.

--------- *John Leland's Itinerary: Travels in Tudor England,* Alan Sutton, 1993.

--------- & Parker, Derek), *The Church in Wiltshire,* Hobnob Press, 2006.

Croft, Roger, *Salisbury Cathedral Close Guide,* Close Publications, 1997.

Davison, Brian, *Sherborne Old Castle, Dorset,* English Heritage, 2001.

Defoe, Daniel, *A Tour Through the Whole Island of Great Britain,* 1724 (ed. P.N. Furbanks & W.R. Owens, Yale U.P., 1991).

Dorling, Edward Earle, *A History of Salisbury,* Nisbet, 1911.

Edwards, Kathleen: *The English Secular Cathedrals in the Middle Ages,* Manchester U.P., 1967.

-------- *The Houses of Salisbury Close in the 14th Century,* Published O.U.P. for the British Archæological Association, 1939.

Fletcher, James Michael John, *Some Royal Visits to the City and Cathedral Church of the Blessed Virgin Mary at Salisbury* (lecture given at Salisbury Cathedral, 24 June 1935), privately printed booklet.

Grundy Heape, Robert, *Salisbury: Some Architecture in the City and in the Close,* Methuen, 1934.

Hutton, Edward, *Highways and Byways in Wiltshire,* MacMillan, 1917.

Hyams, Edward: *Capability Brown and Humphrey Repton,* Dent, 1971.

Ives, Eric William, Knecht, Robert Jean, Scarisbrick, John Joseph (eds.) *Weath & Power in Tudor England,* (essays presented to S.T. Bindoff) (esp. Chapter 8, 'Episcopal Palaces 1535-1660 by Phyllis Hembry), University of London (Athlone Press), 1978.

Jardine, Lisa, *Going Dutch: How England plundered Holland's Glory,* Harper, 2008.

Jowitt, Robert Lionel Palgrave, *Salisbury* (British Cities Series), Batsford, 1951.

Loudon, John Claudius: *The Landscape Gardening and Landscape Architecture of the Late Humphry Repton,* Longman, 1840.

-------- *An Encyclopaedia of Cottage, Farm, and Villa Architecture and Furniture,* Longman, 1839.

McGlashan, N.D., & Sandall, Richard Emery, 'The Bishop of Salisbury's House at his Manor of Potterne', *Wiltshire Archæological Magazine,* 69, 1974, 85-96.

Mee, Arthur (ed.): *Wiltshire: Cradle of Our Civilisation* ('The King's England' series), Hodder, 1939.

Moorman, John R.H., *Church Life in England in the 13th Century,* Cambridge U.P., 1945.

Newman, Ruth, & Howells, Jane, *Salisbury Past,* Phillimore, 2001.

Northy, T.J., *The Popular History of Old and New Sarum,* Wiltshire County Mirror & Express, 1897.

Price, Sir Uvedale, *An Essay on the Picturesque, as Compared with the Sublime and the Beautiful; and on the Use of Studying Pictures, for the Purpose of Improving Real Landscape,* J.Mawman, 1794 (expanded editions 1796-8, 1801).

Richardson, Tim, *The Arcadian Friends : inventing the English Landscape Garden,* Bantam, 2007.

Robertson, Dora, *Sarum Close (A Picture of Domestic Life in a Cathedral Close for 700 years),* Jonathan Cape, 1938.

Ross, Christopher, *The Canons of Salisbury,* Dean & Chapter of Salisbury Cathedral, 2000.

Sandell, Richard Emery, 'Two Medieval Bishops and their Wanderings', *Hatcher Review,* 1:1, 1976, 19-25.

Schofield, John, *Medieval London Houses,* Yale University Press, 2003.

Shortt, Hugh, *City of Salisbury,* Phœnix House, 1957.

-------- *Salisbury, a New Approach to the City and its Neighbourhood,* Longman, 1972.

Smith, Peter Leonard, *In the Shadow of Salisbury Spire (Recollections of Salisbury Cathedral Choristers and their School),* Hobnob Press, 2011.

Spring, Roy, *Salisbury Cathedral,* (Bell's Cathedral Guides Series), (esp. Chapter 7 'The Cathedral Close'), Unwin, 1987.

Symons, Geraldine, *Children in The Close,* Hillman, 1959.

Victoria County History, *A History of Wiltshire,* vol. 6, (ed. Elizabeth Crittall), Oxford University Press, 1962.

Whittingham, Selby, *Constable and Turner at Salisbury,* Friends of Salisbury Cathedral, 1980.

Whitton, Donald C., *The Grays of Salisbury (An Artist Family of 19th Century England),* San Francisco, 1976.

Wood, Margaret, *The English Medieval House,* Phœnix House, 1965.

Index